Architecture | Art

Parallels | Connections

Barry A. Berkus, AIA

WATSON-GUPTILL PUBLICATIONS / NEW YORK

To my wife Gail Hanks Berkus, my best friend and partner in passion and adventures.

To my parents Harry and Clara Berkus, the guiding light in my formative years.

To my children, Jeff, Carey, and Steven, and their spouses and children, for the enjoyment they have given me.

Copyright © 2000, by The Images Publishing Group Pty Ltd
6 Bastow Place, Mulgrave, Victoria 3170, Australia

Published in the United States in 2000 by
Watson-Guptill Publications,
a division of BPI Communications, Inc.
1515 Broadway, New York, NY 10036

Book design: The Graphic Image Studio Pty Ltd, Mulgrave,
Australia

Library of Congress Cataloging-in-Publication Data for this
title can be obtained by writing to the Library of Congress,
Washington, D.C. 20540

ISBN 0-8230-0293-4

Printed in China
2 3 4 5 6 7 8 9 / 07 06 05 04 03 02 01

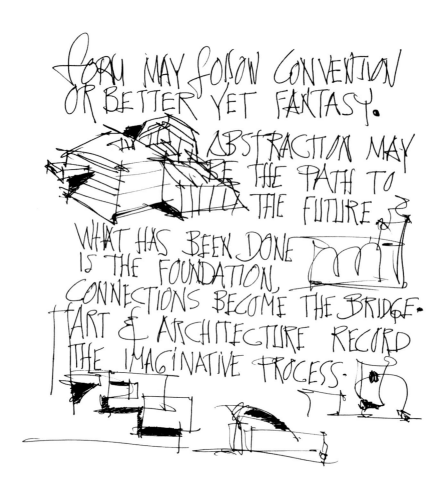

FORM MAY FOLLOW CONVENTION OR BETTER YET FANTASY. ABSTRACTION MAY BE THE PATH TO THE FUTURE. WHAT HAS BEEN DONE IS THE FOUNDATION, CONNECTIONS BECOME THE BRIDGE. ART & ARCHITECTURE RECORD THE IMAGINATIVE PROCESS.

N.B. Citations are made as follows: artworks are cited on the pages where they appear by artist, title, and date only; full citations of artworks other than the author's are found in Appendix 1: Featured Artworks. Drawings that are not otherwise cited are by the author, untitled. Architectural photographers are cited in Appendix 2: Featured Photographers. Architectural illustrations not otherwise cited were produced by the author's affiliated firms (Barry A. Berkus, AIA; Berkus Group Architects; Berkus Design Studio; and B3 Architects + Planners). Buildings designed by the author and his affiliated firms are cited in Appendix 3: Selected Buildings and Projects. Page numbers follow all citation references in Appendices.

This book has become finished art through the hands of Christine Lorenz, who helped put rationale to my thoughts and compositions, and Pamela Armstrong, whose years of interpreting my hen scratches have added greatly to my ability to speak my mind.

Of the many who have helped this book come to pass, I wish to extend particular thanks to a few individuals: to Paloma Cain, for searching out the origins of the artwork and securing permissions; to Pat Moser, my assistant for 17 years, for keeping me organized and focused; to Harry and Sandra Reese, great creative souls, for their guidance; to Margaret Dodd and Rebecca Hardin who listened attentively and took runs with me during early formations of this work; to those who provided helpful feedback on earlier versions of this book, especially Marsha Tucker; to Kenneth Frampton for his encouragement; to the artists who have been part of my life and this book, particularly Herbert Bayer, William Dole, Macduff Everton, Andy Goldsworthy, Ann Hamilton, Tim Hawkinson, John Okulick, Richard Ross, Ed Ruscha, Sean Scully, Richard Tullis II, and John Walker; to those who have been part of our journey through the art world, including Pamela Auchincloss, Richard Armstrong, Betty Asher, John Berggruen, Irving Blum, Leo Castelli, John Coplans, Jim Corcoran, Jim Demetrion, Andre Emmerich, Pat Faure, Ann Freedman, Peter Gould, Felix Landau, Eudorah Moore, Robert Rowan, David Stuart, Nickolas Wilder, and Riva Yares; to Jim Steele and Robert H. Timme at the University of Southern California School of Architecture, for their support and wisdom in directing me to The Images Publishing Group; to Frank Goss for his expert advice; to Steve Siskind, a free spirit who never stayed in the box and who pushed me to new heights; to the multitude of architects who have shared authorship on these projects over the years and influenced my thinking; and to the clients and collaborators who have enabled so many ideas to become reality. I thank all of you. Hooray for the young and the old alike!

Barry A. Berkus, AIA

The work of an architect forges connections from all corners of life. Associations that have inspired my work have come from many sources: from modern and historical painting and sculpture; from regional architecture across the United States; from the structures of antiquity; from continuing innovations in technology; and from the cultures and topographies of Europe, Asia, Central America, and other parts of the world. I am continually filling my knowledge banks with imagery of the past and present, and as I design, I see these images emerge as architectural thoughts.

The more I see, the more questions fuel my desire to learn, to observe, and to create. This process becomes what I call "walking with the eye."

Throughout my architectural career I have been intrigued by how we make associations and translate them into visual expressions. In children's simple drawings of houses and families, I see the components they view as essential to their pictures of their world. As we grow, so does our base of experience, and the associations we make between what we know and see become broader. In the methods I use as an architect to convert thoughts into buildings, I observe connections and parallels to techniques utilized by artists to translate ideas into images—common symbols and gestures. I continually find myself transposing imagery: in the mind's eye, buildings become paintings, sculpture becomes architecture, and reflections in glass and water become more than objects and surfaces.

Over the years, much has been written about the rules in architecture and art. I am constantly amazed at how the breaking of these rules has often resulted in surprising celebrations of unique space and form. From the orders of Palladio, the great Italian architect of the 16th century, to the maxims of the 20th century Modernists and the community coding of today's neotraditionalist planners, such order has become bible, establishing formulas for living. The resulting predictability in proportion between width, height, and the ordering of objects has served to formulate diagrams of the spaces we inhabit. These rules should be used as reference, not dictum.

I am neither a formalist nor a formulist. You will not find rules for a given architectural style in this book. Rather, I have tried to elucidate some of the connecting principles that I have gathered over time—approaches I have found successful, clues to look for in enduring designs, and questions that need to be addressed again and again. I believe in a theory that is embedded in practice, that learns from practice, that lives in practice. I believe in learning from experience.

This book is best approached, not as a comprehensive monograph, but as a collection of compelling art experiences, moments from key projects with which I have been involved, and the resulting parallels I have observed in other places. The connections examined in this book focus on my own creative process. I do not intend to account for the fields of architecture and art as a whole, but to reveal some of the connections and parallels that have captivated my imagination.

This book begins with a section that lays out its parameters with references to art and architecture. Ensuing chapters further develop connections and parallels between specific buildings, projects, paintings, sculptures, and photography. I have a passion for art, and believe I have learned at least as much about the organization of space by looking at paintings as I have from studying building principles.

My wife Gail and I have collected art for many years, and living with art is an important facet of our lives. Many of our most interesting discussions and most enjoyable experiences have been with artists in our home, in galleries, museums, and studios. We count among our valued associations several of the artists featured in this book. One of the things we have learned is that the reasons that you are drawn to a work of art over time are not always the same reasons you find a work compelling at first glance. Such an observation has strong implications for architecture.

For years, many of my colleagues and clients considered my enthusiasm for contemporary art as a personal idiosyncrasy, not something necessary to the understanding of successful architecture. I began giving lectures and holding discussions on seeing art and architecture as parallel ventures, raising questions for audiences and for myself. Addressing these questions has led to this book, which I hope will continue to extend these connections into a larger discourse.

In collecting these ideas and projects into book form, I had in mind a broad readership. It was my intention that anyone curious about the creative thought process that transforms ideas into tactile experiences will find value here. I particularly wish to address the misconception that innovation automatically cancels out the past.

Architecture, Art, Parallels, Connections examines some of the forces that have served me as stimuli, and also includes some case studies of resulting forms. I hope that by putting these experiences into print, the points in my journey will become examples for others—whether reason or wayward impulses are found there.

Barry A. Berkus, AIA
Santa Barbara, California

1

1 Herbert Bayer, *In Search of Times Past*, (n.d.)
2 Ed Ruscha, *See*, 1992

2

I believe that the study of good architecture and art encourages expansion of thought and enriches physical experience.

As an architect, I value the opportunity to advance the language of built form, to explore new possibilities, to convey the message that behind every wall is another experience that may enrich life's journey.

Many times the compositional elements that can make a place feel comfortable or exciting find their parallels in works of art. It is probably not possible to design a building in the same way that one would compose a painting. However, there are similarities to be found in the ways that we apprehend and understand these very different kinds of visual experiences.

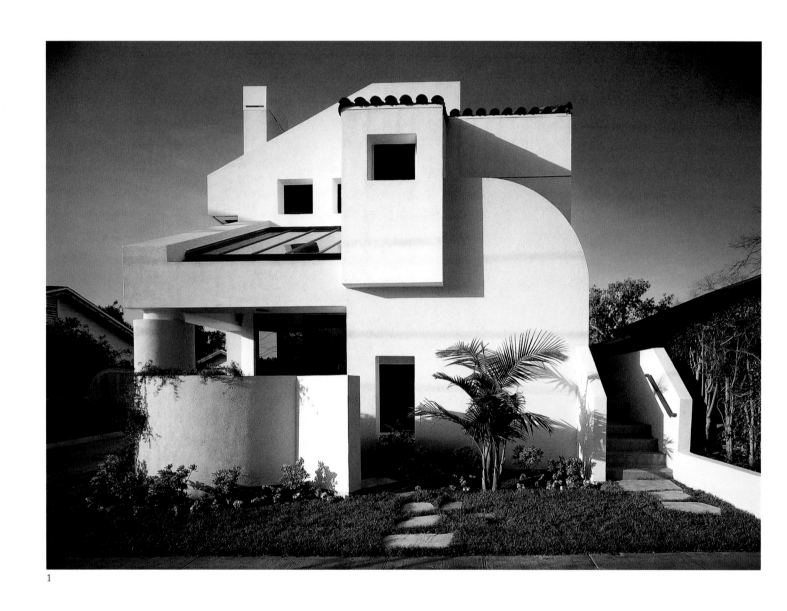

1

1 Secord Medical Building, Santa Barbara,
 California, 1988
2 Pablo Picasso, *Reading*, 1932

Anchored in a specific time and place, buildings embody people's priorities, histories, personalities, and outlooks. In this sense, architecture becomes a portrait of society.

Through hand-drawn sketches, computer diagrams, and models, I become intimately familiar with the many perspectives a building offers. Thus, a large component of the craft of architecture becomes the translation from two to three dimensions and back again.

The Cubist approach to this transformation changed the art world's perception of space. Rather than treating the picture plane as a window—in effect, representing a scene from a single point of view—the Cubists fused several visual perspectives into one.

I see an important visual parallel in the Secord Medical Building (left) and Picasso's portrait (right): each composition reflects a desire to unfold the drama of the picture plane. Through a process of abstraction, many angles are captured and recreated. The relationship between two-dimensional and three-dimensional space changes, and while the subject may remain recognizable, it has been transformed into something new.

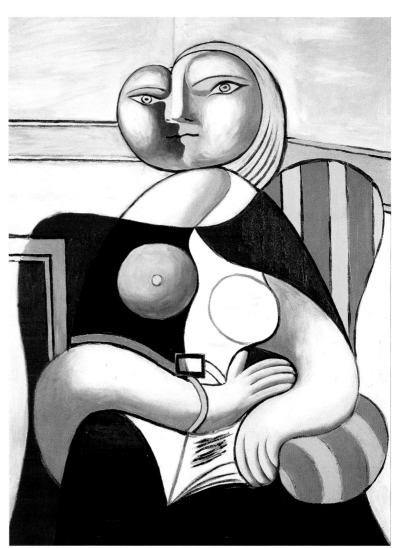

2

5

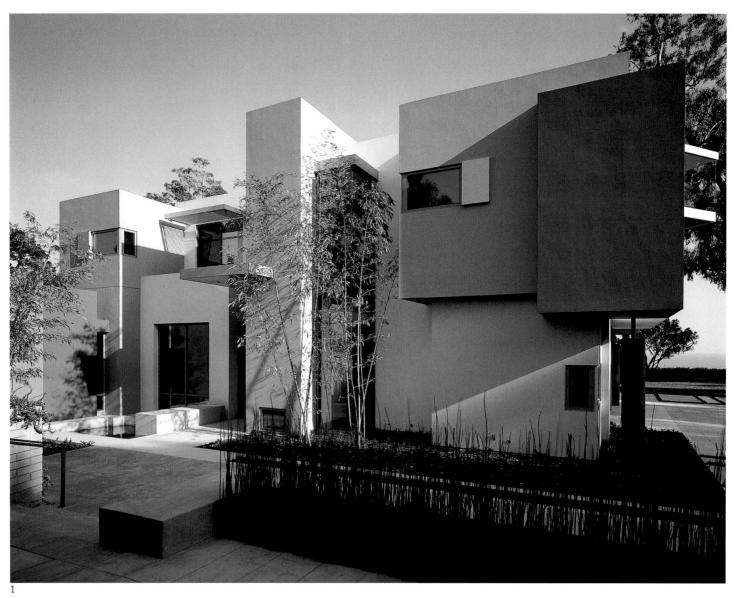

1

Both painting and architecture are concerned with the imaginative ordering of space.

The design for the Terner Residence (above) began with a Modernist grid. The collection of rectangles seen from the outside corresponds to the divisions of space inside.

1 Terner Residence, Pacific Palisades,
 California, 1995
2 Sean Scully, *Dark Face*, 1986

2

As I view the composition of Sean Scully's painting *Dark Face* (above), vertical and horizontal planes step forward and recede, abstracting convention in a manner that recalls the stepped geometries of the Terner Residence.

Furthering their connection, the vertical stripes in this painting recall the Terner Residence's structural corner. In an ensuing discussion with the artist regarding the pairing of these images, Scully commented that in *Dark Face* the vertical elements or stripes in the lower part of the painting describe upward motion, while also working as a compositional metaphor for columns.

1

The window illuminates passages, provides vistas, gives a sense of the world beyond walls and a sense of life within walls. In Nick Wilder's painting (above), I see a window, light, and horizon, and I want to venture beyond the canvas.

1 Nick Wilder, *Early Morning Avignon*, 1986
2 Richard Ross, *Ancient Agora, Athens, Greece*, 1984

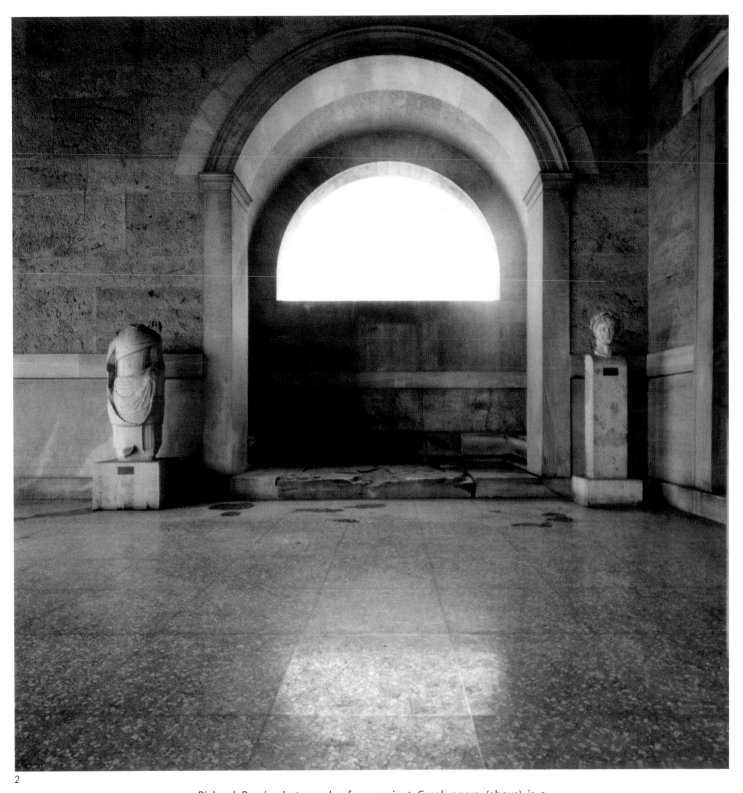

2

Richard Ross's photograph of an ancient Greek agora (above) is a striking parallel to the Wilder painting, as the opening becomes both an eye to the outside world and a point of illumination for the interior composition. Regarding the nature of windows and buildings, Sean Scully recently said to me, "Buildings have eyes." I often see buildings this way. The mask-like qualities of buildings encourage visual interaction.

When a building is designed in collaboration with a client, the finished form will often reveal a great deal about the people involved.

The Wade Residence (opposite), designed for a corporate futurist and his wife, features a "tower of knowledge" composed of smaller, fundamental forms in dynamic balance (see also pages 126–27). The precarious nature of the cylinder perched upon the rotated glass box is grounded by the strength of the supporting column and platform. In addition to paying tribute to the work conducted within, this assemblage of forms alludes to the structure of the human body.

The process of bringing imagination to life in the built environment—lifting design from two dimensions to three—is among architecture's great rewards. As time passes, resketching completed projects offers the chance to revisit ideas, and to rebuild the structure as pure design without pragmatic structural demands.

2

1 Wade Residence, Villa Hills, Kentucky, 1992
2 Drawing by the author (1998) referencing the
 Wade Residence's "tower of knowledge"

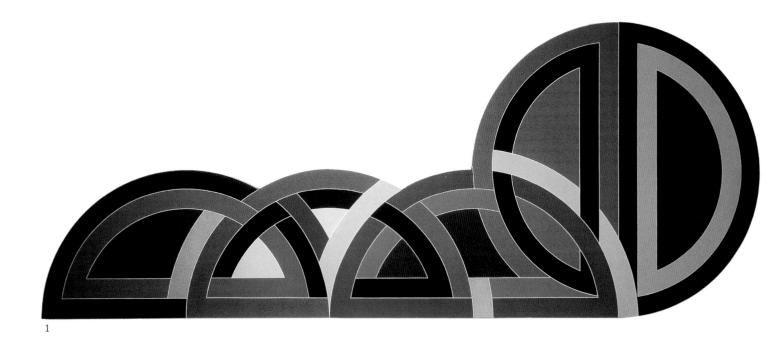

1

In Frank Stella's *Protractor* paintings, the simple curve of the arc is abstracted and repeated as a pattern (above). The rhythm of paths articulates the surface of the painting, dividing the shaped canvas and drawing it back together again. Stella's paintings often approach epic scale, and they behave architecturally in the spaces where they appear. They take dramatic command of a room, bringing the wall and the floor together with their shape and their sweeping, geometric lines. Similarly, the layered arcs in Timothy Hawkinson's *Lingum* (below right) build height as well as structuring the composition.

Repeated forms can be used to create variety and patterning—whether in color and line, as in a painting, or in three-dimensional space and form.

1 Frank Stella, *Raqqa 1*, 1967
2 Tim Hawkinson, *Lingum*, 1999
3 Via Abrigada, Santa Barbara, California, 1983

2

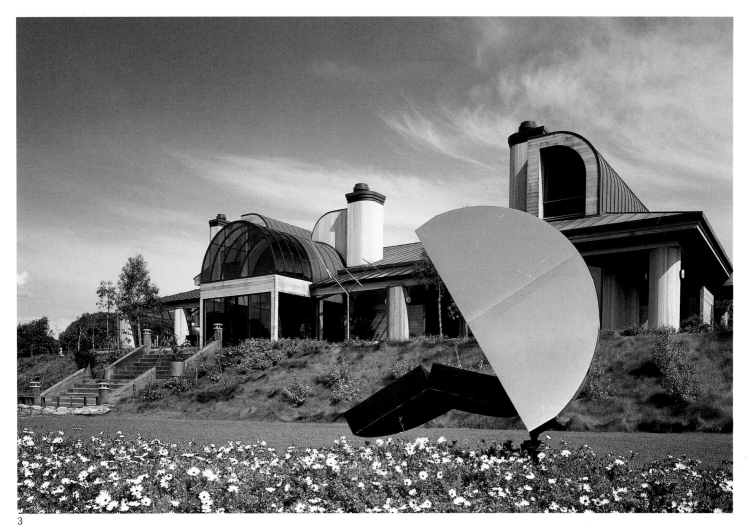

3

In my buildings, I often repeat forms to create a logical path through a complex plan. At Via Abrigada (above) I used the geometry of the arc in plan, in plane, and in form—as arches, balconies, walls, and columns. Patterned forms in architecture can have a unifying effect when they are incorporated as a part of the structure. By returning to the same forms along the unfolding journey through a building, a contemporary architect can create a story that proceeds with a sense of coherence. Continuity lends familiarity to a new environment, making a place easier to navigate.

This structure, like other buildings I have designed, represents a convergence of many influences, none of which is privileged to the exclusion of all others. I think the things we spend time looking at contribute to subconscious reservoirs, which can be drawn upon later. Influences are not always processed straightforwardly: sometimes it is not until I look back at completed work that I recognize a source of inspiration.

1

To walk with the eye is to be open to all kinds of visual experiences. Different means of layering, patterning, and organizing space reveal themselves when we look at things receptively.

1　Al Held, *Brughes II*, 1981
2　Sydney Opera House (designed by John Utzon, 1957–73), photographed by the author

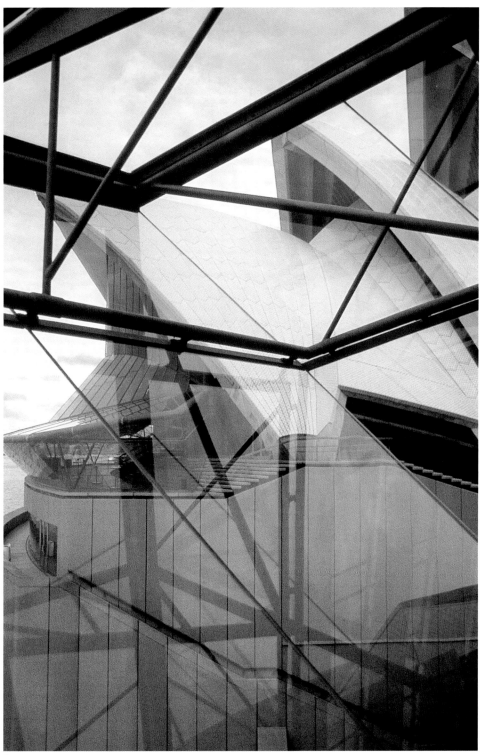

2

Photographing the Sydney Opera House through panes of glass (above), I was intrigued by patterns of reflection that complemented the building's dramatic, echoing forms. In its translation to two dimensions through the photograph, the view became a composition of layered geometries and reminded me of a painting by Al Held (left). Held's paintings construct a depth of experience through geometric paths. In architecture, layering presents an invitation to visually move through a space.

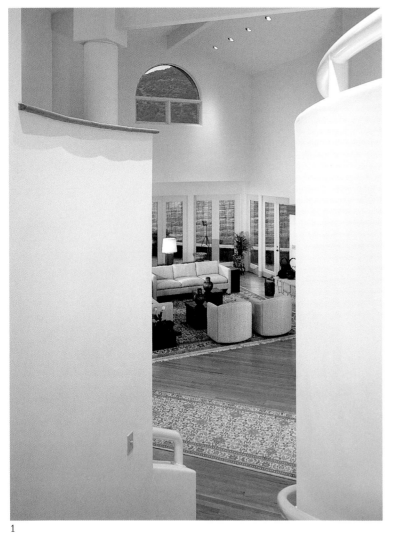

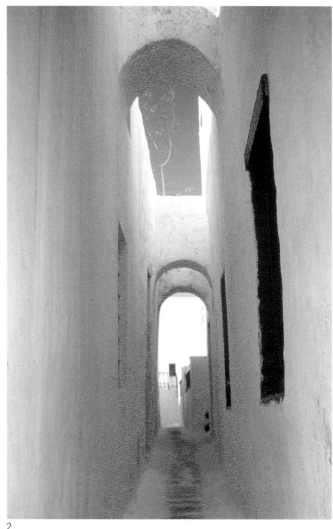

1

2

The layering of space is the layering of experience, encouraging movement, welcoming exploration, revealing surprises along the way.

It is possible to design spaces so that everything can be grasped at once, but I am much more interested in gradual revelation—leading people through a building by layering spaces. Well-orchestrated spaces reveal themselves with a certain pacing, unfolding as you pass through the composition. This process is vital to how we experience architecture. A well-composed plan creates an invitation to discover, stirring interest in what lies around the corner or down the corridor.

3

4

In my journeys through architecture and art, I am often surprised by unexpected parallels, and wonder at the undercurrents that bring objects together. Walking with the eye leads to the discovery of such parallels and relationships.

When I see familiar forms in unfamiliar places (such as the arches and passageways on these pages), I recognize that something I had thought was new and original is part of a chain. What brings the links together is often something other than a simple or causal relationship. The more I look, the more I open myself to the variety of visual experiences around me, and the more I become aware of compelling patterns and connections.

1 Curved passageway detail, McComber
 Residence, Napa, California, 1989
2 Passageway in Mykonos, Greece
3 Rene Magritte, *The Human Condition II*, 1935
4 Entry, Westen Residence, Santa Barbara,
 California, 1989
5 Illustration of Eglise du Saint Esprit, New York
 City, by architect Alexander Jackson Davis, 1834

5

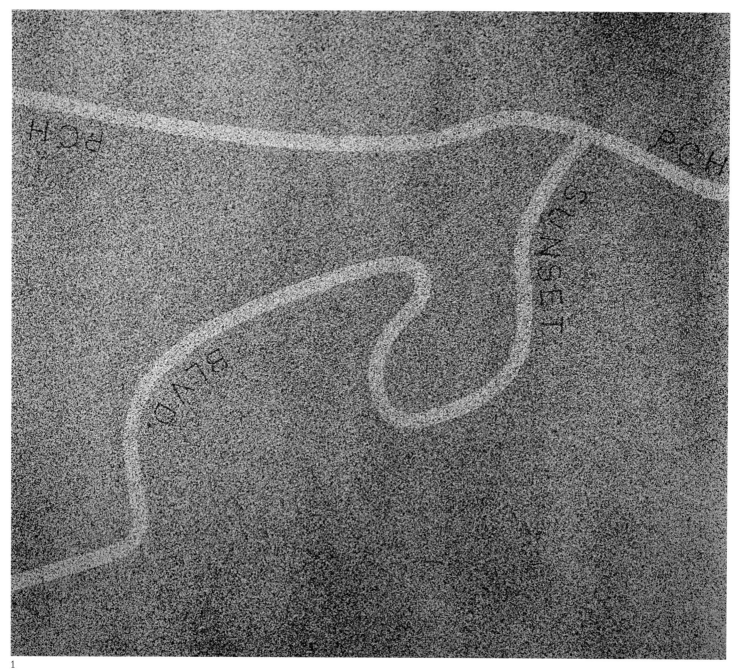

1

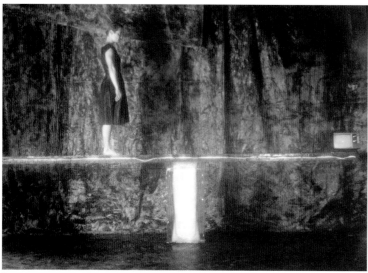

2

In two-dimensional images, compositional boundaries define space, suggesting visual and physical directions of movement. Some paintings, like some three-dimensional spaces, offer clear compositional destinations and paths for the eye to follow. In Ed Ruscha's *Pacific Coast Highway* (above), meandering paths propose choices, connections, topography, and exploration. In contrast, the path of light in Ann Hamilton's piece (left) implies a precarious balance, while a strong visual directive structures *Upside Down* by Frederick Hammersley (opposite), its borders and edges creating energetic zones of color.

3

Borders become paths, in two or three dimensions, giving new ways to travel with the foot and with the eye.

The distinctive patterns of paving stones in this Japanese walkway (right) allow the visually impaired as well as the casual traveler to follow the path with ease, guided by changes in texture. The path imparts structure and directs movement, both in the real space of the street and the pictorial space of the photograph.

1 Ed Ruscha, *Pacific Coast Highway*, 1998
2 Ann Hamilton, *the choice a salamander gave to Hobson*, 1987
3 Frederick Hammersley, *Upside Down #5*, 1970
4 Japanese pathway, photograph by the author

4

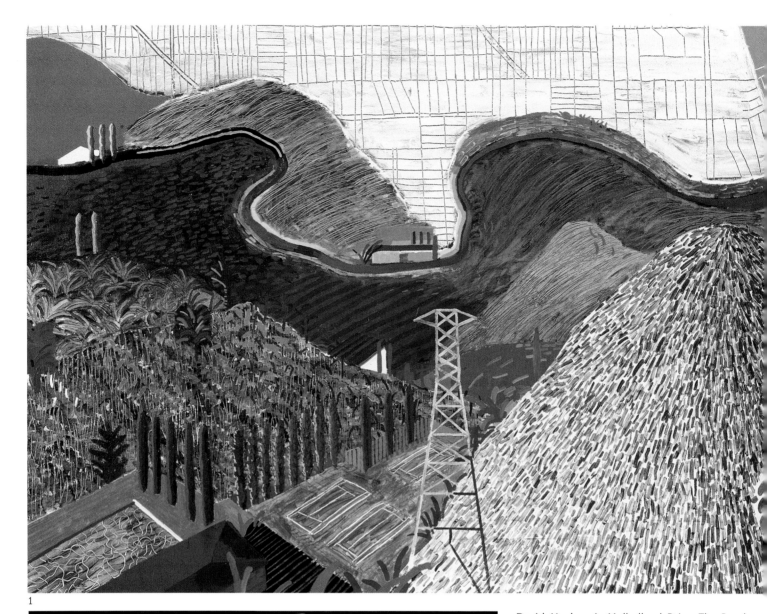

1

David Hockney's *Mulholland Drive: The Road to the Studio* (above) articulates traveling through the landscape by contrasting the grid of the San Fernando Valley with a textural, colorful, and organic expression of hills traversed by a meandering road.

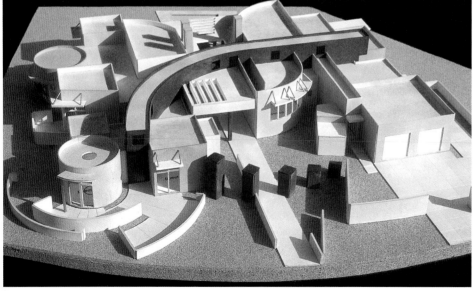

2

1 David Hockney, *Mulholland Drive: The Road to the Studio*, 1980
2 Model of Private Residence, Bighorn, California, 1999 (in progress)
3 Working computer model of Bighorn Private Residence

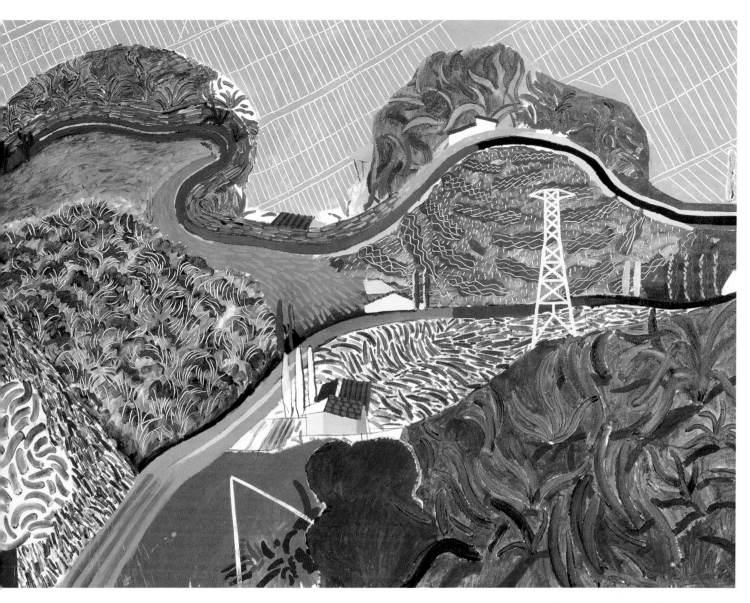

In a similar manner, a central curved form defines a circulation pattern in a proposed private residence (right), and links the contrasting geometries of the composition.

3

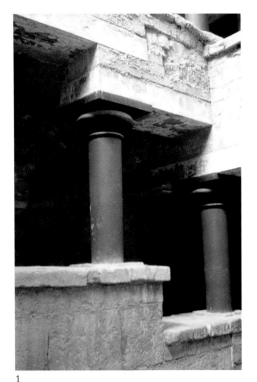

1

4

Artists and architects alike participate in the evolution of culture by abstracting from what has come before.

The process of abstraction involves manipulating familiar elements, which may be fundamental forms, such as circles or cubes, and carrying them forward from new departures. To take the known as a foundation and to work with it so that it becomes something new is to take a step in advancing visual vocabulary.

Every era produces an aesthetic that speaks to its particular time and place. To reproduce something from the past, in its entirety, results in empty replication of a bygone style, rather than vital participation in today's cultural dialogue.

Abstraction from convention can create a path to the future. Truly original work involves a rethinking of familiar traditions in a way that is meaningful to people in the present. The most powerful works not only survive as legacies of a period or style, but become icons that link one period to another, giving a sense of artistic endurance and continuity.

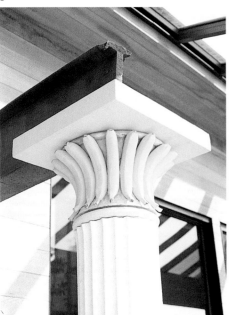

2

3

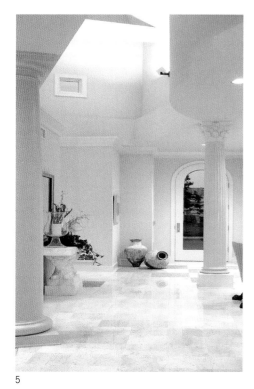

5

The form of a column has traditionally related to procession, division, and strength. A colonnade invites the eye to meander, enjoying the contained path as well as an outside vista. It adds to the layering of space while creating a celebration of movement.

In the Palace of Minos at Knossos, atrium courts were placed to bring light to the interior core, with colonnades distinguishing the edge (top left). Calder's untitled gouache presents column as icon (above left), and Hans Hollein's stylized portal makes a lighthearted turn upon the legacy of this form (bottom left). The column is a brave form: its slender proportions defy the mass it supports. Ed Ruscha's *Brave Man's Porch* (opposite right) plays on the associations of the strength of the column.

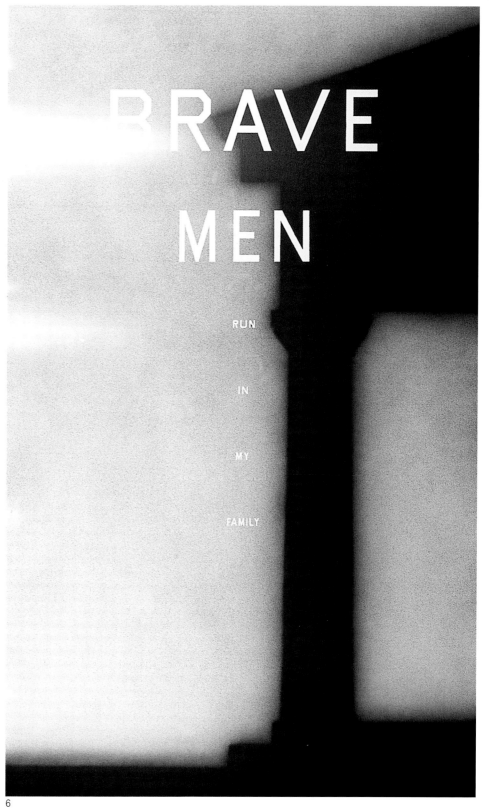

BRAVE MEN

RUN

IN

MY

FAMILY

6

1 Atrium column detail from Palace of Minos, Knossos, Greece, c. 1700–1400 BC
2 Ken Yokota, *Call 'em Bananas* (sculptural column), 1984
3 Facade of Retti Candle Shop, Vienna, designed by Hans Hollein, 1965
4 Alexander Calder, untitled gouache, 1973–74
5 Interior column details of New American Home, 1987
6 Ed Ruscha, *Brave Man's Porch*, 1996

2

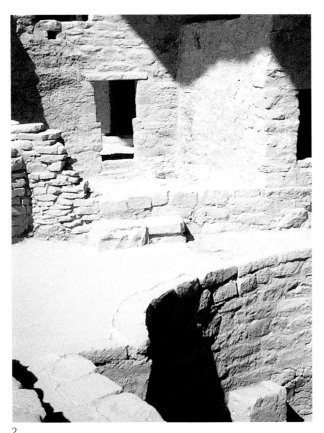

3

4

Art and architecture perpetually draw viewers back to fundamental forms, the building blocks of visual vocabulary. The significance of these basic forms is never exhausted—they are loaded with possibilities in new configurations to explore.

1 Drawing by the author
2 Cliff dwelling ruins at Mesa Verde, Colorado
3 Las Campanas Golf Clubhouse, Santa Fe, New Mexico, 1998
4 Entry, Reide Residence, Palm Desert, California, 1993
5 Reflection pool and lounge, Felker Residence, Paradise Valley, Arizona, 1994
6 Carol Robertson, untitled, 1997
7 Aristides Demetrios, *Steel Drawing IV*, 1996

1

24

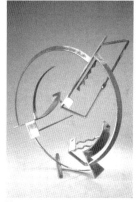

6 7

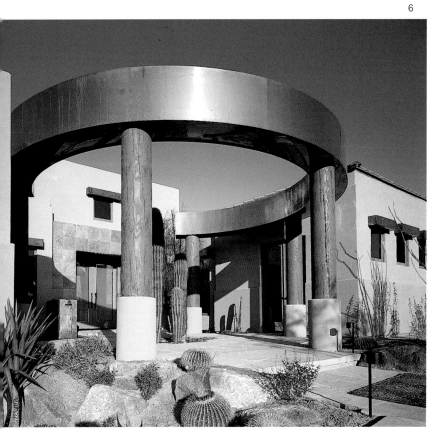

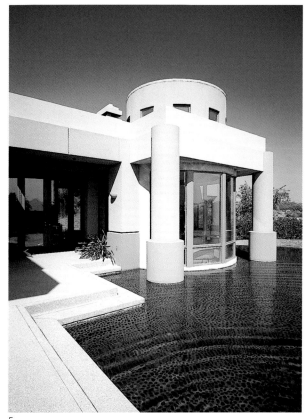

5

Discerning use of fundamental geometric forms is evident in the architecture of prehistoric cliff dwellings, such as the ruins at Mesa Verde (see opposite left). Simple rectangles and round kivas (subterranean pueblo social and ceremonial chambers) were harmoniously integrated in complex, densely built arrangements.

In designing buildings, I often return to the circle for the sense of stability, security, and closure it provides. Likewise, the unifying component in the sculpture by Aristides Demetrios (top right) is a circular form that both encourages a spiraling sense of movement and holds the dynamic forces in a pattern. The circle within a square in the monotype by Carol Robertson (top left) recalls the interesting relationships that occur between circles and squares when they are inscribed or circumscribed in built structures.

1

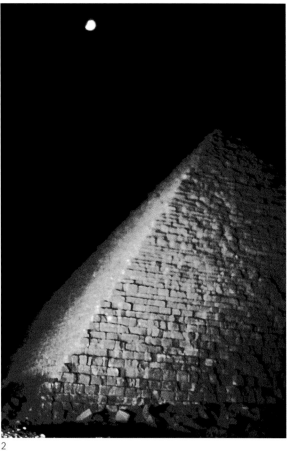

2

A pyramid stands with majesty, compelling the eye to rise. It is an icon of mystery, a monument to labor, a testament to human aspirations toward immortality.

1 Herbert Bayer, *Seasonal Reflections*, 1980
2, 3, 5 Pyramids at Giza (2,5) and Saqqara (3),
 photographs by Hugh Huddleson
4 Entrance tower, Hult Residence, Santa Barbara,
 California, 1985
6 Roof detail, Felker Residence, Paradise Valley,
 Arizona, 1994

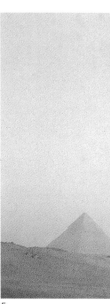

5

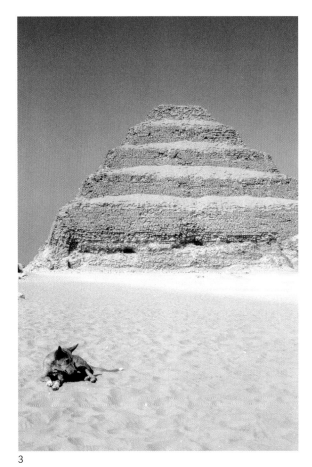

3 4

The triangle transforms into gable, becoming the symbol of shelter in the vocabulary of home.

Walking with the eye leads us to discover connections in time and thought.

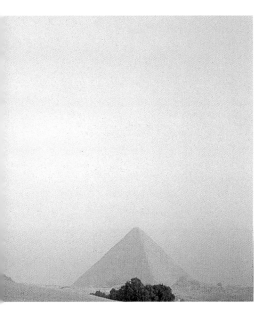

6

1

2 3

The generation of structure is both an expression of creativity and an exercise of a deeply-rooted need. The need to inscribe boundaries is a fundamental principle in our relationships with our environments and with one another. The most meaningful boundaries are those that adapt to specific terrain and conditions, rather than simply applying universal geometric equations.

In 1994, I went on a mountain climbing expedition in Antarctica, where I was inspired by the vastness of the landscape. From one horizon to the other stretched a terrain of brilliant white planes of ice and snow, sculpted only by natural forces, under 24-hour sunlight. It was exhilarating and overwhelming. The endless expanse stimulated a wonderful sense of freedom, and at the same time, it challenged me to establish my own space. At times, I felt as if I had stepped into a blank canvas.

The architect in me immediately sought to define edges and boundaries and to determine points of reference. In this unbounded space our climbing group constructed snow walls to protect our encampment from the wind, maintaining the degree of individual space that came naturally. The edges around our encampment became points of departure into the vast landscape. Temporary and mobile as these encampments were, they provided definition and structure in a brutal, untamed environment.

This impulse to draw parameters in our environment is a basic human drive. We need to bring things to a manageable scale, to make them graspable, to make them our own.

1 Photograph by Richard Ross, *Landing Strips for the Space Shuttle, Edwards Air Force Base*, 1995
2 William Dole, *Hypotheses*, 1971
3 Antarctic landscape, photograph by the author

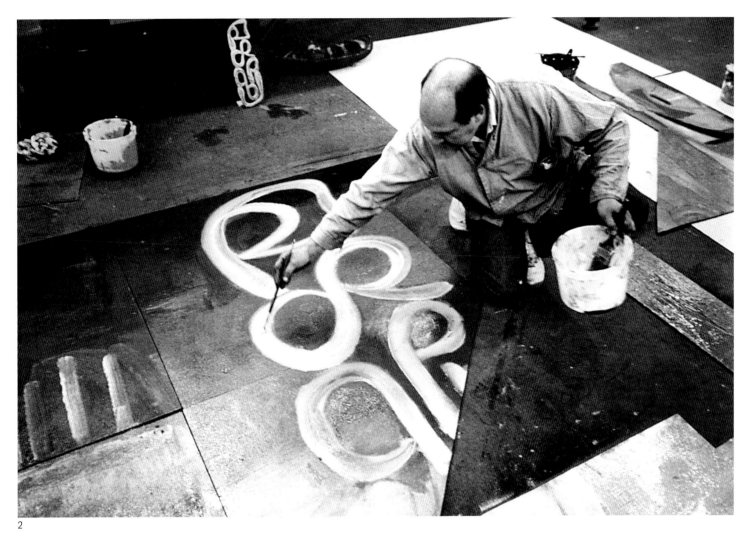

2

The practice of staking boundaries has become a ritual of decoration on the Greek island of Mykonos.

During visits to this island, I have found that certain residents designate their personal space by painting designs on the paving stones that border their homes (opposite). Various households have their own patterns of colors and shapes for this practice. They take pride in maintaining these thresholds between private and public space.

This activity seems to be the assertion of a territorial imperative. People need to be able to mark the space where they live as their own. When we stake a claim on a place we express our individuality. More than a mark of ownership, it is an extension of personal identity.

Photographed by Richard Tullis II in the Tullis Workshop, artist John Walker inscribes a gestural mark inspired by aboriginal art and rituals (above). The process of painting often suggests a connection to gestures that inscribe boundaries, defining place.

1 Mykonos resident painting paving stones,
 photograph by the author
2 Photograph by Richard Tullis II, *John Walker,*
 1988

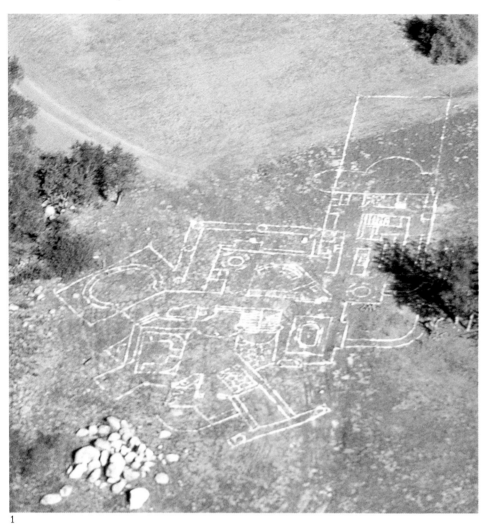

1

The act of drawing boundaries also stakes a claim to space, creating a place that we can call our own. When the Westen family participated in the design of their home, they drew the completed plan full-scale on their site (top left). This helped them to imagine the relationship the structure would develop with the land upon completion.

Mapping structures on a landscape is a way of drawing. In Diebenkorn's *Ocean Park* series, the artist has abstracted an urban setting into a composition of boundaries and adjacencies (opposite). The relationships created by establishing borders are critical to the creation of art and architecture.

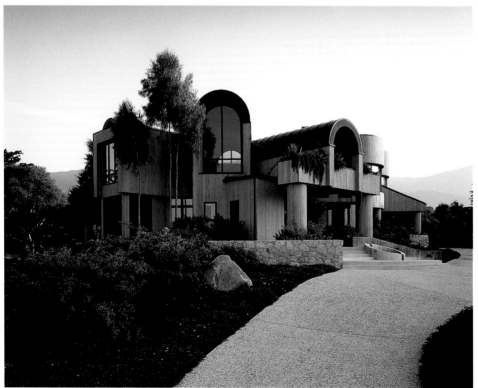

2

1 Westen Residence, Santa Barbara, California, 1989,
 plan drawn by clients on site
2 View to entry, Westen Residence
3 Richard Diebenkorn, *Ocean Park No. 48*, 1971

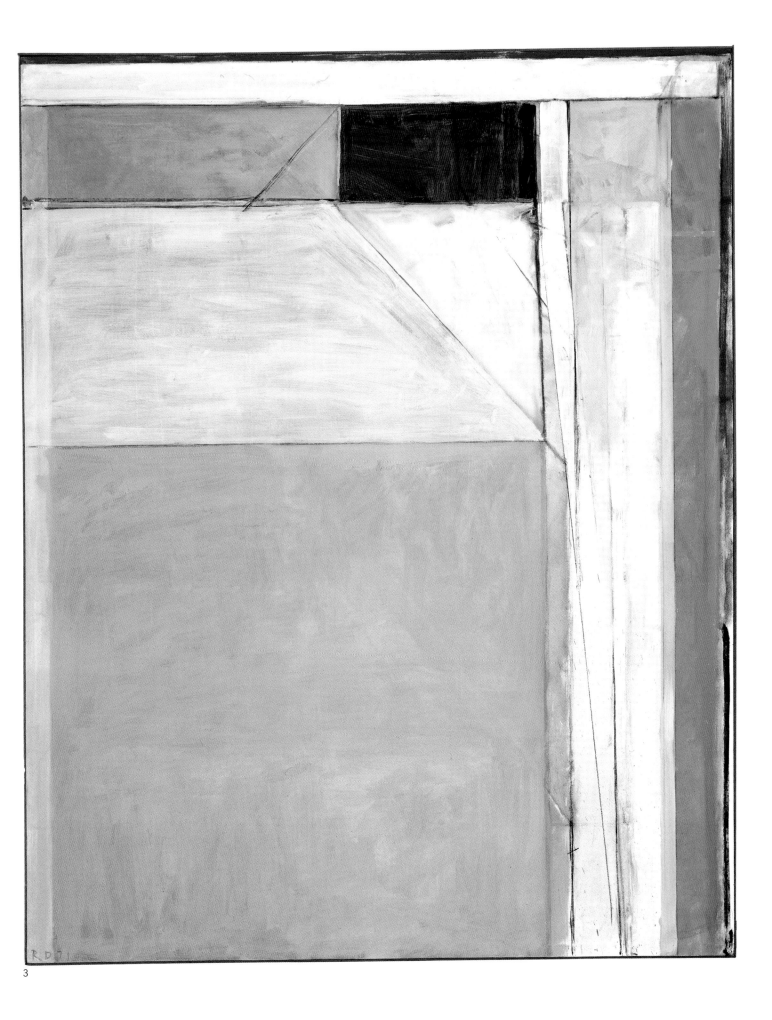

3

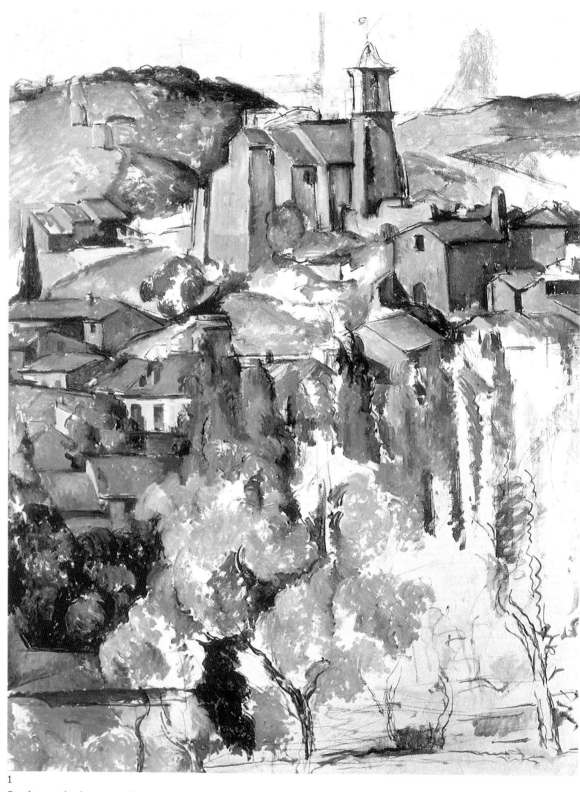

1

Borders and edges contribute to the character of a living environ-
ment. Places that people enjoy and identify with are most often
places with distinct, recognizable character. The sense of a place
draws heavily upon its geographical beginnings and endings, and
the points of reference within it.

1 Paul Cezanne, *View of Gardanne*, 1885-88
2 View of landscape bordered by mountains and
 ocean, Santa Barbara, California
3,4 Santa Barbara hedgerows

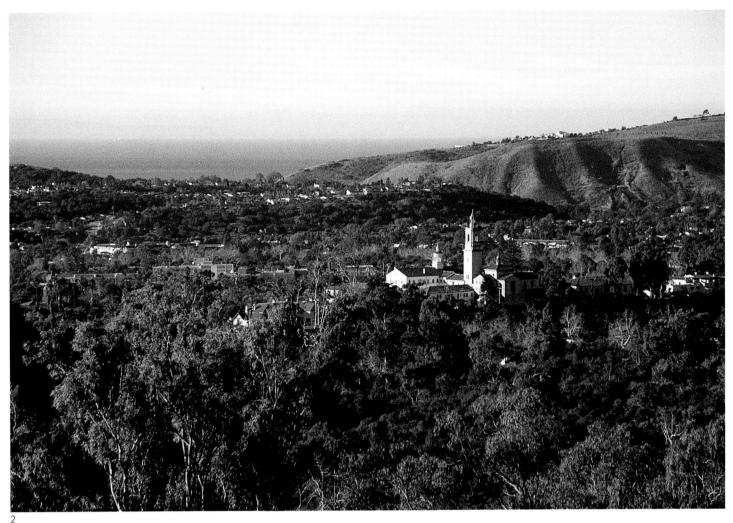

2

The borders that define a place can be as vast as the fields surrounding a village or as small as the greenery surrounding a courtyard. The living borders created by hedgerows foster a sense of harmony with the natural landscape, maintaining privacy and presenting attractive edges to the street (see bottom right).

A well-crafted and well-tended place shows that people care for it. The element of care, I believe, is a crucial factor in sustainability; the degree to which people cultivate and maintain a place contributes to its capacity to endure.

3

4

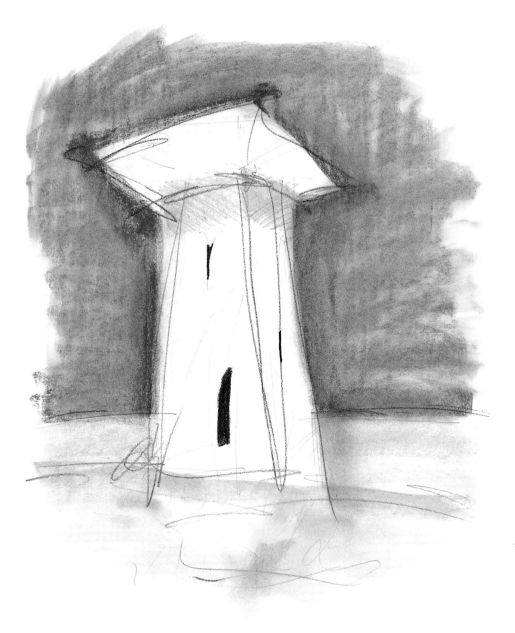

Points of reference are vital elements that provide orientation, both in the composition of artworks and in the built environment. When traveling in an unfamiliar place, I often find that it is easier to organize my journey once I have discovered an architectural reference point. A tower punctuates the concerto of the landscape, announcing a focal point and a center of activity. From the outside it is a beacon, an organizing element, a guiding sign that can be seen from long distances. From the inside it affords the ability to observe, to defend, and to broadcast.

1

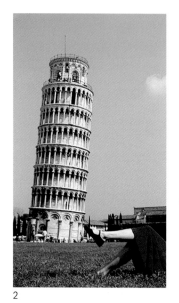

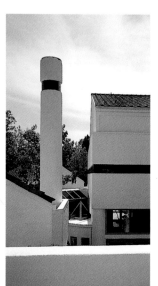

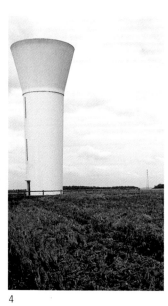

2

3

4

5

In Venice, St. Mark's Plaza (right) struck me as the landmark around which the rest of the city seemed to fall into place. The campanile (bell tower) could be seen from great distances, and as I wandered the pathways of the city, a glimpse of that tower always restored my sense of direction and gave me a point of return. Many different kinds of towers, such as those shown on these pages, emanate a sense of strength in the built environment.

1 Drawing by the author, 1998
2 Tower of Pisa, photograph by Steven Berkus
3 Detail, Norris Residence, Encino, California, 1988
4 Structure in rural France photographed by the author
5 Untitled watercolor by the author, 1999
6 Detail from Midway Barns, Taliesin, Wisconsin, designed by Frank Lloyd Wright in 1938
7 St. Mark's Plaza, Venice

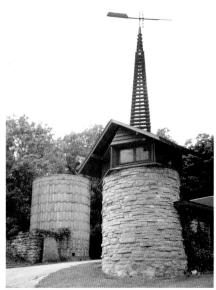

6

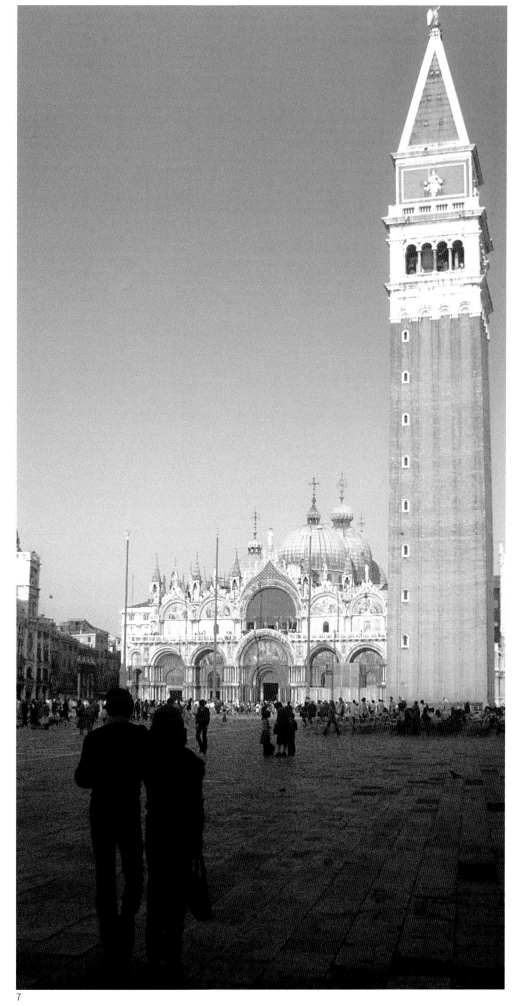

7

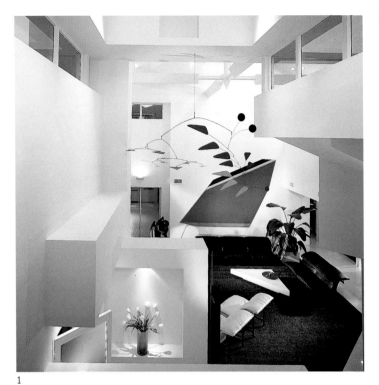

1

The work of Alexander Calder sparked my passion for contemporary art. When I was in a basic architectural design class, my wife and I saw an early film of Calder at work, outdoors, on a beach. I was immediately drawn in by the energy of his work. I was and remain fascinated by Calder's ability to define space through color, structure, and line, and the way his sense of humor imparted a human quality to simple sculptural forms. I recognized that Calder had accomplished as a sculptor what I hoped to do as an architect: to define and sculpt space with a fresh viewpoint and a very human attitude. Since that time, I have felt deeply connected to visual artists.

My wife and I began collecting art shortly after seeing that film and our first vital purchase was a Calder mobile. Over time, as we moved from one house to another, that sculpture was always at home. It was a keystone in our desire to understand more about art. Much later, when we acquired an outdoor piece (center left), it was something of an end to a long journey. It was an important sculpture to us, not as an investment or in terms of its value to anyone else, but just because of the feelings we had for the piece. As we walked around it to enjoy the landscape and the architecture of the site it would move with us. It was always friendly and brought a smile.

The modules of Calder's mobiles are always in transition, and remain in harmony with one another. Their form is designed to move, to revolve in balance, so that every time you look at it you see something different. These sculptures energize space giving it definition and direction: they put the landscape in motion.

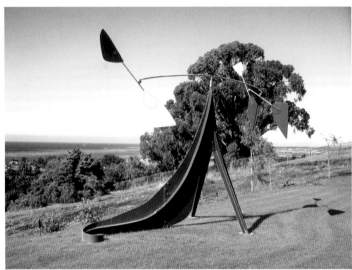

2

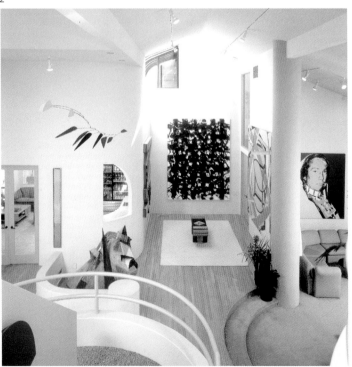

3

1 Interior space showcases art collection at Siegel Residence, Boca Raton, Florida, 1989
2 Alexander Calder, *Fafnir-Dragon II*, 1969
3 Living area designed to highlight artworks, Via Abrigada, Santa Barbara, California, 1983
4 Art Box (private gallery), Santa Barbara, California, 1985 (shown in detail in Architectural Follies)

4

In modern architecture it has been said that form should always follow function ... but sometimes it is more interesting when form follows fantasy.

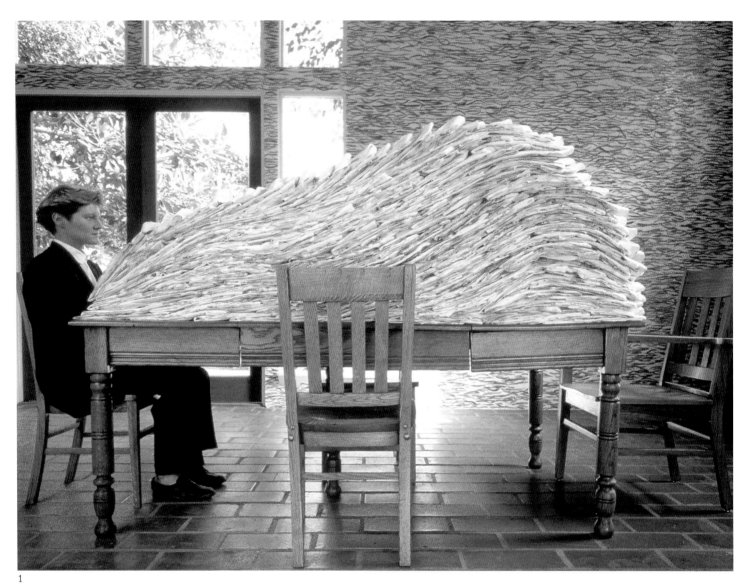

1

Some artists create work that transforms space in a magical sense. I know of no formula for this magic, but it seems evident when in the presence of such a work, be it art or architecture.

Ann Hamilton's materials are usually familiar objects (see above). Her work builds on our associations with these things, their material qualities, and how they are used. The way she alters, accumulates, and recombines these objects transforms them: they transcend what they were before.

1 Ann Hamilton, *still life*, 1988
2 Work in progress by Andy Goldsworthy, 1992

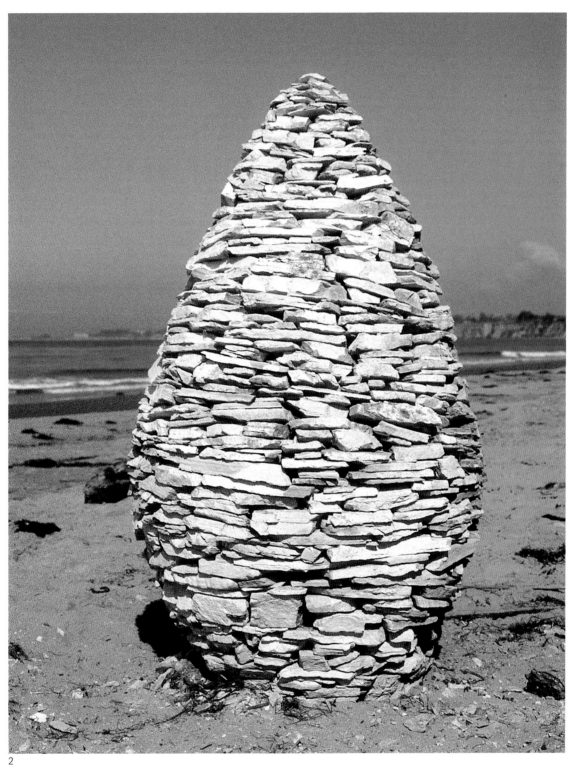

2

Andy Goldsworthy works with the elements of the landscape, creating new arrangements with the materials already present on the site (see above). He modifies these things with great artistic effort and they last only as long as the elements allow. They become part of the history of the landscape. I had the privilege of accompanying Andy Goldsworthy as he transformed a beach site into art near our home in Santa Barbara, California. I felt a witness to an important event, special in its execution, materials, and ephemeral nature.

Part of the magic of Andy Goldsworthy and Ann Hamilton's artwork is their temporality: we see their works with the knowledge that they will soon be gone. As an architect, I am both intrigued and confronted by the thought of constructing something that could vanish without a trace.

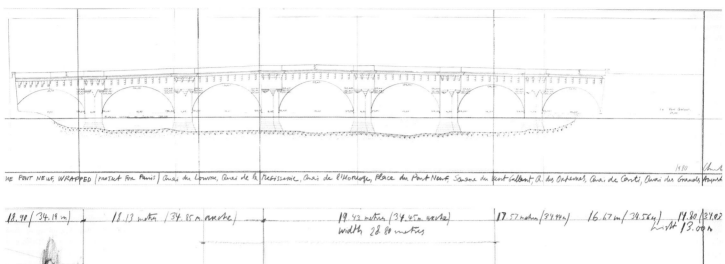

THE PONT NEUF, WRAPPED (PROJECT FOR PARIS) Quai du Louvre, Quai de la Mégisserie, Quai de l'Horloge, Place du Pont Neuf, Square du Vert Gallant, R. des Orfevres, Quai de Conti, Quai des Grands Augustin

18.90 / 34.18 m 18.13 metres / 34.85 m. arche 19.42 metres / 34.45m. arche 17.57 metres / 34.94m 16.67 m / 34.56m 14.80 / 34.03
width 28.80 metres Light 13.00 m

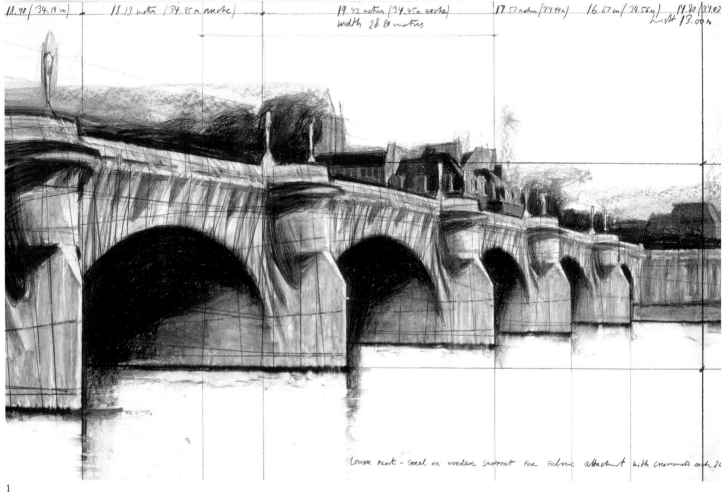

Louvre bank - steel on wooden support for fabric attachment with grommets each 20

1

The work of Andy Goldsworthy and Ann Hamilton exerts a great influence on me, and challenges me with its ephemerality. Christo and Jeanne-Claude also produce artwork that changes people's perceptions about time and structure. Their wrapped building projects and interventions into the landscape are vast in scale, and short in duration. One of the resonant effects of these projects is their ability to provoke thoughts about things that last, and things that do not—on a very large scale.

We expect art to break rules, to draw its own guidelines, to change perspectives, and to change lives. Art has the power to alter as much or as little as our thinking will allow. Architecture faces a different set of parameters. The creation of a structure that will serve people's needs over time is a responsibility that an architect must consider every day.

1 Christo, *The Pont Neuf, Wrapped (Project for Paris)*, preparatory drawings 1980
2–5 Details from Ann Hamilton's installation, *volumen*, 1995

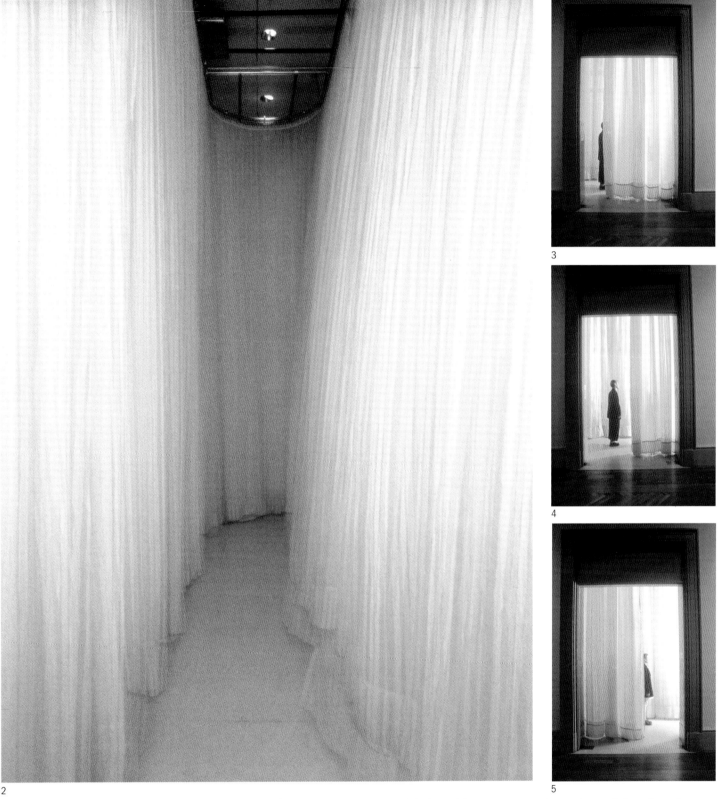

2

3

4

5

The gossamer curtain in Ann Hamilton's *volumen* installation, moving along a track, creates a mysterious path to an unknown destination (above). The undulating cloth, revealing and concealing, makes the journey as important as the arrival.

In a world where things are constantly moving and changing, when our paradigms are enduring a rapid and profound shift, perhaps it is time to consider how ephemerality could function in architecture. What kind of changes could we imagine if we were to seriously reconsider the relationship of architecture to passing time?

We can only create a sustainable future through careful attention to enduring traditions. We must learn from the past and carry forward what we have learned into new departures. The successful communities of other times and places hold the keys to the solution of today's dilemmas and present hope for new directions of growth.

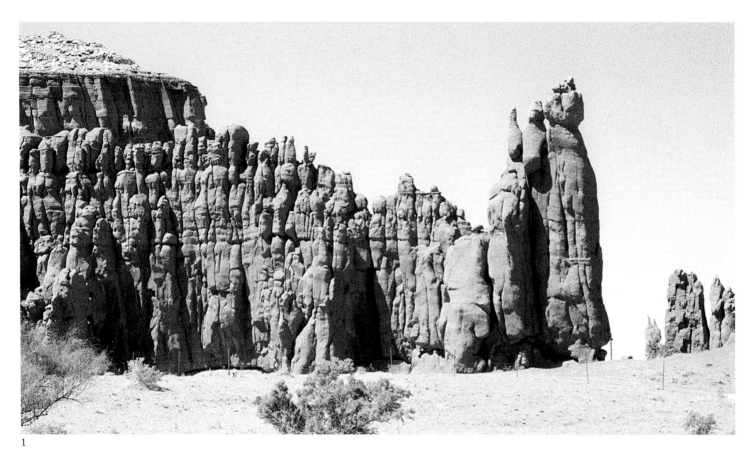

1

The desert mesas exhibit nature's hand in sculpting unique forms. Time is manifest in the landscape, where eons of elements have carved solid rock into monoliths and pinnacles (above). There are moments when I see the clay soldiers of ancient China there; at other times, such pinnacles resemble cathedral spires. These monumental forms on the desert horizon have provided inspiration for longer than we can imagine.

Artist Charles Simonds speaks of the forces of erosion as well as organic composition in his sculptures, which often integrate the architecture of fictitious societies into the existing architectural fabric. Made of clay, his swaying towers are of the earth (see opposite). These structures appear precarious, as if tempting nature, while also recalling similarities between stages of construction and destruction.

1 Desert mesa, photograph by the author
2 Charles Simonds, *Towers*, 1985

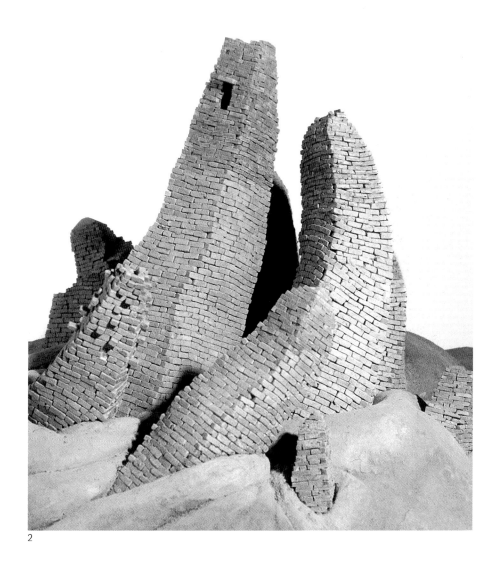

2

To build in harmony with the desert is a rewarding challenge. Far from being a blank canvas, the desert is a complex environment filled with inspiration.

Centuries-old traditions of Native American desert architecture leave us cues for building adaptively, with densely massed structures and simple rectangular perforations in thick walls of adobe or stone (below and opposite right).

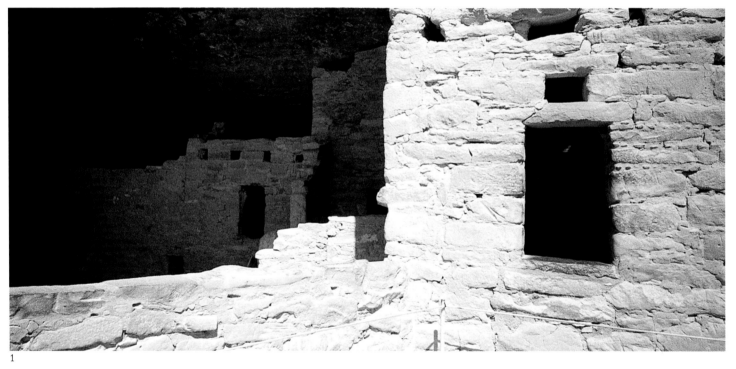

1

The land and climate of the US Southwest suggest forms that pay tribute to the strong elemental character of desert geology, with a palette drawn from the colors of arid hillsides.

1 Mesa Verde National Park, Colorado
2 The Fifth Green at the Boulders, Scottsdale, Arizona, 1987
3 Maas Residence, Palm Desert, California, 1994
4 Marion K. Wachtel, *Pueblo of Walpi*, 1929

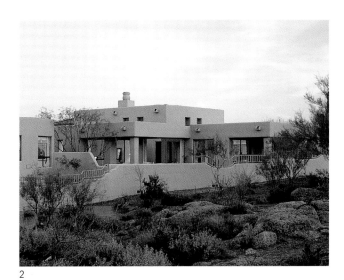

2

3

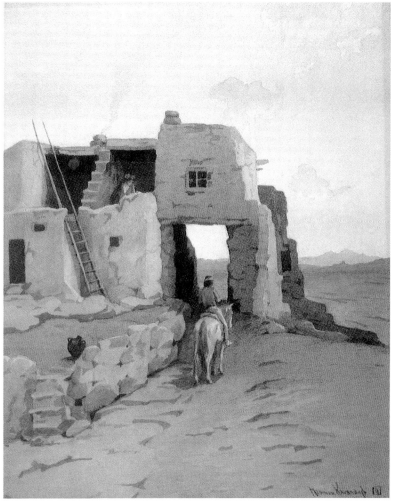

4

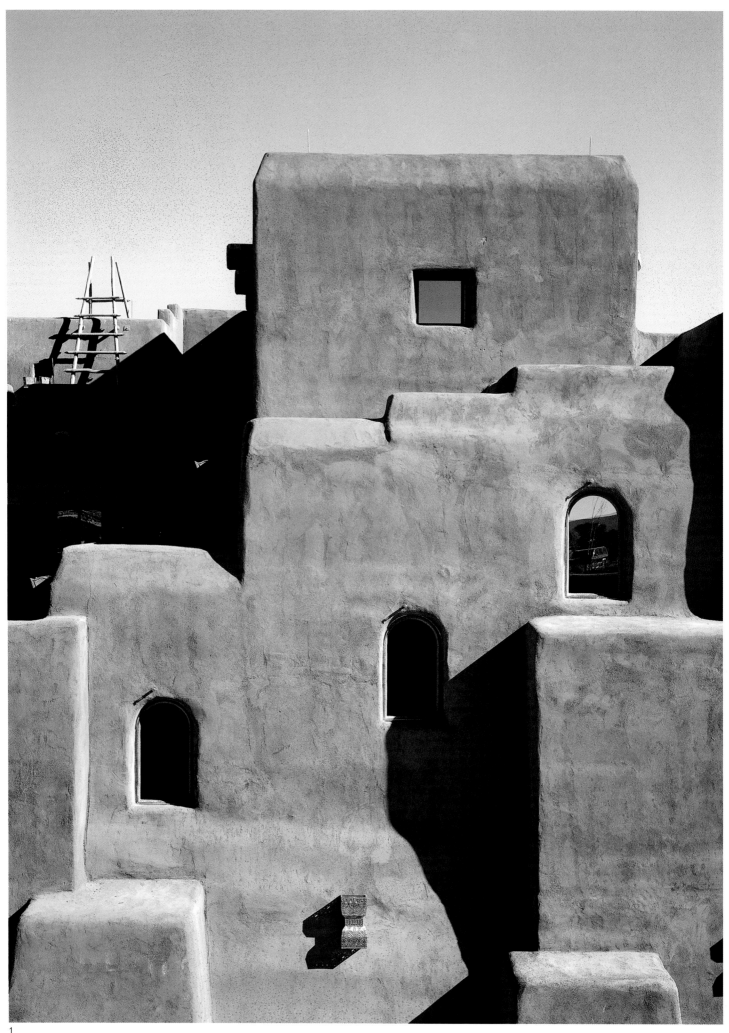

Over time, creators of many kinds have gravitated to desert environs seeking inspiration and solitude. Many pioneers of Modernism have found an affirmation of their aesthetic ideals in the pueblo architecture of New Mexico, where serene adobe forms organized the lives of vibrant societies of the past. The clean lines and tactile finishes of adobe structures still enliven the austere desert landscape today.

In their compact construction, the pueblos addressed the need to conserve precious shared resources. Rather than dispersing structures in a horizontal sprawl, this clustering of forms reduces the wall surface exposed to the intense desert sun.

Las Campanas recreational village pays tribute to the architectural history and character of New Mexico. The Golf Clubhouse (opposite) puts into play the massed composition of pueblo-style architecture, and the rounded corners and flat roofs seen in such Santa Fe architecture as the Loretto Hotel (top right). Rounded corners and warm, tactile surfaces characterize this style, which is well adapted to the desert. I see these elements in sculpture—an anonymous ceramic piece in my home (far right) suggests to me a hilltop village, using the vessel as the landscape form.

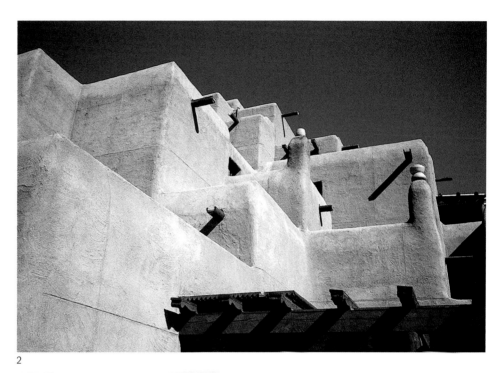

2

3

4

1 Las Campanas Golf Clubhouse, Santa Fe,
 New Mexico, 1998
2 Hotel Loretto, Santa Fe, New Mexico, designed by
 Harold Stewart, 1975
3 Walter Ufer, *Oferta para San Esquipula*, 1918
4 Work by unknown ceramist

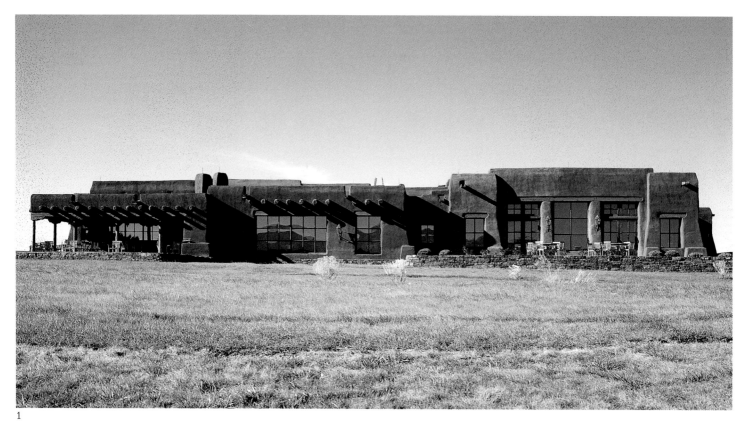

1

In a time when places seem to be sacrificing their historical character to become more and more alike, it is rewarding to be able to identify a destination by its architectural and cultural traditions.

As the largest adobe structure built in New Mexico since 1930, Las Campanas Golf Clubhouse (above) acknowledges the historic pueblo-style architecture in its arrangement of rectilinear spaces, its material vocabulary, and authentic details. Light and shadow model the smooth adobe planes causing the structure's surface and composition to change throughout the day.

1 Las Campanas Golf Clubhouse, Santa Fe, New Mexico, 1995
2 Las Campanas Spa and Fitness Center, Santa Fe, New Mexico, 1998
3 Detail from 1877 illustration *Entablements des Cinq Ordres Avec Une Comic*

2

Entablement Composite.

3

History is recorded in the buildings of Santa Fe. The architecture holds traces of how Europeans integrated pieces of their own culture with what they encountered as they moved across the Southwest. Greek pediments appeared in adobe constructions, with entablature detailing defining the roof lines, and classical post and lintel elements structuring doors and windows (see above).

The territorial style that developed is rich with historical significance. In designing the Las Campanas recreational complex, we addressed both indigenous and territorial architectural styles, paying tribute to the unique legacy of the region.

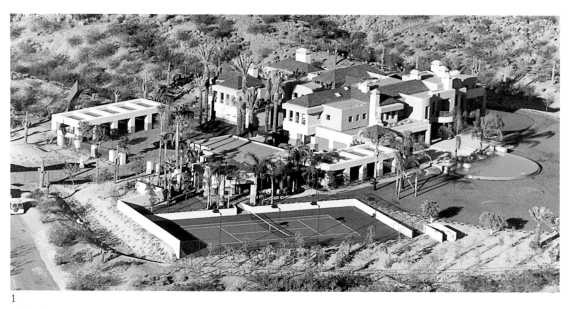

1

The design of most residences calls for a dynamic relationship with the landscape. Occasionally the opportunity arises to create a dramatic counterpoint—to place a lush oasis in an arid plain.

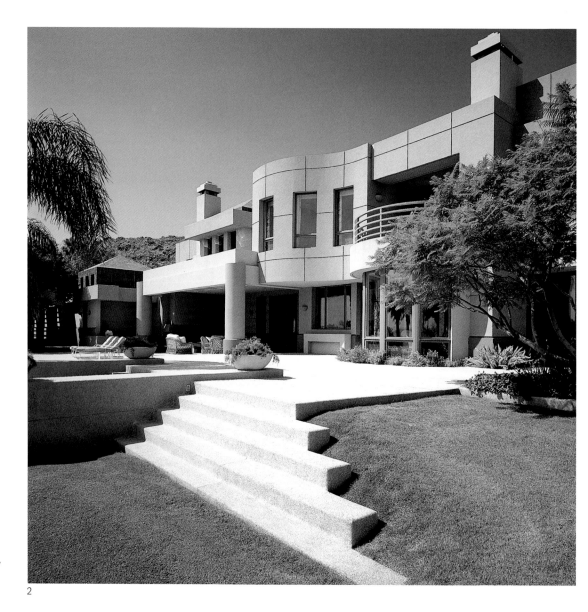

1 Aerial view of Felker Residence, Paradise Valley, Arizona, 1994
2 Entrance facade, Felker Residence
3 Kaz Chiba, *Desert Sand* (n.d.)
4 Pergola and fence, Felker Residence

2

The Felker Residence (these pages) is an orchestration of contrasts, from the rich colors of exterior surfaces to striking patterns of light and shadow. It is a dynamic composition of geometric forms centered on an earthen canvas. The rhythm of high-contrast shadows cast by the open structural work in the enclosed walkway (below) echoes the sculptural fence nearby and suggests the patterns of light on sand dunes (right).

3

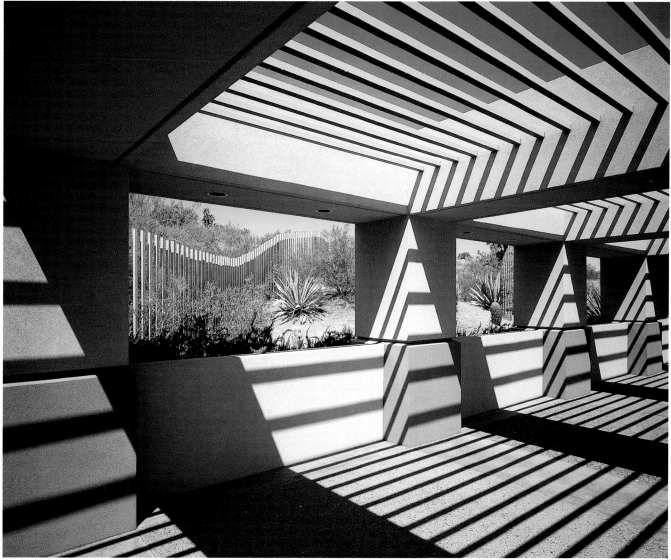

4

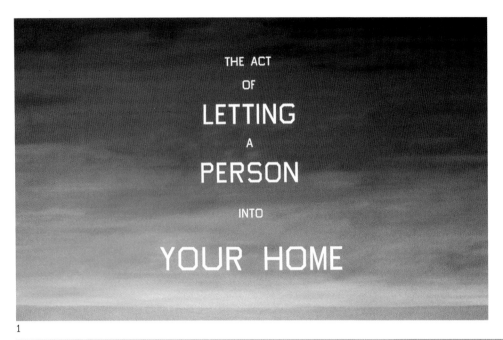

In the East Mountain Drive Residence (below), drought resistant landscaping serves to integrate a desert aesthetic with the slope of its hillside site. The forms, materials, textures, and colors are an adaptation of the silhouette and palette of pueblo architecture to the existing streetscape and the indigenous chaparral.

Ed Ruscha's painting *The Act of Letting a Person into Your Home* indicates the significance of crossing a portal into a private space (left). A building can be designed to extend an invitation to enter. I see coming home as a welcoming, a procession carefully articulated for individual personalities.

1

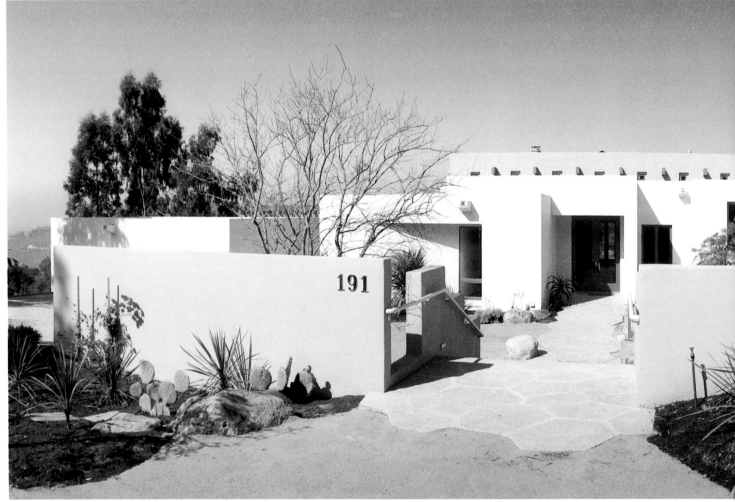

2

1 Ed Ruscha, *The Act of Letting a Person Into Your Home*, 1983
2 East Mountain Drive Residence, Montecito, California, 1989
3 Entrance courtyard, Horiguchi Residence, Palm Desert, California, 1993
4 Entrance pavilion, Gough Residence, Santa Barbara, California, 1989

The wall encircling the East Mountain Drive Residence (below) adds to the enveloping character of the home. We are drawn into a protected place.

The entrance pavilion to the Gough Residence (lower right) dramatizes arrival through a garden passage accented by a colonnade of natural vigas (ceiling beams). The procession of columns carries the landscape into the home, where heightened volumes open to expansive views.

Clearly distinguishing the transition from outside to inside, the entrance courtyard of the Horiguchi Residence (top right) embraces the desert in material and massing, but adds traditional Japanese elements of water and a bridge to the experience of arrival.

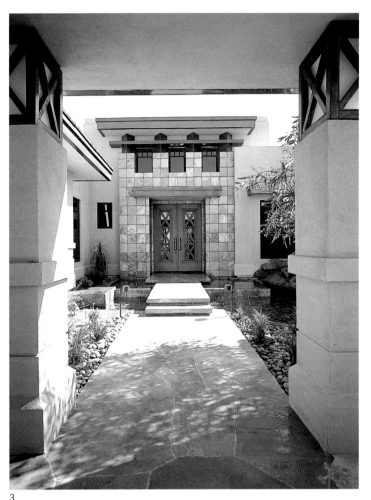

3

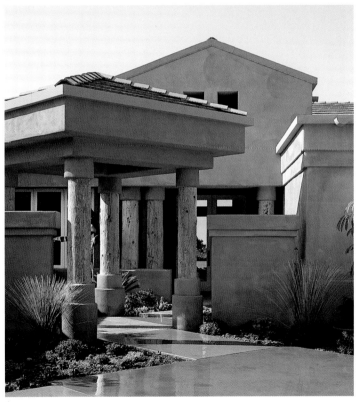

4

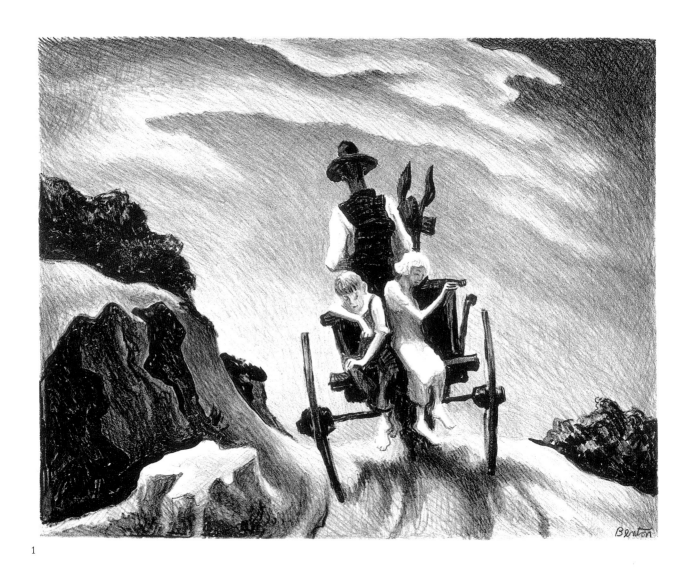

1

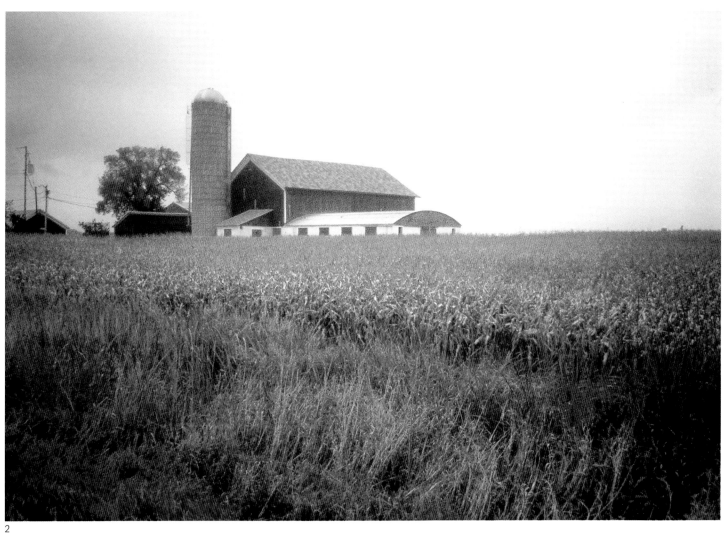

2

A childhood car trip through the Midwestern states sparked my lifelong fascination with farm buildings. There is a sense of security in the sight of these assemblages of utilitarian forms surrounded by broad expanses of land. Farmhouses, barns, silos, coops and corrals, stables and sheds—all manner of structures gather in groups as necessity demands. Standing tall in a field, the silo becomes a reference point visible from miles away, like the tower in a village center.

Farm buildings have become icons for a way of life, suggesting a connection to the land, the strength of family, work by hand, and a respect for tradition and history.

1 Thomas Hart Benton, *Wagon Ride*, (n.d.)
2 Photograph of farm buildings by the author

The purposes that various agricultural buildings serve are visible in the shapes they take: their forms have followed their functions as a matter of course. The houses, barns, and ancillary farm structures are elegant in their simplicity and lively in their variety of forms. In Joseph Stella's drawings and paintings there seems to be a respect for the beauty found in working structures, an appreciation of their machine-like character (see below). Rural forms command the landscape with a sense of strength and isolation in Suzanne Caporael's painting *Whatever He Says* (left). Neither of these paintings are nostalgic depictions of farm life.

Designing a private residence in rural Minnesota (opposite) surrounded by open fields and remnants of farms was an opportunity to explore the potential of clustered rural forms. Formal references to silos and sheds extend both vertically and horizontally in an assemblage that is a contemporary interpretation of traditional farm buildings.

1

2

1 Suzanne Caporael, *Whatever He Says*, 1986
2 Joseph Stella, *The By-Product Storage Tanks*, (n.d.)
3 Private Residence, Medina, Minnesota, 1985

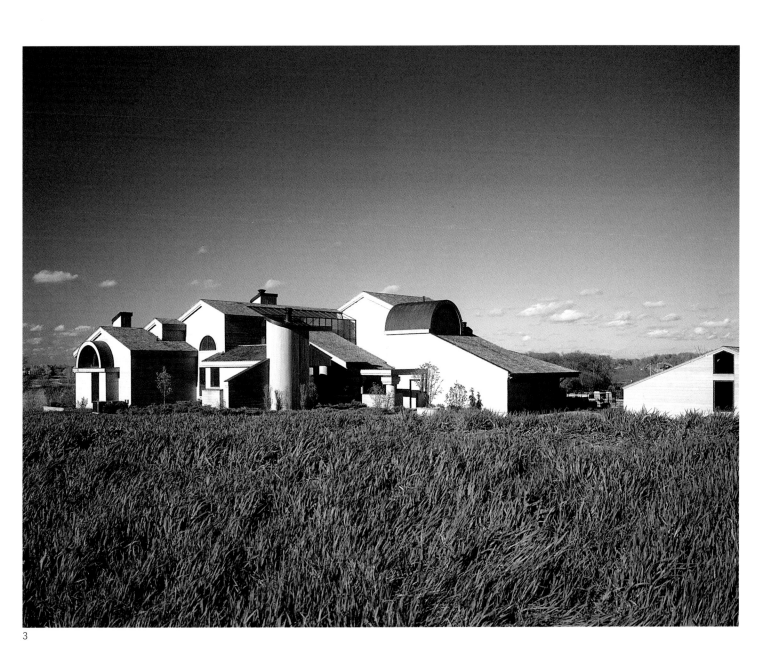

3

1

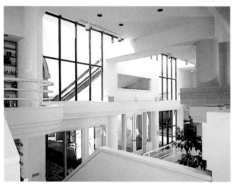

2

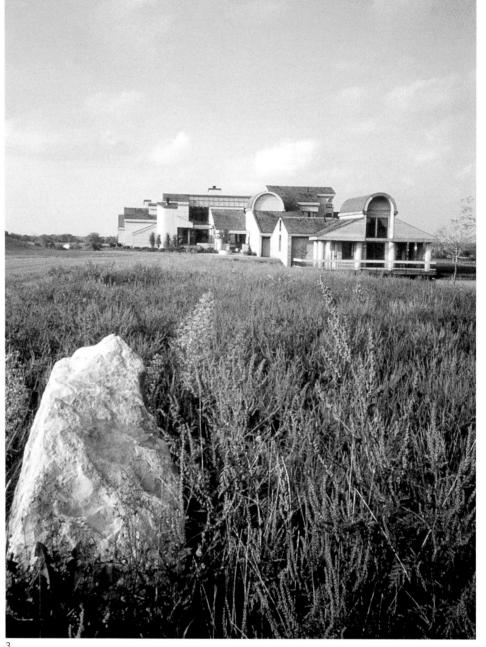

3

Traditionally, farm life revolved around the hearth. The farm kitchen evokes images of a simpler time in the past when a family would gather after a day of work and school to share their successes and struggles over the dinner table. The contemporary family, traveling in many different directions, is well-served by revisiting the principles underpinning the family gathering around the table.

In this Minnesota private residence (above), a spacious kitchen contiguous with the dining area provides an accommodating gathering place (above top left). At mealtimes, opening up the kitchen allows individuals who are cooking or cleaning to be in touch with the activity of the household. During the rest of the day, the open kitchen invites people to come together in the available moments when their paths cross.

The interior of this contemporary farmhouse is bright and spacious, with two-story window-walls to the entrance atrium allowing for maximum enjoyment of sunlight (see bottom left). The process of integrating living patterns with sculptural spaces brings art to life.

For the Glen Annie Golf Clubhouse in Goleta, California (right), the silo becomes a central pivot and point of reference. As an icon of the complex, a stone clad lookout tower anchors a recreational gathering place surrounded by avocado and citrus groves. With its suggestions of a silo form, the tower reflects a further contemporary abstraction of the region's rural vocabulary.

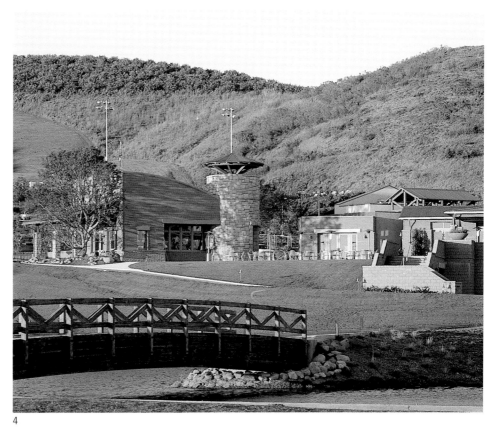

4

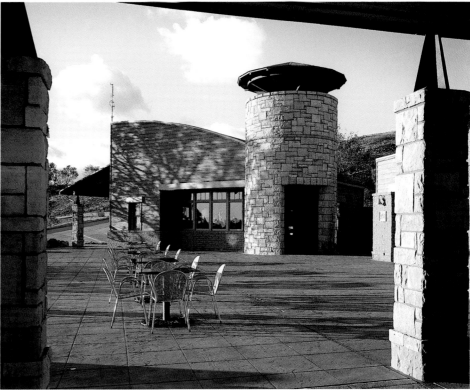

5

1 Kitchen, Private Residence, Medina, Minnesota, 1985
2 Entry atrium, Private Residence
3 Exterior showing tilted silo forms, Private Residence
4 View from course, Glen Annie Golf Club, Goleta,
 California, 1997
5 Clubhouse tower detail, Glen Annie Golf Club

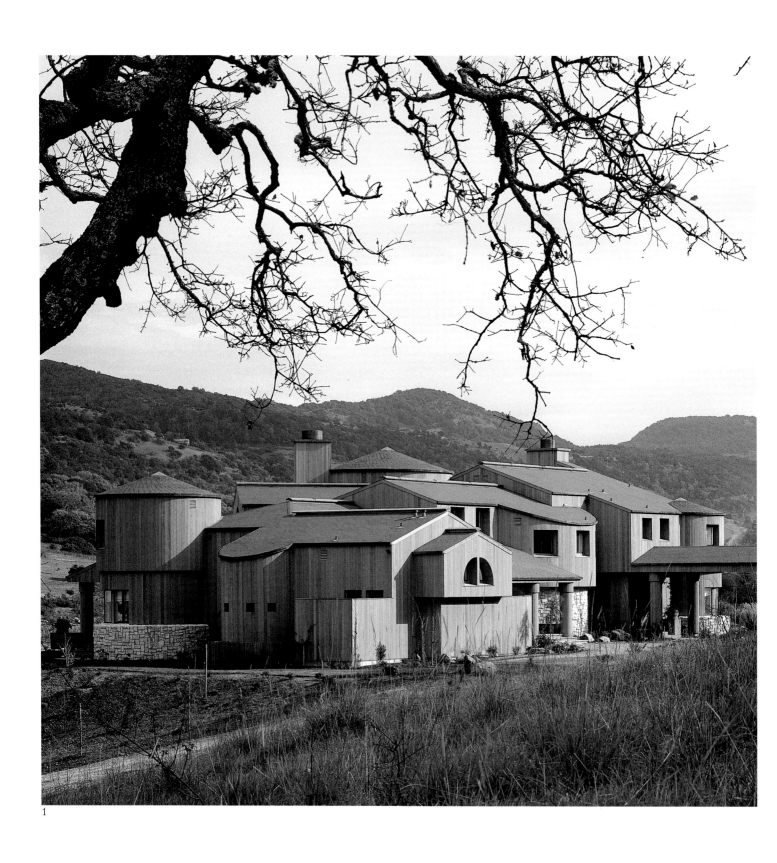

1

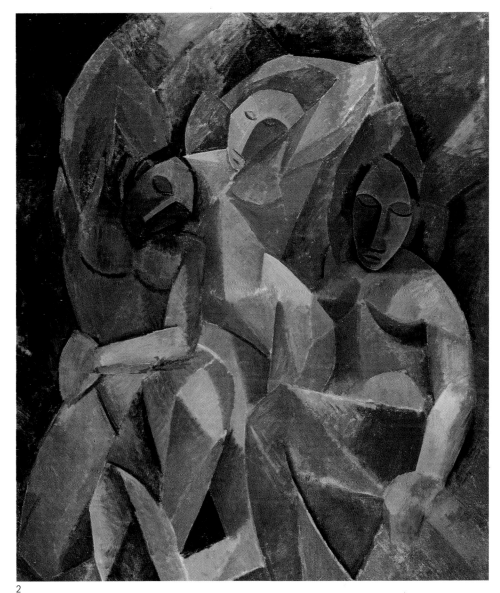

Rising above the vineyard, the McComber Residence (opposite) is a metaphor for California's wine country. Responding to the clients' "contemporary Victorian" fantasy, this assemblage of round towers, wide verandahs, and stepped roofs also pays homage to the silos, wine vats, and farm buildings of the Napa Valley. Earthbound materials and green roofs tie the home to the verdant landscape.

After the home was completed, I realized that the McComber home was also connected to a Cubist aesthetic. Viewed as a photograph, the "masks" formed by window patterns coupled with the play of light and shadow on the varied surfaces resemble Picasso's articulation of multiple figures and planes in such paintings as *Three Women* (left).

2

3

1 View toward entry, McComber Residence, Napa,
 California, 1989
2 Pablo Picasso, *Three Women*, 1908–9
3 *Home, Primrose Park, New York*, 1883

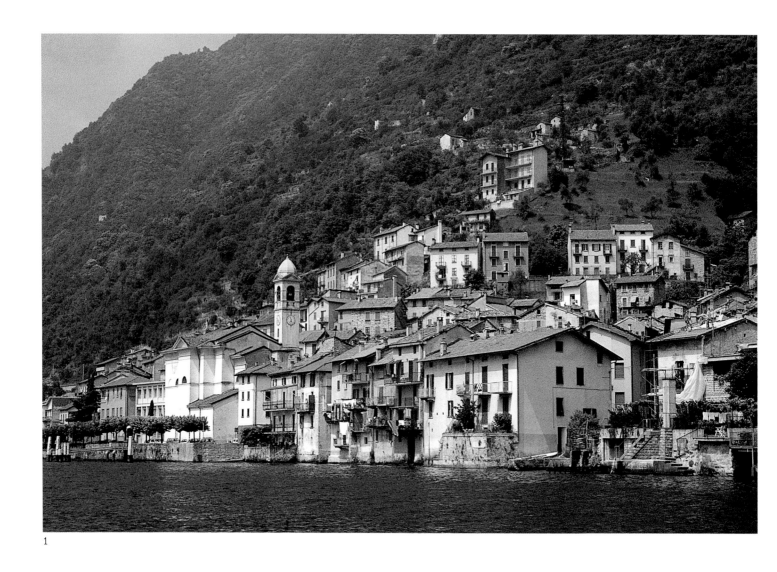

1

I marvel at the cohesion of a European village built over time, in compatible architectural fabric, incorporating the work of many artisans, craftsmen, and caretakers.

It takes many hands and minds to bring even a single building to life. Orchestrating a gathering of buildings, combining forms that coordinate many directions and desires, presents a heightened challenge.

It is the architect's responsibility to examine the architectural successes of the past and to build upon those observations in the design of new places. European traditions have many clues to offer us.

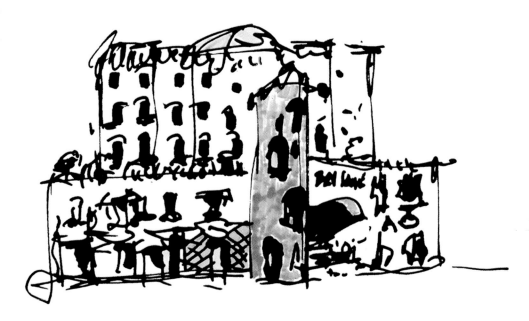

1 European village, photograph by the author

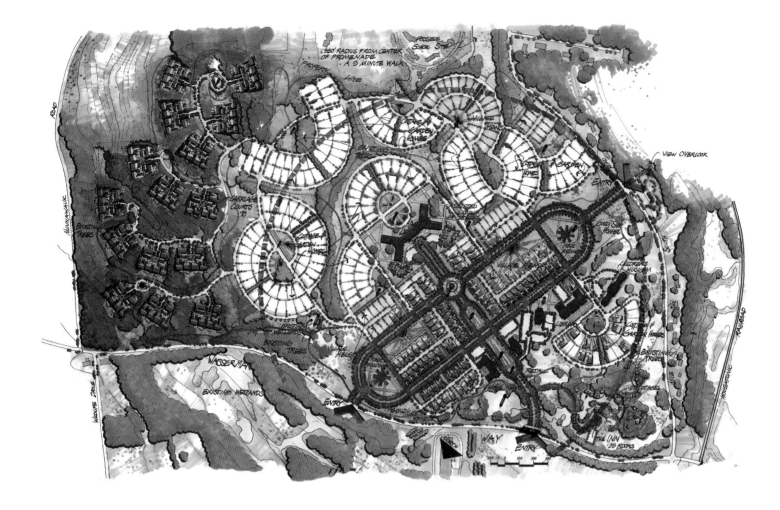

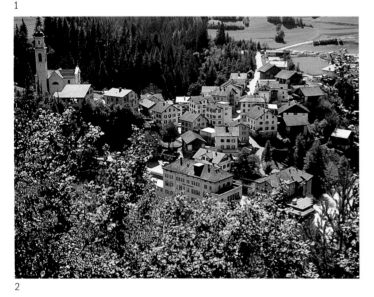

The village character that holds the imagination as an ideal setting draws on a variety of elements: meaningful boundaries, textural changes, density balanced with openness, and the mystery of meandering narrow streets. Passageways that weave through densely built villages thread destinations together, drawing the components into a complete composition. The organizational principles observed in traditional settlements (such as the Swiss village seen at left) can be adapted in the design of contemporary land plans (such as the proposed project depicted above).

A characteristic common to many European villages is a densely built architectural core with passageways to organic edges. Winding corridors create changes of pattern, providing visual relief. The curving pathways lead to moments of mystery and surprise, and eventual release into the open landscape outside the village. These principles, too, can be incorporated in contemporary designs (right).

1 Proposed land plan for Legacy at Newtown, Connecticut, 1999
2 Swiss village, photograph by the author
3 View of Lindos, Greece
4 Passageway in Mykonos, Greece
5 Residential complex walkway, Tobian Townhomes, Glendale, California, 1985

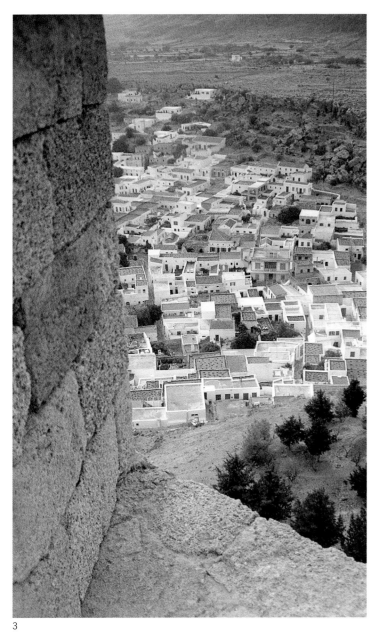

3

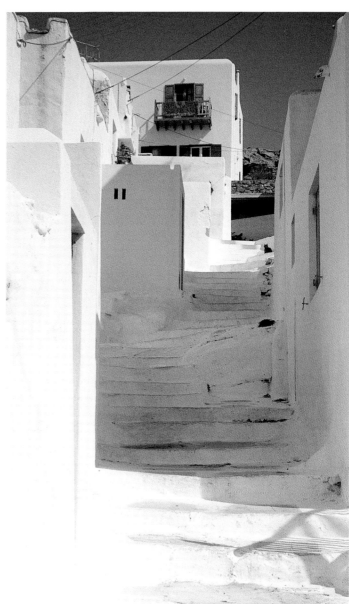

4

While some towns are constructed with dense cores and less compact edges, others have more distinct perimeters (above left). Long ago, the distinct borders of many densely constructed villages served as defensible boundaries. Today, without the threat of invasion, the gates of the village are open. The walls of defense have become borders of definition, encouraging a reweaving of the core rather than sprawling beyond.

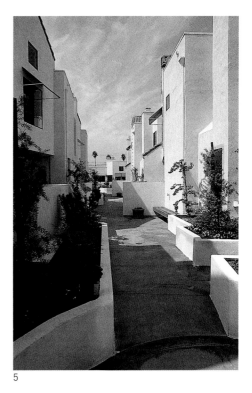

5

1

Enclosed by a periphery wall, the Norris Residence (above) becomes a self-contained haven from the blur of city life. In the composition of this home, a frame enunciates the outer edge and the tower provides a visual anchoring point. This assemblage of simple geometric forms, stepped roof lines, and clean white stucco punctuated by a narrow chimney, reinterprets the structure of the walled village.

2

1 View from periphery wall, Norris Residence, Encino, California, 1988
2 Aerial perspective, Norris Residence
3 Church in Mykonos, Greece

The edifice, tower, or landmark that beckons us to return is of great comfort as it arises within the village fabric. Points of reference clarify the journey. We can wander farther and wider knowing that we can find our way home.

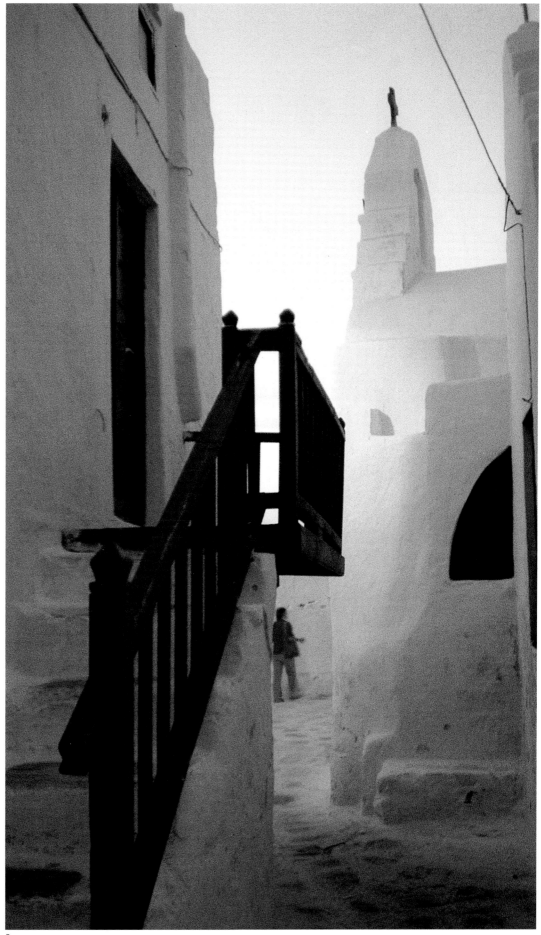

3

1

72

Massing and color can differentiate units in high density. Rhythmically layered planes rise in energetic harmonies of color alluding to the many different lives within their walls.

The clustered residential structures of the Franciscan Villas (top left) stand out from their site in vibrant tones. In the Italian village of Positano (bottom left), the colors of vernacular buildings bring variety and texture to a densely built hillside.

2

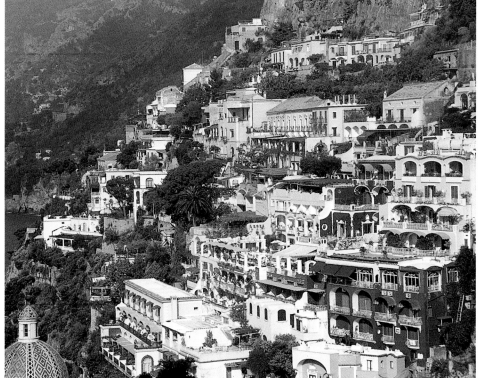

3

1 Drawing of Positano hillside by the author
2 Clustered homes with perimeter wall, Franciscan Villas, Santa Barbara, California, 1989
3 Positano structures, photograph by the author

Buildings that endure bear the marks of their years as traces of undisclosed history. The patina of weathering suggests the many stories buildings have to tell of their creators, their inhabitants, and the events that have come to pass inside.

1

2

3

The arched entry tends to evoke the equations of antiquity—the fundamentals of engineering. The advent of the arch introduced the human spirit to structure. Its curved means of support addressed human proportions more closely than the posts and lintels that had come before.

Time records its passage in peeling layers (left). The fingerprints of many eras pay tribute to buildings that endure. Patina is richly earned by structures that have served generations well.

1 Arch in Verona
2 Ruins in Rome
3 Garden court arcade, Villa Lucia (private residence), Montecito, California, 1989
4 Home in Torgiano, Italy

4

1

The hill towns of Italy are structures that developed gradually in many steps. They were not designed as a single unit, but they are still structurally cohesive. Over the years, various sections have been added, repaired, and modified, as dictated by need and available materials. As a result there is variety in the assembled forms, yet they are in perpetual harmony.

The passage of ages is palpable in these places; they are vibrant with history. The practical functions served by these structures may have changed over time and the lives of their residents have surely changed as well. But people feel a connection to these places and persist in caring for them.

1 Italian villa, photograph by Jeffrey Berkus
2 View from hillside vineyard, Villa Lucia, Montecito, California, 1989

2

The clients with whom we designed Villa Lucia (above) shared my love of Italian vernacular architecture and reacted enthusiastically to my suggestion that we draw from the assembled forms of these hill towns. Most times, designing a new home for one's family means starting with a clean slate; in this case we strove to capture an aura of history.

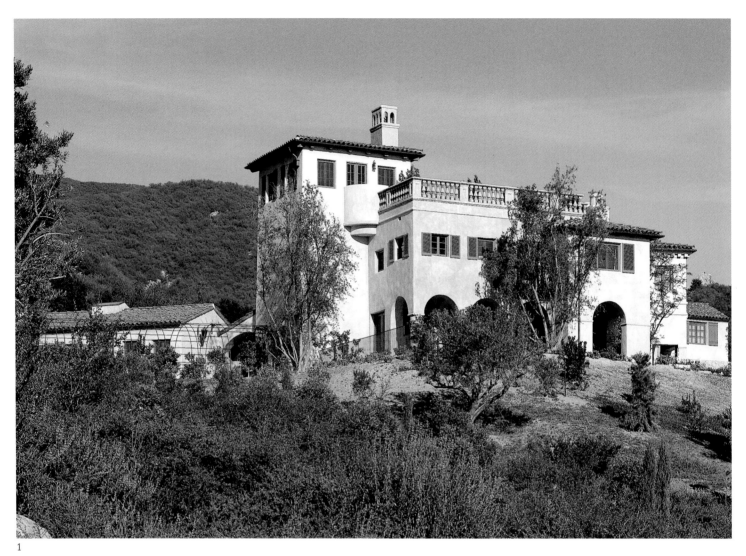

1

The clients and I traveled to Florence to search out inspiration and materials for Villa Lucia. The rural assemblages found among the vineyards and orchards of northern Italy are clustered together, allowing surrounding pastoral fields to extend unbroken. The garden's edge embraces the developed core maintaining a distinction between the two (see bottom right).

Like a town that has developed over centuries, Villa Lucia became a composition of living cores that are treated as autonomous buildings. This meant imagining the construction of the home as more like a village than a single structure.

The structure of Villa Lucia is apprehended, not all at once, but in sections that can be grasped one at a time. Instead of starting with a single form and breaking it down into parts, we imagined the house as a collection of human-scaled components that had been added to one another over time. Rather than being arranged along a single grid, the rooms turn on different axes—connecting, layering, and melding spaces at surprising angles (see opposite right). The various portions of the house, with their diverse styles and functions, are aligned to suggest an organic structure that has evolved in response to use.

2

1 View from olive grove, Villa Lucia, Montecito, California, 1989
2 View across vineyards of an Umbrian hill town
3 Paul Cezanne, *Houses at L'Estaque*, 1880-85
4 Villa Lucia chimney of rustic sandstone
5 "Second house," with partial sandstone cladding
6 Exterior of living room with neoclassical detailing

3

4

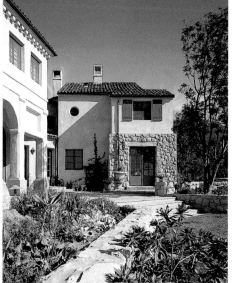

5

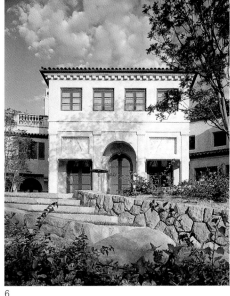

6

Aspects of Villa Lucia's exterior tell the story of a family that built a legacy. We imagined a family that raised grapes and olives on the surrounding hills, and as the generations gradually prospered, their residence became a village of increasing stature. Thus, the "first house" (top right) is clad in rustic, rough-hewn sandstone, and the next "house" carries that stone into a slightly more complex design (middle right). The refined Palladian style of the "later house" (bottom right) features dentil detailing at the roof edge, an arcaded entryway, and translucent alabaster panels that subtly illuminate the living area inside.

Roof tiles of different ages and styles were collected from a variety of sites across California maintaining the sense that generations had used the materials that were available to them as they added to the structure. Meticulous hand-painting of the exterior surfaces creates the effect of weathering from sun and rain.

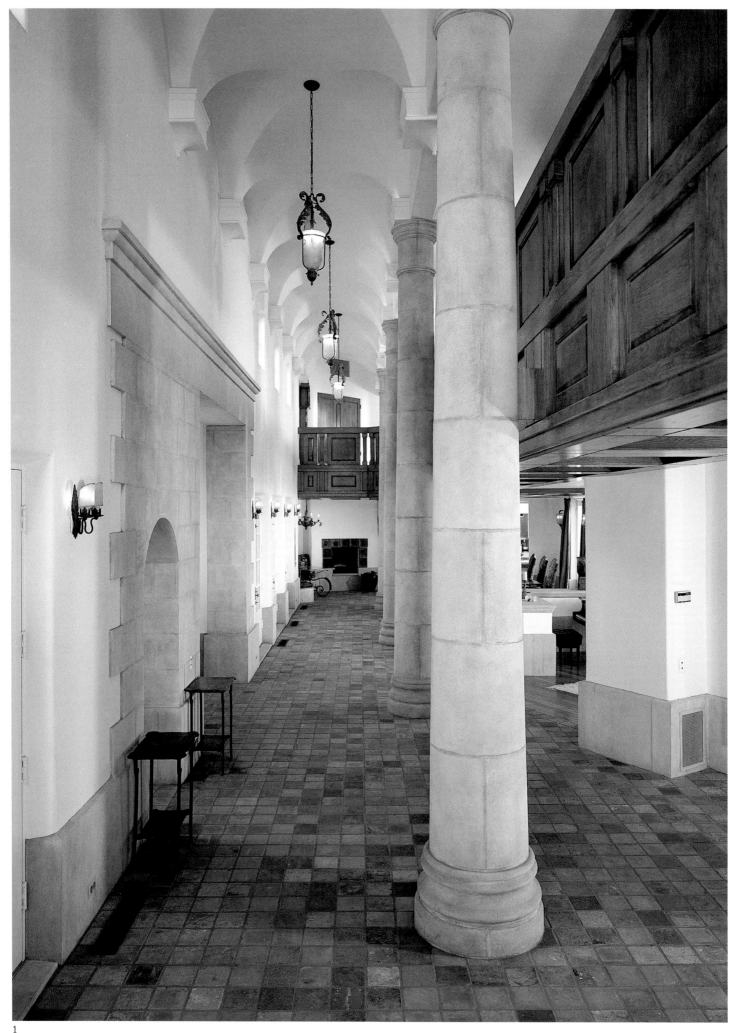

Lined with columns and capped with groin vaults, Villa Lucia's central colonnade (left) is a nave-like hall that brings to mind the rich legacy of European architecture. An arduous commitment to authenticity can be seen in the virtuoso performance of traditional building trades including hand-painted wall surfaces, extensive use of hand-crafted iron, hand-tooled marble, blown glass, handmade bricks and tile, and fine hardwood craftsmanship throughout. Many of the materials brought together had histories of their own, from 200-year-old French tiles in the colonnade, to the family room's ceiling timbers from rural Pennsylvania, antique mahogany doors, and Florentine wall sconces.

Bringing our fantasies to life in the form of Villa Lucia involved the skill, dedication, and creative energy of many devoted professionals. The details reflect the care invested in every inch of this home.

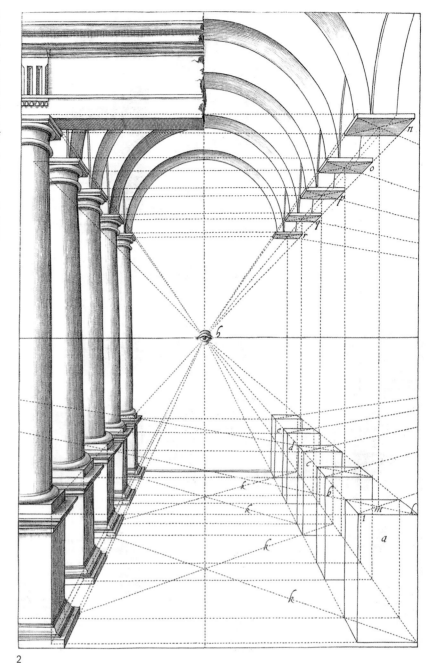

2

1 Vaulted entrance hall, Villa Lucia, Montecito,
 California, 1989
2 Perspective diagram of colonnade, Hendrik Hondius,
 1617
3 Main entrance door and scalloped niche details, Villa
 Lucia

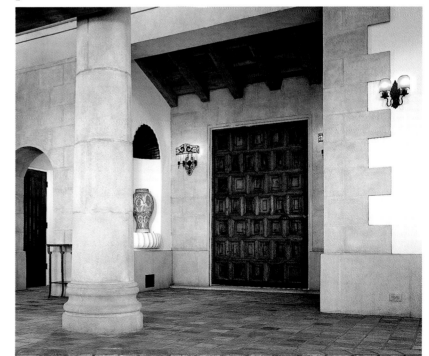

3

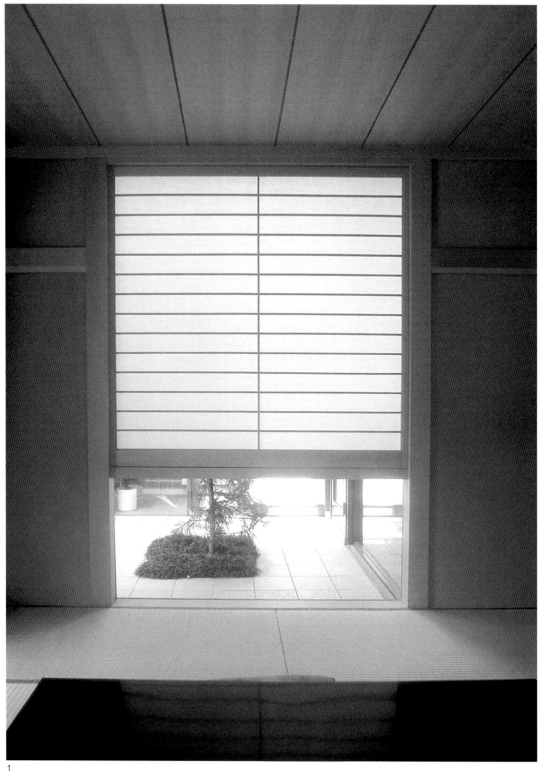

1

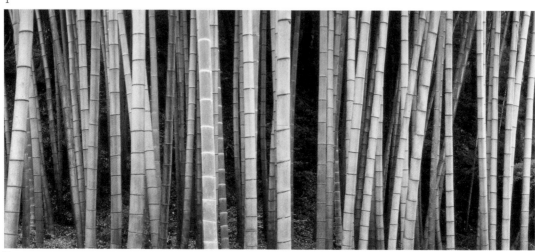

2

A grid is a standard in the world of design, a rule against which any form can be compared. As a matrix, the grid provides an often invisible structural pattern representing perfect order. In the Western tradition, we have come to see the grid as representing a mastery of order over the chaotic natural world. Seen often in paintings such as Sean Scully's *Change #8* (below), a grid can be transformed into a tactile pattern with subtle shifts in color.

Where the grid is seen in Japanese design, the textures of natural materials are often enunciated in the grid pattern. The characteristic Japanese use of the grid appears more human and closer to nature. The infinite variations of grid patterns inspired by tatami mats, shoji screens, and exposed post-and-beam construction found in traditional Japanese structures command respect. I visit and revisit this geometry of weaving structure and fiber in the design of buildings.

In Japanese architecture, flexible spaces and sliding doors contribute to a sense of continuity between indoors and outdoors. Inside, one often finds rooms that can change in size and feeling with the easy movement of a screen. This fluid treatment of interior spaces using movable or partial partitions has long influenced my approach toward open-plan design.

3

1 Traditional Japanese interior details
2 Macduff Everton, *Bamboo, Moss Temple, Kyoto, Japan, 1999*
3 Sean Scully, *Change #8*, 1975

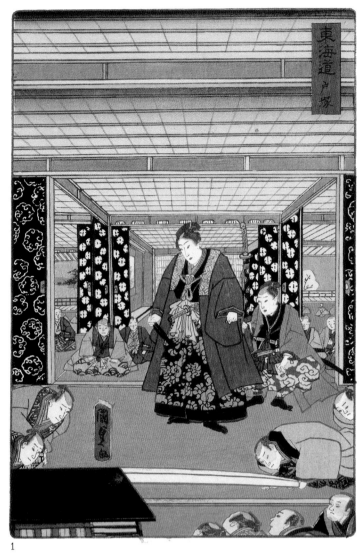

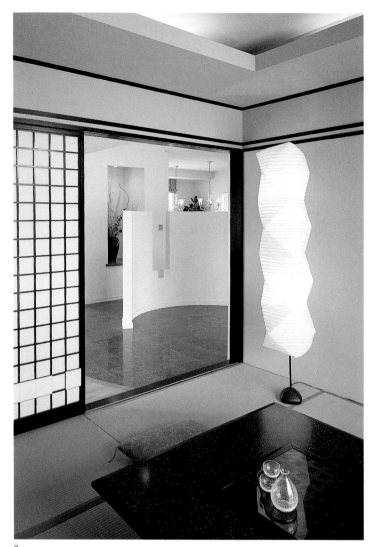

1

2

Japanese architecture has been an important influence in my career. Growing up in Pasadena, California, I was well acquainted with the architecture of Greene & Greene, Frank Lloyd Wright, and other Craftsman architects. Japanese design traditions had a profound influence on the Craftsman style. As a student, I interned with Ken Nishimoto, a talented architect with close ties to Japan. Years later, one of our firms had an office in Tokyo and opportunities to design buildings and masterplan communities throughout Japan.

Designing in Japan raised many questions. The heritage of Japanese architecture is filled with craftsmanship and care. The desire to adopt Western building forms and technology has, at times, led to a defection from the contextual. The challenge was to integrate traditional Japanese design with contemporary planning and construction in order to develop a design vocabulary that retained the character and individuality of Japanese architecture. Our goal was to respect the integrity of Japanese architecture while introducing more contemporary planning and design principles used in Western living arrangements (see bottom right and opposite).

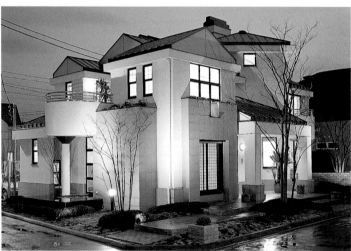

3

1 Utagawa Kunisada, *Tokaido, Totsuka*, 1862
2 View from tatami room to curved wall in entry, Kobori House, Tokyo, Japan, 1989
3 Twilight view from front, Kobori House
4 Interior, Woodleigh, La Canada, California, 1965 (photographed after restoration in 1990)
5 Entrance facade, Woodleigh

4

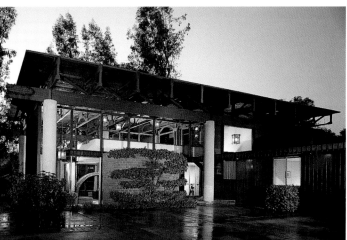

5

An interesting play of geometry occurs when working in three-dimensional grids. A dialogue begins between horizontal and vertical, solid and void, volume and plane, that directs our attention upward, encouraging continued exploration.

Built in 1964 and recently restored, Woodleigh (above and left) was one of the early houses I designed for my family. The use of high ceilings, exposed structural work, and openness to the outside were attributes I had come to admire in Japanese-influenced architecture.

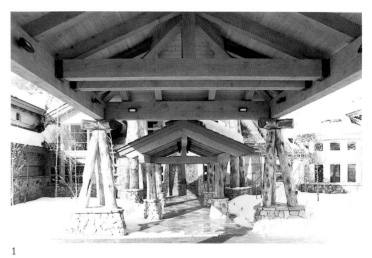

1

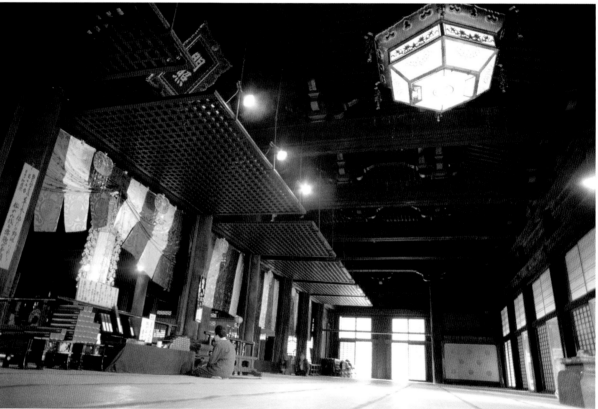

2

A prominent characteristic of traditional Japanese vernacular architecture is the use of complex roof systems (see above). Long clearspans require a network of structural supports, creating a pattern of timbers that is integrated into the aesthetic of the building. The intricate patterns resulting from the repetition of trusses recall the elaborate perspectives in the work of Robert Stackhouse (opposite top).

Many of our buildings incorporate the massive timber trusses, post-and-beam construction, and heavy wood trim prevalent in Japanese architecture (see opposite bottom). Exposing the structural connections, the integrated network of roof members celebrates the strength and materials of structure. The skill of the craftsperson becomes evident in the detailing of these structures.

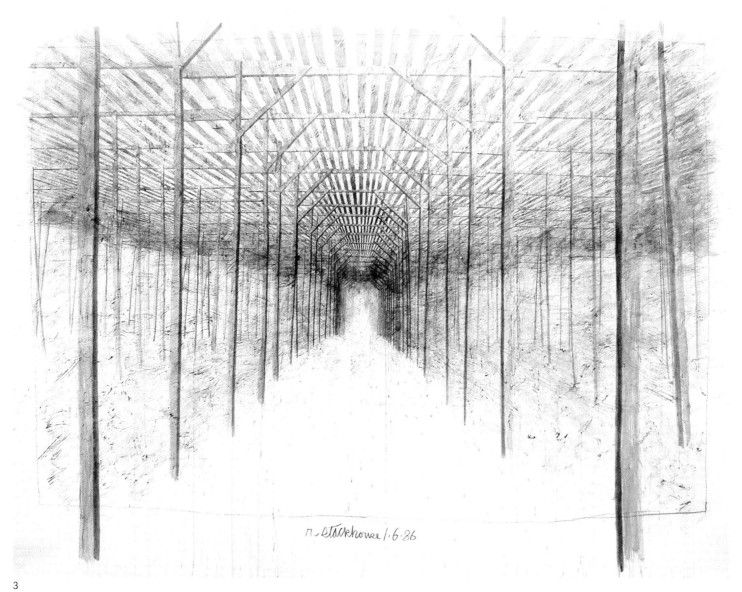

3

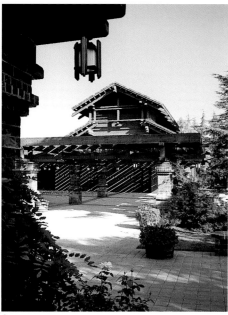

4

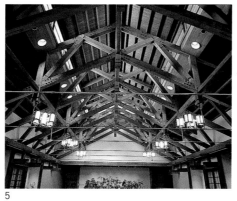

5

6

1 Covered entrance structure, Burnap Residence, Sun Valley, Idaho, 1995
2 Japanese temple
3 Robert Stackhouse, *Inside a Passage Structure*, 1986
4 Exterior of exhibition hall, Descanso Gardens, La Canada, California, 1982
5 Interior roof beams of exhibition hall, Descanso Gardens
6 Snowcreek Village Sales Office, Mammoth Lakes, California, 1997

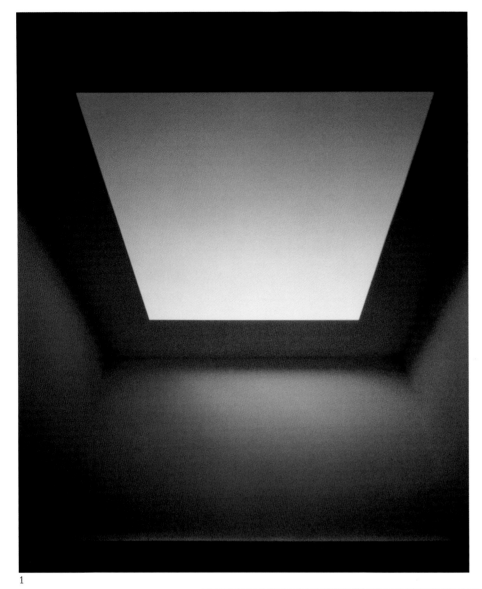

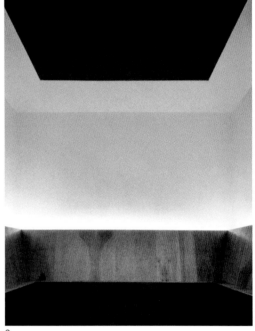

1, 2 James Turrell, *Meeting*, 1981–86
 3 Contemporary Japanese window
 (Akasaka Prince Hotel, Tokyo)
 4 Interior of study overlooking water
 garden and bridge, Henry
 Residence, Pasadena, California,
 1994
 5 Front view featuring angled study,
 Henry Residence
 6 Model, Henry Residence

Accustomed to windows capturing panoramic views, I was surprised the first time I encountered the Japanese stylistic device of a knee-level window. I felt invited to pause, to appreciate a small detail of a well-composed garden, rather than being required to encounter a vast expanse of landscape. This element brought me back to the subtle magic of gradual disclosure in architecture.

In designing the Henry Residence (below), we positioned the study to overlook La Loma Street Bridge in Pasadena. A series of low viewing windows framed the bridge, while allowing reflections from the water garden to illuminate the library (below). The study became like a ship that floated over the water garden outside, imparting a sense of movement to the room. Changing light patterns captured within the frame of the window shift throughout the day.

A parallel concern for light, wall planes, and placement of openings can be seen in James Turrell's work. In Turrell's environments, light is transformed into something that has substantial presence within a space. The installation *Meeting* uses gradually shifting interior lighting to transform a view of the sky into spatial artwork (opposite top).

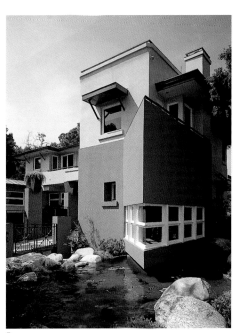

5

6

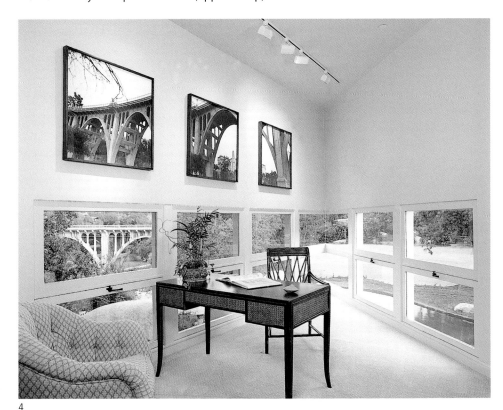

4

1

2

90

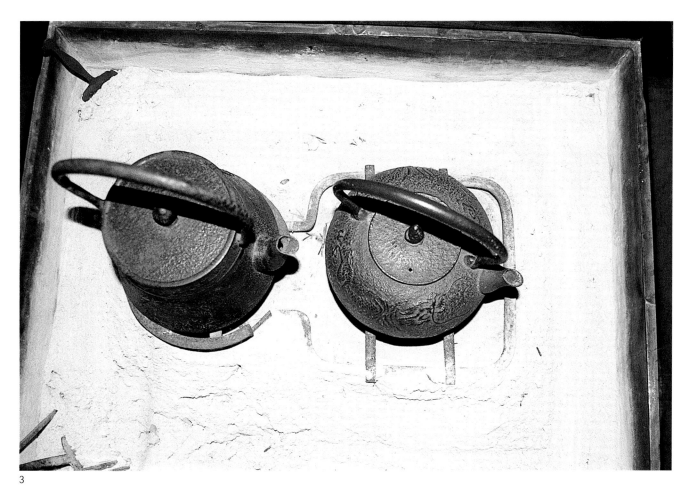

3

As part of a proposed community in Japan called Hoshida, we designed a building that was to be the communication, recreation, and gathering center for the village. While ultimately unrealized, the proposal allowed me to develop thoughts about the structuring of gathering spaces. In addition, I enjoyed the play of color and geometrical forms in this project; it was especially sculptural and gave me a new perspective on the work of artists like John Okulick (opposite bottom).

Several years after the Hoshida project, we visited a historic Japanese building that was many centuries old. A woman made tea for us there using a traditional method. As I looked into the heating grille I saw, in the teapots, the form of the building we had designed for Hoshida and a reminder of the sense of community that motivated the project. These surprising connections suggest a hidden place inside where images of daily life, art, and architecture converge.

1 Proposed community center, Hoshida, Osaka, Japan, 1987
2 John Okulick, *Saw Tooth*, 1985
3 Traditional Japanese tea preparation

1

A demonstration house for the first Kobe International Home Fair, the Rokko House (top left) was commissioned as a demonstration of Western design utilizing products from the United States. The open plan, maximizing views of Kobe Harbor, was a departure from the traditional enclosed entry common to Japanese homes. Transitions of height delineate separate living functions: the upper story, which opens to the street, is for active living and working, the lower for sleeping and solitary retreat. Colored forms break up the massing of the building creating an interplay of unexpected geometric relationships.

The Adolph Gottlieb painting *Red Sea* (bottom left) became another instance of unexpected parallels. When I saw this painting, it brought me back to the Rokko House's vibrant colors. These were solidly painted in my memory as some of their audience had found them too far from the traditional subtle tones more often seen on Japanese streets. Comparing these images again recalls the suggestion of a building's windows as eyes.

2

1 Rokko House, Kobe, Japan, 1990
2 Adolph Gottlieb, *Red Sea*, 1971, 48" x 60"
3 Entrance gate, Davidson Residence, Santa Barbara, California, 1992
4 Traditional Japanese gate
5 Harry Reese, *Gateless Gate*, 1992
6 Traditional Japanese gate
7 Processional gate painted by Patrick McClure in Villa Buena Vista (private residence), Santa Barbara, California, 1987

The use of decorative gates in Japan drew my attention to the importance of noting transitions at a human scale. Whether between adjoining sections of a garden, from outside to inside a building, or to define a special room within a living space, these gates grant a ceremonial formality to the moment of entrance.

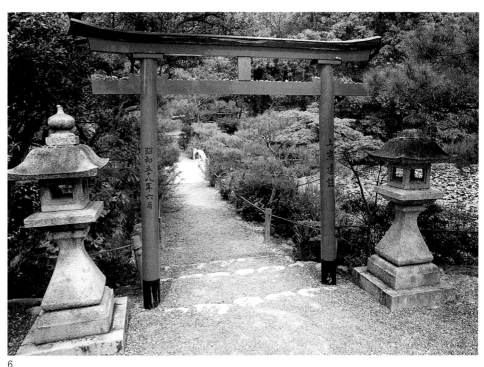

6

3

4

7

5

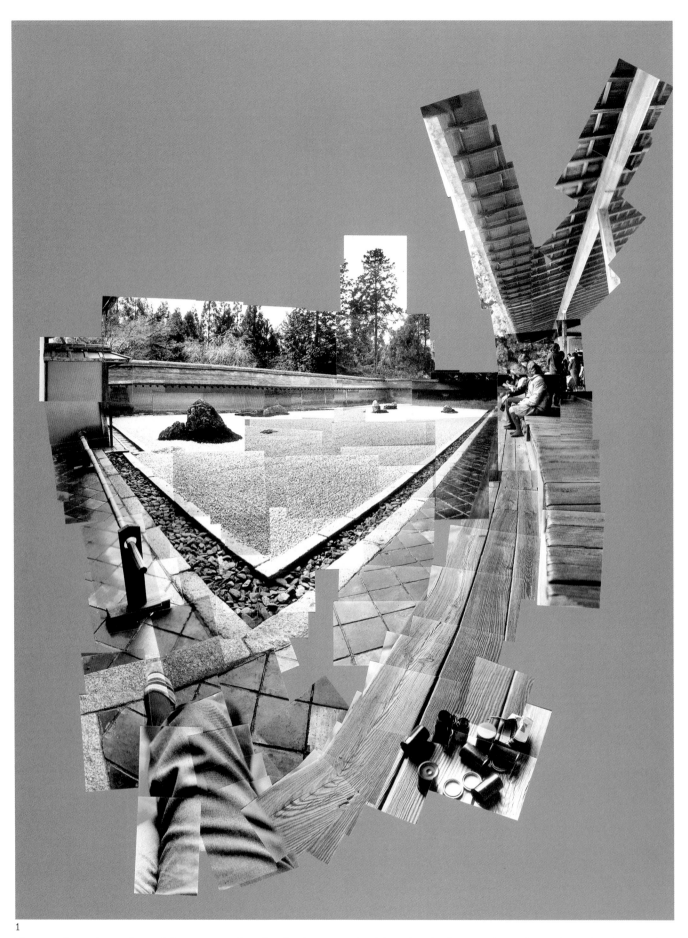

1

The temple garden at Ryoanji features a series of rocks that are dispersed with unique precision. The viewer must walk around the garden to experience them in full. This leads one to take time, allowing the natural elements to reveal themselves gradually.

David Hockney's photographic collage (above) breaks out of the Western traditions of single-vanishing-point perspective, using overlapping views as fragments of experiences, capturing a greater sense of place than exists in a single view.

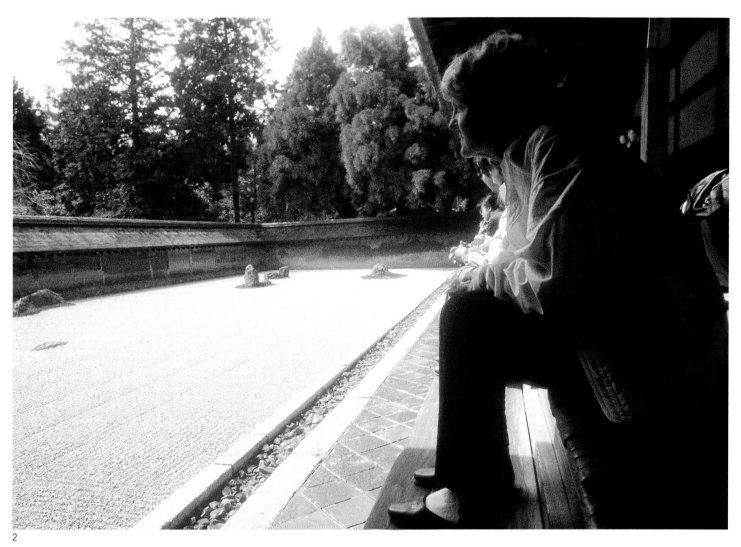

2

Moments in such a garden invite us to pause, to focus on the individual parts that compose the whole.

1 David Hockney, *Sitting in the Zen Garden at the*
 Ryoanji Temple, Kyoto, Feb. 19, 1983
2 Photograph taken by the author at Ryoanji Temple

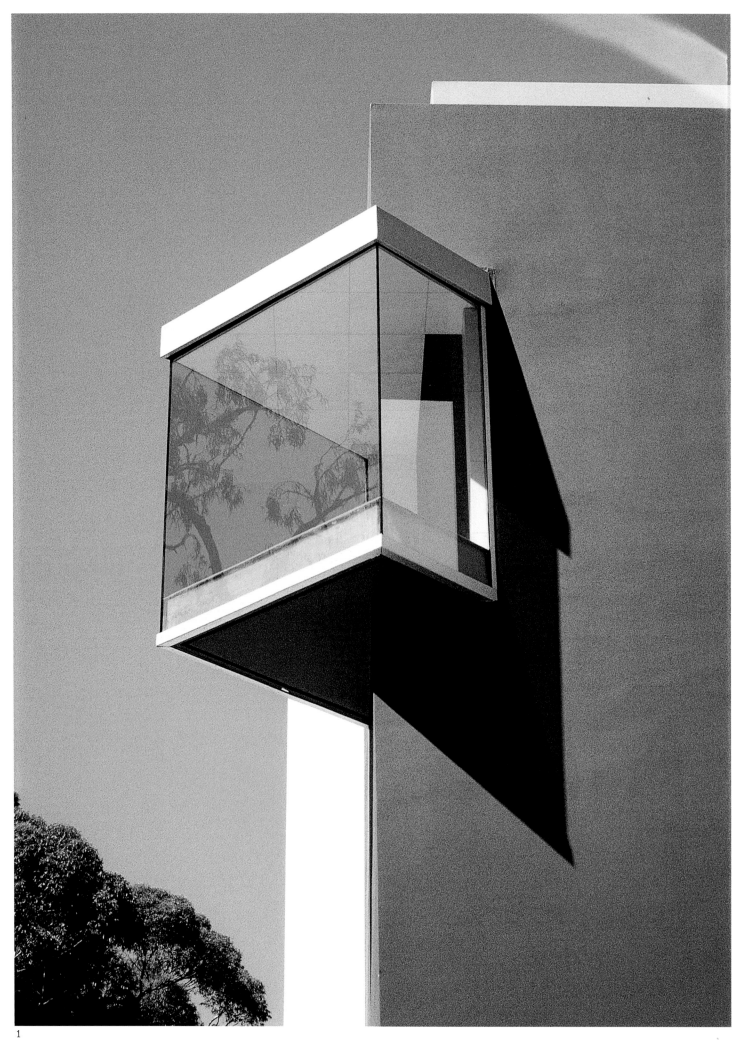

Modernism was a movement encompassing architecture, the arts, industrial design, and social thought. In its departure from convention, modern design is best understood in the context of history.

I cannot think of Modernism without thinking of LeCorbusier's masterful Villa Savoye (right). Its lean, mechanical forms, particularly its pin-like columns, demonstrate how design has investigated the qualities of materials. The hard lines of Modernism were closely related to developments in industrial building materials as new possibilities invited changes in aesthetics.

Corbusier introduced the notion of buildings as "machines for living," which was interpreted differently by many people who followed him. Many Modernists believed that a better society could be engineered through spaces that promoted efficient, harmonious lifestyles. While this approach demands admiration for its social aspirations, it was difficult for the general public to embrace.

There were times when Modernists departed on a journey for structure's sake. Theirs was a belief in the future, in industrial supremacy, in the clean lines of machine-made materials. The tactile qualities of rusticated stone or painterly surfaces, the softness of weathered organic forms, and the friendly qualities that an eccentric passage or an unexpected brushstroke bring to structures or paintings are not necessarily part of the Modernist philosophy. In some cases the results proved too pristine, too sterile, and not human enough in feeling.

In many cases modern design has been made more accessible to a popular audience by maintaining a human scale, by introducing classical elements that ground innovative features, and through gestures that bring warmth to forms and surfaces.

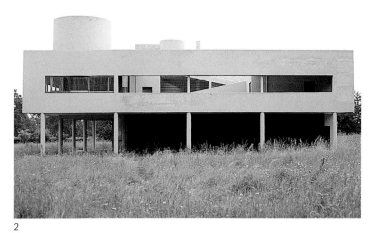

2

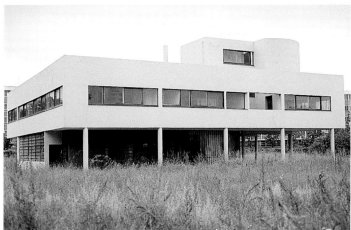

3

1 Angled window of Terner Residence, Pacific
 Palisades, California, 1995
2&3 LeCorbusier's Villa Savoye, Poissy-sur-Seine,
 France, 1928–29

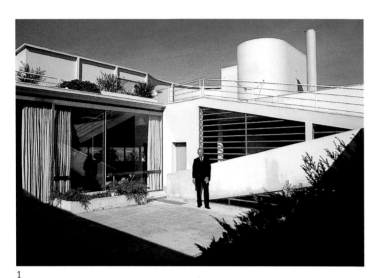

1

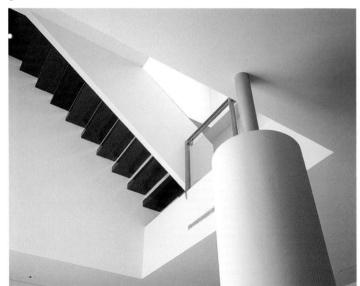

2

Southern California was a hotbed of Modernism during the 1950s. In the work of such architects and designers as Richard Neutra, Albert Frey, John Lautner, Charles and Ray Eames, John Rex, and Pierre Koenig, a platform for new ideas was being explored building on the legacy of the Bauhaus. As a part of this exciting climate, John Entenza's program of Case Study Houses (see opposite) represented conscious changes celebrating new materials, forms, proportions, and floor plans in residential architecture.

As an architecture student, I was privileged to witness the evolution of a style that made brave departures from classical architecture. Lunch hours spent on construction sites led to stimulating conversations about new possibilities for the future of design. This spirit of innovation captivated me. Inspired by a new vocabulary, I began to think of architecture in terms of its connections with the past and bold steps toward the future. The connection between past and present is an evolving process that integrates the science and technology of present thinking with aesthetic concerns.

New forms in architecture and art often demand an interested and sophisticated audience to appreciate their reasoning: the greater the innovation, the greater the risk of being misunderstood and disliked. The advancement of design through contemporary form is a risk and in many cases the architect's original conceptions will be tempered in the process of approval, development, and construction. The innovative artist's work, while subject to criticism, is less regulated by public opinion.

1 Architect John Rex at Villa Savoye
2 Stairway detail, Terner Residence, Pacific Palisades, California, 1995
3 Case Study House #9 (Entenza House), Pacific Palisades, California, designed by Charles Eames and Eero Saarinen, 1945–49; photograph by Julius Shulman, 1949
4 Case Study House #9 after 1995 renovation

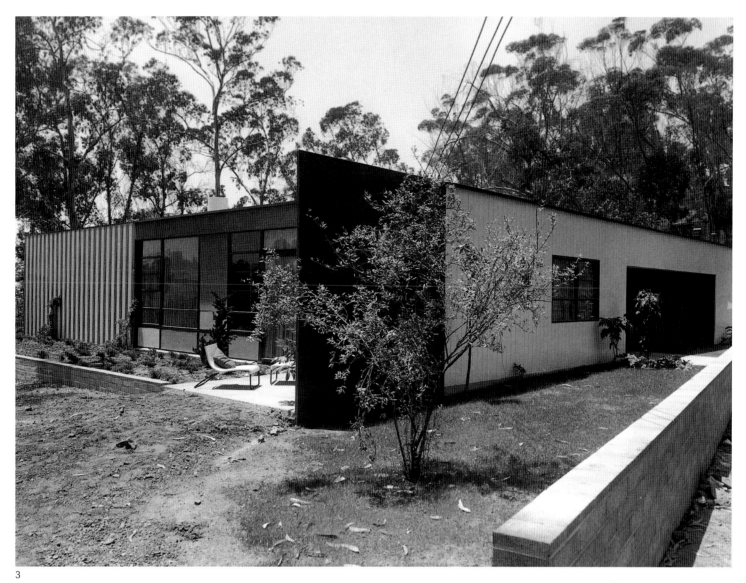

3

Background: The Case Study House Program

One of the high points of modern design in the United States, the Case Study House Program was a project instituted by John Entenza through his magazine, *Arts and Architecture*, in affiliation with the American Institute of Architects (AIA). It was born of a faith in the future during a period of growth, investigation, and innovation.

As an editor and publisher, Entenza tempered an idealistic vision with a human-scale attitude towards architecture. While he was not formally educated in architecture, Entenza had a strong sense of good design. His philosophy was that the architecture we live with is important to everyone, and he believed that the general public was capable of appreciating good living environments. The magazine worked to popularize the best architecture of its times, delivered with wit and style.

During the World War II years, new materials and construction methods (such as arc-welded steel joints, new synthetic resins, and laminates) made possible tremendous

changes in architecture. In the upbeat post-war social climate, Entenza introduced the Case Study House Program, through which the magazine commissioned eight architectural offices to create designs that would bring the new technologies home.

The program's aim was to create better living environments. While the Case Study Houses made design history, they were not conceived as form for its own sake, but rather as ways to best put technological and industrial innovations to work. The Case Study House program left us with a complex legacy. To my mind, one of the program's great contributions was its populist spirit—great departures were made in design with the ultimate goal of making technology benefit people's home lives.

4

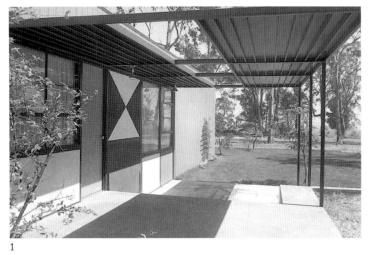

1

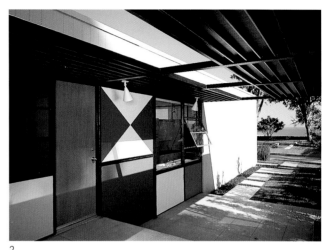

2

The practice of architecture is an ongoing dialogue between history, the present, and the future. To recapture an icon of a past period is an honor and a challenge. Designing the Terner Residence (see opposite right), which incorporated the renovation of a historically vital Case Study House, was such an opportunity.

In the late 1940's, John Entenza commissioned Charles Eames and Eero Saarinen to design his own home as part of the Case Study House program. One of the house's distinguishing features was its principle of "elastic space." Subtle shifts in the composition of its living areas allowed the same space to feel as comfortable for an intimate conversation as for entertaining groups. The result was Case Study House #9 (above and below): a small residence, but one with an important place in architectural history.

Four decades later, years of thoughtless additions and deferred maintenance had eroded the architectural integrity of the Entenza House. Nearly half of the original exteriors had been demolished or badly modified. When our clients, Jacob and Sandy Terner, acquired the Entenza property, they wished to build a new residence for themselves and to re-establish the integrity of the Entenza House, Case Study House #9. Our work with the Entenza House involved both restoring some areas to a renewed semblance of their original state and updating some elements with contemporary pieces in the spirit of the originals. The restored Entenza House is connected to the Terner Residence by means of a subtle passageway that allows the two structures visual autonomy.

The Entenza House and the new Terner Residence overlook the Pacific Ocean from a site adjacent to the Eames House (opposite left), a well-known highlight of the Case Study House program. For both the renovated Case Study House #9 and the new Terner Residence we designed to accompany it, the neighboring Eames House left us quite a legacy and finding the right way to address it was an important step in designing the new home. As a team, we sought to honor the ideals of Modernism as seen in the Case Study Houses and to address the relevance of these ideals in the context of the 1990s. In both the large-scale form and the details of the Terner Residence, we incorporated elements that acknowledged the lean, geometric lines of high Modernism, such as the column forms (opposite right) that reference the work of LeCorbusier. Yet the modern feeling is made more approachable by the use of color, tactile surfaces, and a composition that suggests organic clustering.

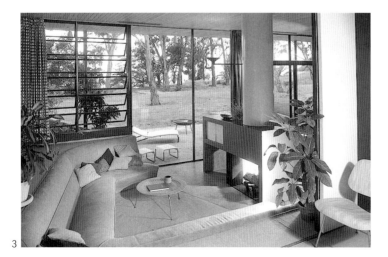

3

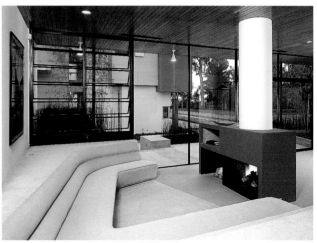

4

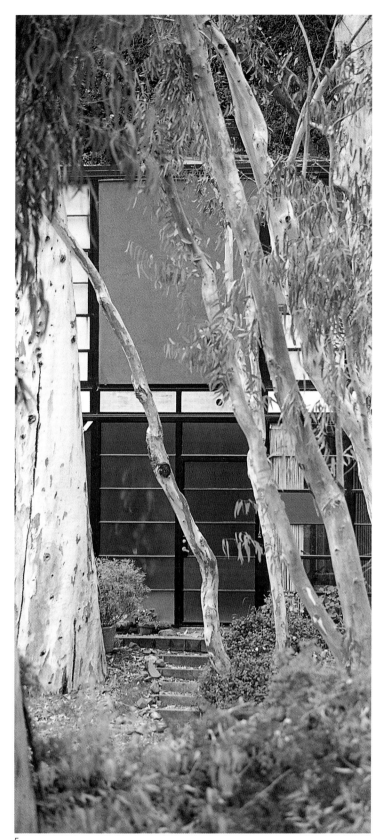

5

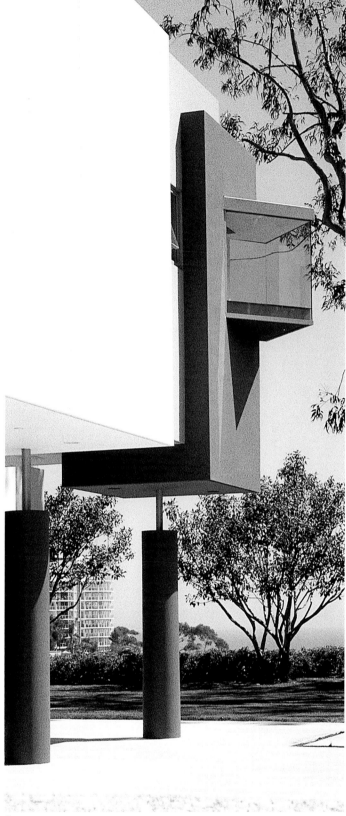

6

1 Entenza House, Case Study House #9, 1949; photograph by Julius Shulman
2 Case Study House #9 after 1995 renovation
3 Entenza House, Case Study House #9; photograph by Julius Shulman
4 Case Study House #9 after 1995 renovation
5 Eames House, Case Study House #8, Charles Eames, Pacific Palisades, California, 1945–49
6 Terner Residence, Pacific Palisades, California, 1995

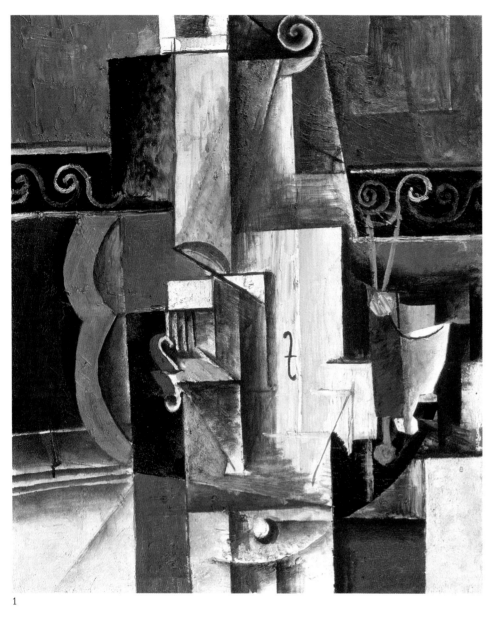

1

Cubism is among the historical precedents explored in the Terner Residence (opposite). In this building, rectangular forms express volumes as structural components differentiated by color, texture, and angle. The connections between the parts and the whole in this building reflect my interest in Cubist art. I have always thought of Cubism as dealing with the relationship between two and three dimensions in inventive ways. In paintings, the Cubists were able to give a sense of space and form unfolding. As a phenomenon in art history, Cubism has left the world with new ways of looking at space that have continued to evolve.

During the process of creating a building, I continually develop the exterior envelope with thoughts emanating from its interior function. As I rotate the building in my mind, I often visualize forms in ways that evoke Cubist space.

In Cubist collage and assemblage, elements are brought together in ways that retain the individuality of their sources. As a result, there is an energetic play between the whole and the parts, and neither dominates the other. Many of our designs organize the component parts of a building along a variety of alignments, rather than conforming everything to a single grid. In the Terner Residence, the articulation of the diverse interior spaces is a harmonious celebration of individuality.

When approaching architecture from a Modernist attitude, convention is set aside for new adventures. Rather than strictly emulating the forms that have been passed down to us, we determined to embrace the old with the new to create a visual counterpoint that worked in a style all its own, while respecting the legacy of its neighbors.

1 Pablo Picasso, *Violin and Guitar*, 1913
2 View from ocean side, Terner Residence, Pacific Palisades, California, 1995, showing Case Study House #9 at left
3–5 Exterior details, Terner Residence

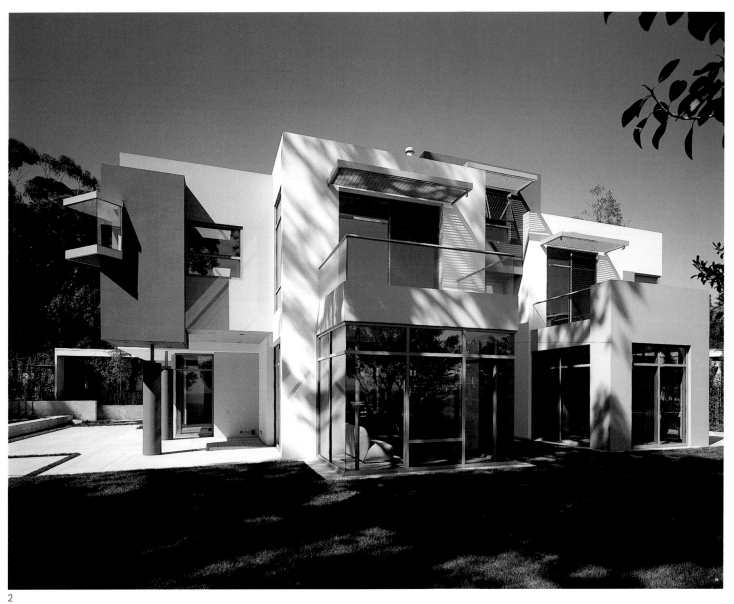

2

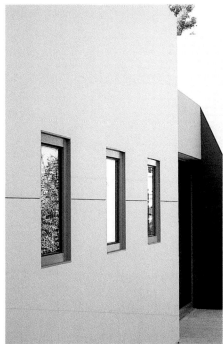

3

4

5

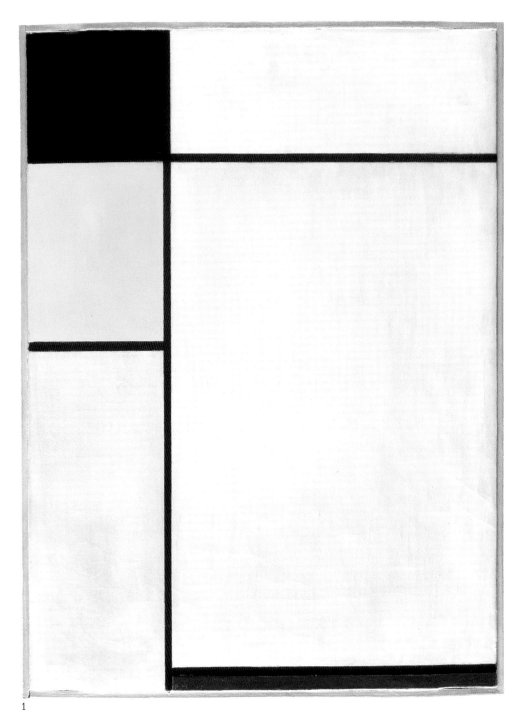

1

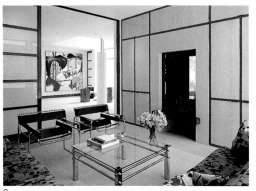

2

The interiors of the Terner Residence examine connections between Japanese aesthetics and Modernist details (see opposite and left). Collaborating with Dana Berkus as interior designer, we wished to capitalize on vaulted central spaces spanned by interior bridges and open stairways, while providing the intimacy and privacy of smaller retreats. Sliding doors and screens facilitate flexibility in the living areas. These light-diffusing panels, resembling shoji screens, also refer to the grid structure of the Eames House's window-walls (see pages 100–101).

In this, too, we were tracing paths inscribed by the Modernists. Modern design has learned much from Japanese traditions. The openness of the Eames House to its surroundings has been much commented upon. As Kenneth Frampton notes: "The quality of light inside changes constantly due to the glass and to the shadows cast by the surrounding foliage. There is something Japanese about this house that cannot be truly accounted for in stylistic terms".[†] I see in Mondrian's work (above) an exploration of geometric relationships within grids that shares this Japanese connection.

1 Piet Mondrian, *Composition #1, Black, Yellow and Blue*, 1927
2 Sitting room with shoji-inspired room dividers, Terner Residence, Pacific Palisades, California, 1995
3 Open central space uniting first and second floors, Terner Residence

[†] Kenneth Frampton. *American Masterworks: The Twentieth Century House*. New York: Rizzoli, 1995.

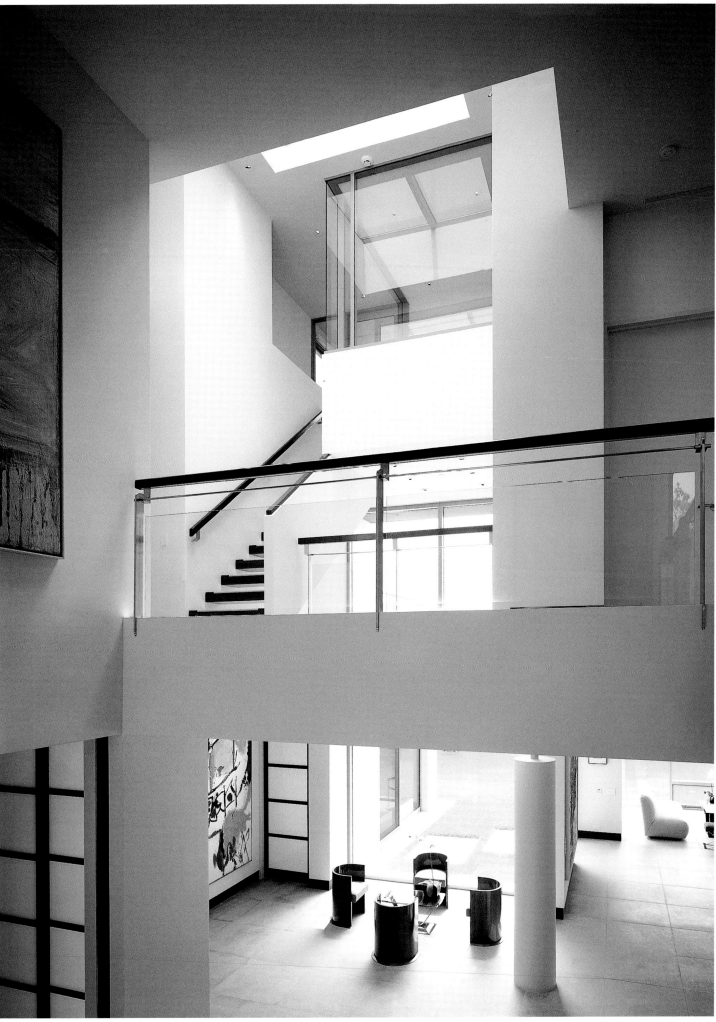

Designing a building is a process of intense collaboration among many people, requiring a program that addresses the needs and opinions of many voices. Creating a work of art is usually more singular in nature; with the exception of commissioned works, the artist is generally not required to answer to clients and various approval agencies as part of the design process.

Connecting the human experience to a structure is a marriage of art and science. The interactive practice of architecture is a proactive process, a constant exploration of space, form, materials, and technology. It also requires an ability to listen, to observe, and to nurture an awareness of how people live and how they desire to live.

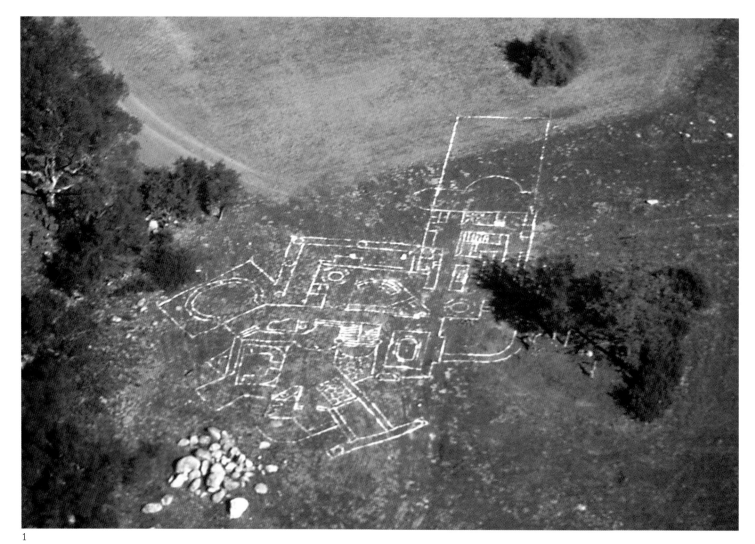

1

2

1 Floor plan drawn on site, Westen Residence, Santa Barbara, California, 1989
2 Macduff Everton, *Callamish Stone Circle, Isle of Lewis, Outer Hebrides, Scotland, 1997*
3 Rear view with gardens, Westen Residence

One of the closest collaborations and most dynamic design experiences during my career was that of working with the Derek and Beth Westen family in creating their home. They were intimately involved in every step of the design. Following months of sketching, the Westens chalked the house on their site to better understand its relationships to the surrounding landscape.

The drawing on the landscape near a cluster of rocks (opposite top) conjured visions of archeological sites and of some of the mystical stone monolith sites in Britain (see opposite bottom). This sense of ceremony offers a parallel to the Westen's personal sense of ritual and process.

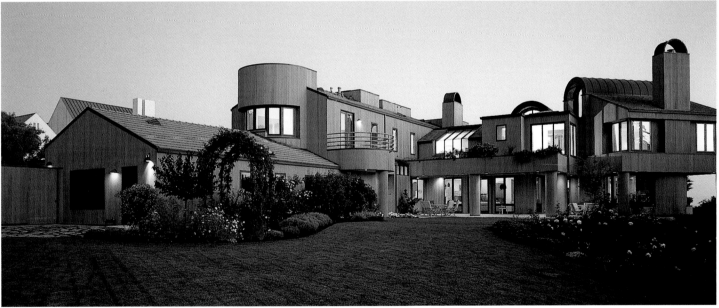

3

I have long approached design from the inside out. Architectural design that starts from a given exterior shape and moves inward risks neglecting the needs of the people within. I find the resulting building is more successful when the external form of the structure follows the form of its interior spatial relationships. The materials used in the Westen Residence unify the forms and functions of a home that is a sculpture for living in. Like folded paper, exterior forms describe interior spaces.

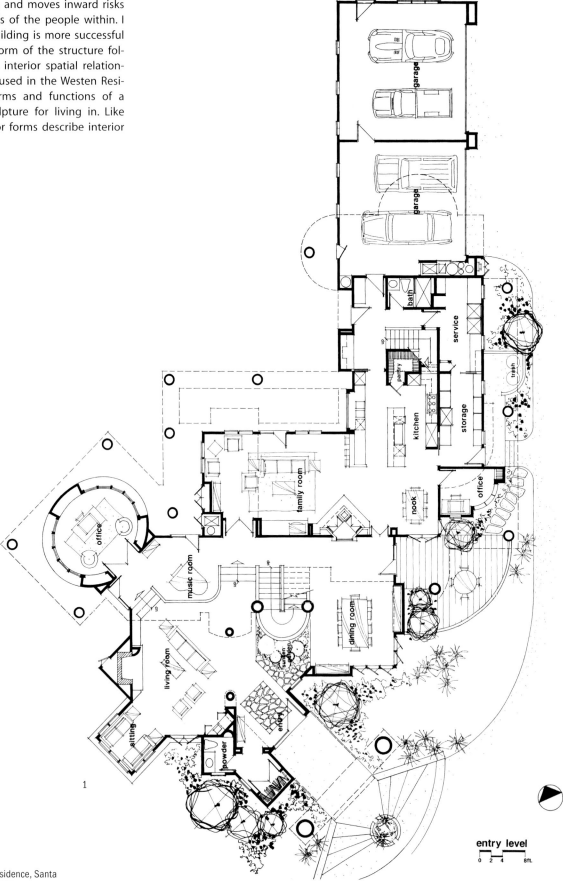

entry level
0 2 4 8ft.

1 Floor plan, Westen Residence, Santa
 Barbara, California, 1989
2 Living area, view to dining room showing
 central stairs and overlooks
3 Entrance detail

110

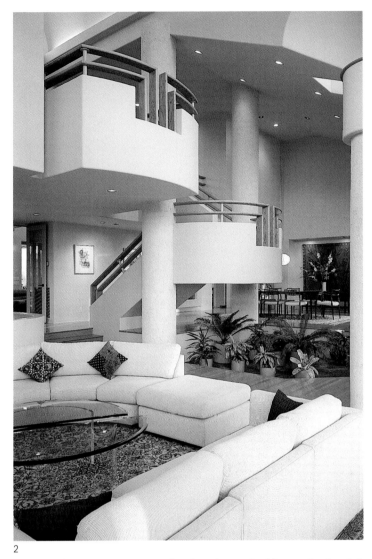

2

3

As part of the design process for the Westen Residence, the family's three children contributed notes and drawings of how their ideal rooms would function in the house. By including the children in the process, the parents encouraged their creative spirit and sense of importance.

At times, the tremendous energy evidenced by all the members of this family reminded me of charged particles. I imagined the central living area as a reaction chamber, where particles collide, fuse, and bounce apart again. I visualized an interior landscape giving free rein to the unique character of this dynamic family. Fluid spaces, soaring volumes, and elevated platforms offer continuously changing views of sculpted spaces (see above).

One of the tasks of architecture is to bring order to the chaos of family life, connecting generations through the orchestration of form. The structures that we live with have great influence over our lives—they construct patterns through which we see the world.

A home's design is a platform for activity, a stage set for the drama of living. Interior form, when carefully articulated, stimulates the senses of those within. A well-designed home both encourages interaction and respects individuality.

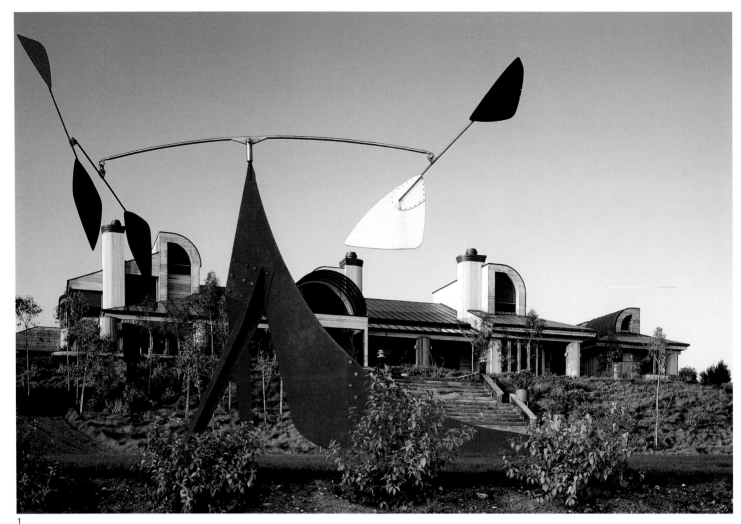

1

Via Abrigada was a home I designed for my family in Santa Barbara, California. In the design of this home a primary challenge was to take advantage of spectacular vistas, while providing broad, evenly lit wall surfaces for viewing works of art. The proportions of the house were designed to accommodate large paintings. Clean, uncomplicated detailing and a limited color palette allow the interior to serve as a backdrop without competing with the art (see opposite). High vaults bring light onto expansive interior walls and into living spaces, while the south-facing window wall opens to ocean and island views.

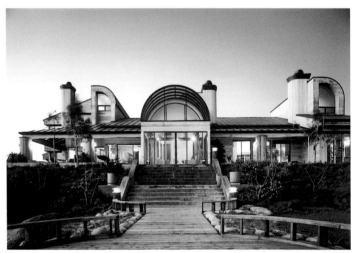

2

1 Via Abrigada, Santa Barbara, California, 1983, complemented by Alexander Calder's sculpture, *Fafnir-Dragon II*, 1969
2 Coastal view
3 View from entry
4 View from entry to dining room with stairs and sculptural landings

A compositional balance between social areas and intimate spaces animates the house. The repeated arc and cylindrical forms in this home are connected to the forms of the farmhouses in Chapter 2. These connections and the patterns derived from repeating forms unite horizontal and vertical planes, bringing logic to this complex composition. The resulting spatial organization is not reliant upon a structured formula. It is akin to an organic sculpture — stimulating, unpredictable, inviting interaction.

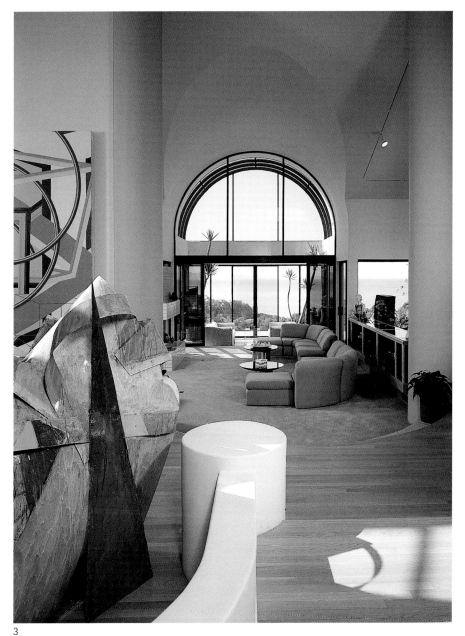

3

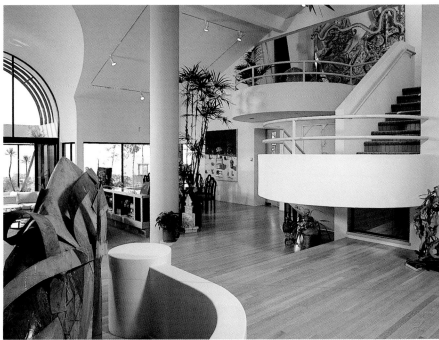

4

1

The majestic display of natural forces on the Carmel coast of California
inspired the design of Spindrift Cove. The painting *Castle in the Pyrenees*
by Rene Magritte (above), with its surreal vision of a precarious balance
between architecture and natural forces, suggested to me a parallel
with this dramatic site.

1 René Magritte, *Castle in the Pyrenees*, 1959
2 Spindrift Cove, Carmel, California, 1997, aerial view
3 Living room showing arced ceiling, Spindrift Cove

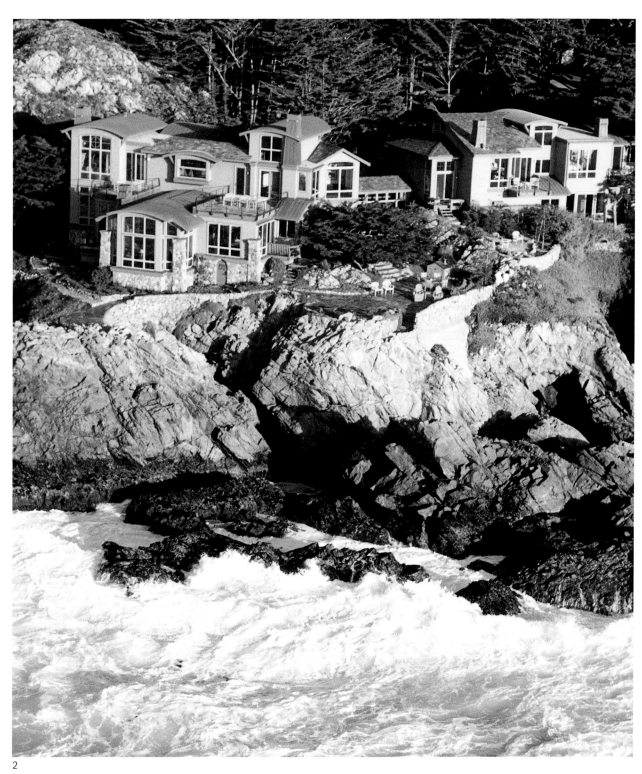

2

Each building component takes its axis from a cove, orienting staterooms and primary living areas toward spectacular views of waves crashing over rocks. Design elements evoke images of the high seas: arced copper roofs suggest billowing sails; polished woodwork is reminiscent of finely crafted ships' cabins; and a decorative motif based on the four points of a compass is worked into windows, railings, and lanterns. From the main salon, wide views framed by curved ceilings conjure a sense of riding on the waves (right).

Seen at ground level, Spindrift Cove is anchored by a strong stone base. Facing a volatile seascape, the structure feels securely wedded to its rocky site.

3

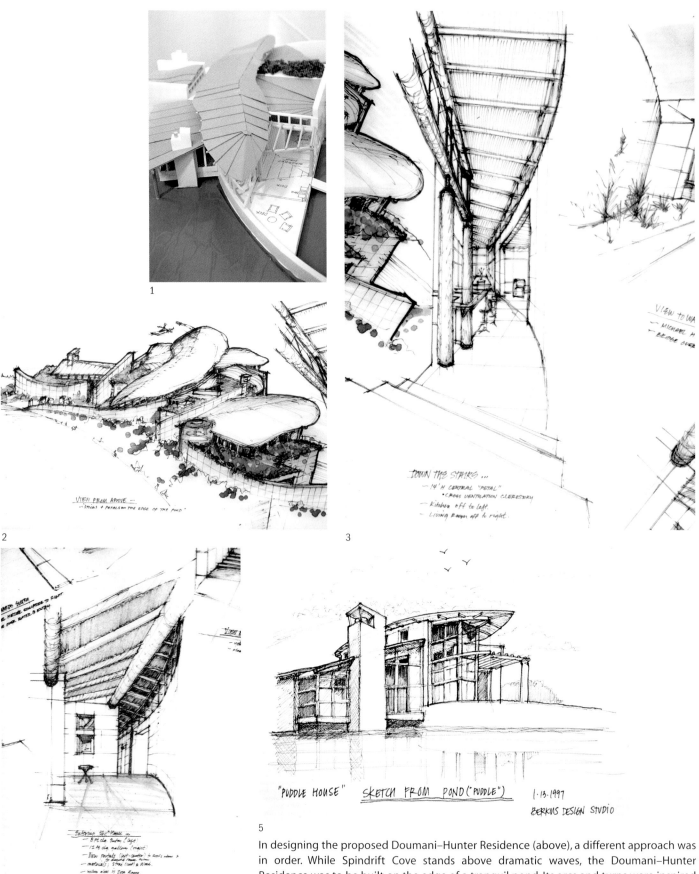

1

2

3

VIEW FROM ABOVE —
~ STICKS + PETALS ON THE EDGE OF THE POND

DOWN THE STAIRS …
— 14'H CENTRAL "METAL"
• CROSS VENTILATION CLERESTORY
— Kitchen off to left.
— Living Room off to right.

VIEW TO WA
~ MICHAEL H
~ BRIDGE OVER

4

"PUDDLE HOUSE" SKETCH FROM POND ("PUDDLE") 1·13·1997

BERKUS DESIGN STUDIO

5

In designing the proposed Doumani–Hunter Residence (above), a different approach was in order. While Spindrift Cove stands above dramatic waves, the Doumani–Hunter Residence was to be built on the edge of a tranquil pond. Its arcs and turns were inspired by an image of leaves floating on the surface of the water. As I held a leaf-like ceramic piece in my hand, I saw, in the way my palm fit around the edge, the forms of this dwelling. As the design progressed, the series of curved roof lines brought to mind the strength and sensitivity of Japanese structures.

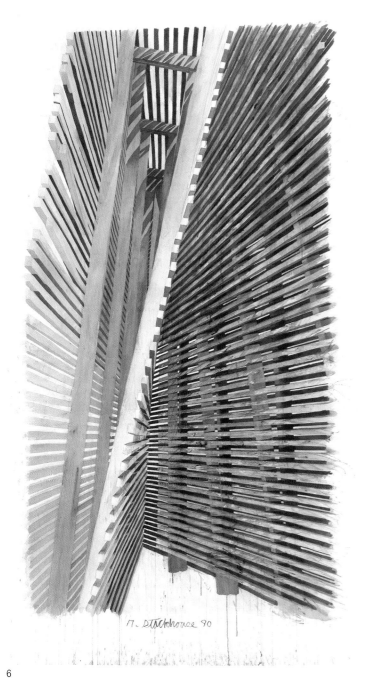

During framing, the knitting together of structure sometimes offers moments of inspiration. When the joinery of components creates sculpture, I want to stop the construction process, leaving exposed the craftsmanship that will later be concealed within the finished product.

There are times in the making of a work of art when the piece, while in progress, is as compelling as the end product.

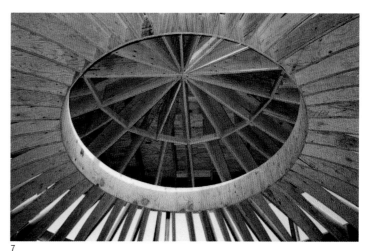

7

8

With the principal design goal of merging interior and exterior spatial relationships, architectural elements of the Yagoda Residence (above) maximize views and natural light sources to bring the outdoors in and create an ambience of tranquility. Close to the desert terrain, the building suggests sculpted forms rising from the earth.

In the deserts of California and Arizona, you can find many houses that are designed as wings that hinge together, conjoining at angles that often seem awkward. With this phenomenon in mind, we designed the Yagoda Residence with a rotunda as a central axis and focal point. Anchored by the rotunda, the arms of the residence constitute a whole that is complex and varied, but which unfolds in clearly discernable paths to destinations within.

6

1-5 Conceptual drawings, proposed Doumani-Hunter
 Residence, 1998
6 Robert Stackhouse, *Approaching Blue Diviner*,
 1990
7 Construction photograph of rotunda, Yagoda
 Residence, Scottsdale, Arizona, 1999 (in progress)
8 Model, Yagoda Residence

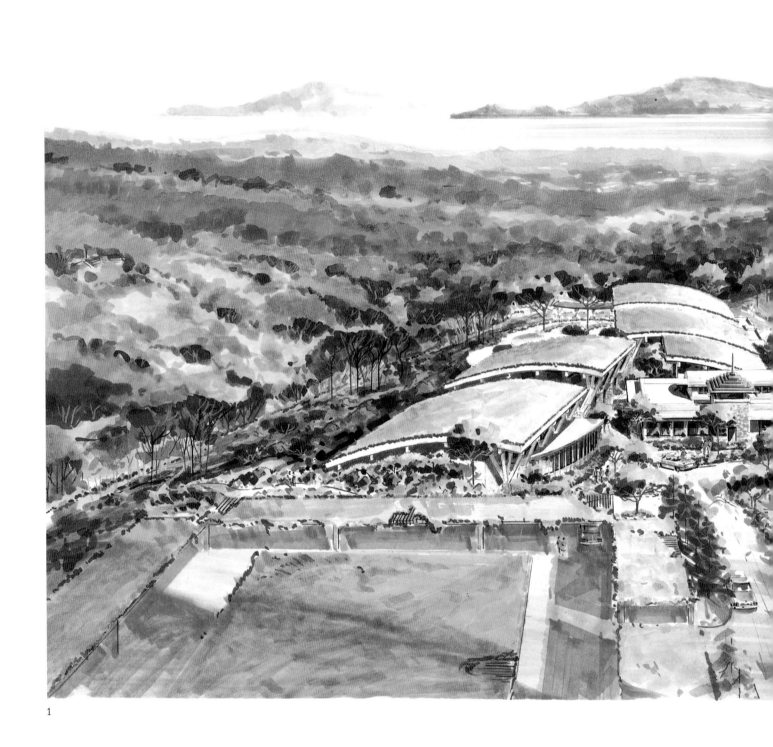

1

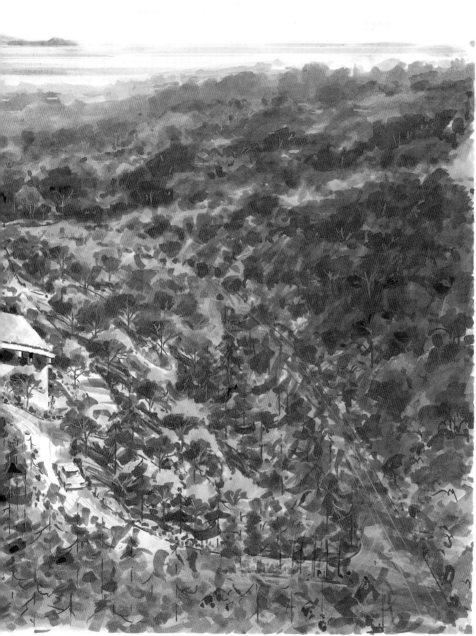

The Santa Barbara Botanic Garden is an abstraction of the landscape. Intended to remind us of our connection with the natural environment, the building forms embody the characteristics of the rugged site.

The clients requested the design of a science and learning center on a ridge surrounded by drought-resistant vegetation. My first diagrams were of a partially earth-bermed cluster sustainable in its setting. Supported by columns inspired by native trees, the forms rise gently, covered in indigenous growth (left).

To the Garden Entry Approach

WEST ELEVATION

1 Proposed Santa Barbara Botanic Garden complex,
 Santa Barbara, California, 1999 (in progress);
 illustration by August Zamolsky, B3 Architects +
 Planners
2 Garden entrance elevation

2

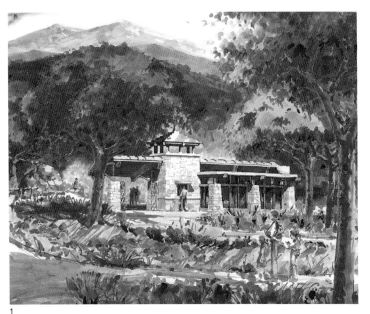

1

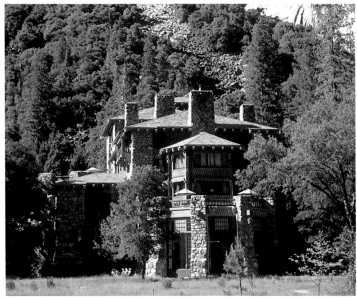

2

A base camp for a scenic adventure, the Santa Barbara Botanic Garden Learning Center building complex signifies arrival at a rustic destination. Crafted to sit comfortably in the landscape, the forms and materials recall Gilbert Stanley Underwood's buildings at such United States national parks as Yosemite, Bryce, and Zion. Respecting the materials of the outdoors, his work demonstrates how structures can function comfortably in a wilderness setting, forming rustic shelter with a sense of strength.

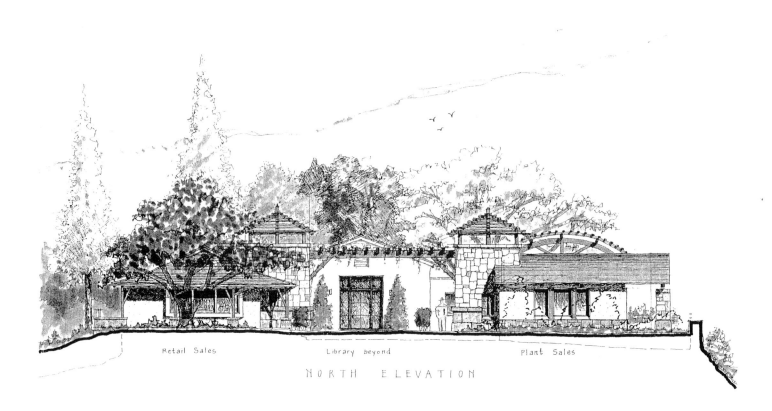

Retail Sales Library beyond Plant Sales

NORTH ELEVATION

3

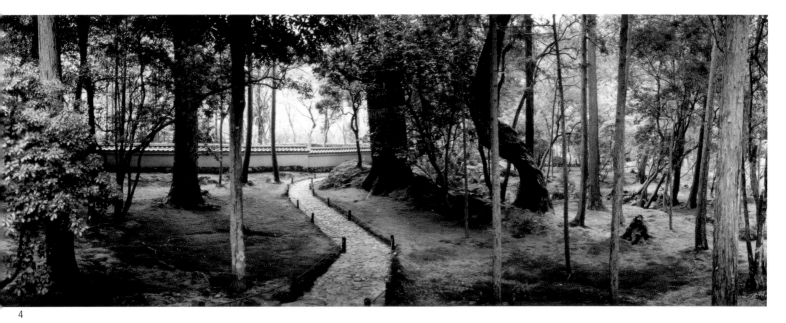

4

Designed to blend with its gardens and terrain, the Santa Barbara Botanic Garden Learning Center utilizes earth forms and natural rock found in the area. The walks and trellised structures of the Botanic Garden extend an invitation to travel through the composition of the landscape.

In art and architecture, much attention has been paid to human interaction with the landscape. Macduff Everton's photograph of a Japanese garden (above) invites contemplative exploration, its distant light suggesting the discovery of new destinations.

1 Illustration of garden entry, proposed Santa Barbara
 Botanic Garden complex, Santa Barbara, California,
 1999 (in progress)
2 Gilbert Stanley Underwood's Ahwahnee Lodge (1927)
 at Yosemite National Park
3 Elevation of visitors' center, proposed Santa Barbara
 Botanic Garden complex
4 Macduff Everton, *Moss Garden, Saiho-ji, Kyoto, Japan*,
 1999
5 Preparatory sketch by the author for Santa Barbara
 Botanic Garden
6 Elevation of learning center, proposed Santa Barbara
 Botanic Garden complex

5

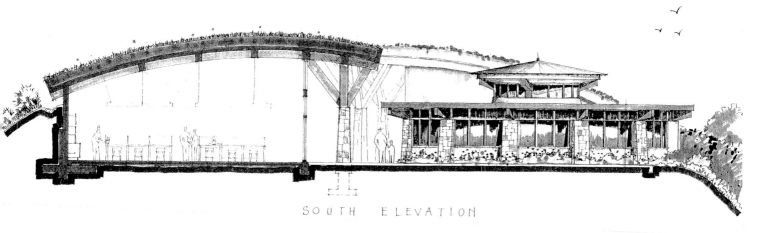

SOUTH ELEVATION

6

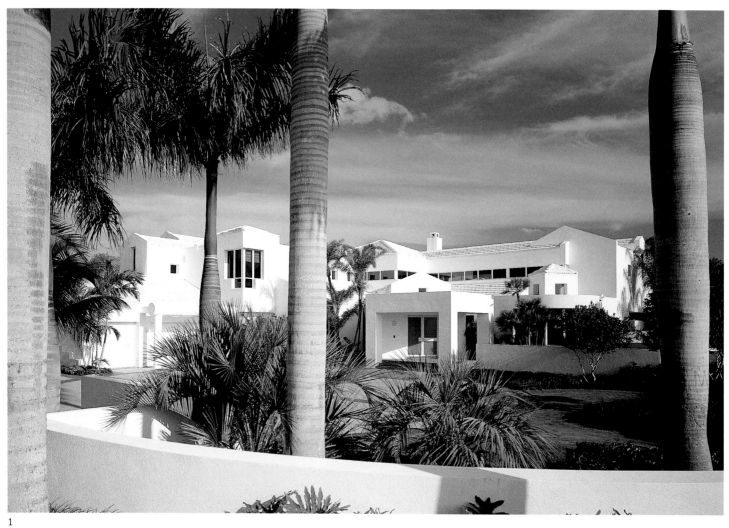

1

The custom home client is often in a position to take aesthetic strides. Such was the case with Stephanie and Ned Siegel. We strove to integrate the clients' exquisitely modern design sensibility with their unconventional sense of humor.

The exterior of the Siegel Residence conveys an impression of a village—a diverse composition of forms that defines the arrangement of interior spaces. As a shell with a steel skeleton, the structure allows interior walls to be liberated from their structural function encouraging a sculptural treatment of interior spaces that flow unimpeded into one another.

A minimal color palette further unifies the complex arrangement of rooms. Planned to the last detail, this home is entirely consistent in aesthetic. All surfaces are white, black, or brushed aluminum, which required that many elements be custom made. An airplane manufacturer, for example, fabricated metal cabinet doors, and light fixtures were specially powder-coated. Living room furniture (seen on following pages) was custom-designed by Paul Tuttle.

The brilliant skies of south Florida create a dramatic setting for a structure whose dynamic geometry and clean surfaces recall the tenets of Modernism. Blue skies filled with white clouds are captured in high clerestory windows, becoming a constantly moving organic composition in juxtaposition to the hard edges of the structure. The residence achieves a balance between complexity and elegance, and it is as enjoyable to me today as it was at the date of completion.

1 Exterior showing low encircling wall, Siegel Residence, Boca Raton, Florida, 1989
2 Exterior featuring sculptural "wave wall"
3 Geometric corner windows
4 View of rear from open structured pool cabana

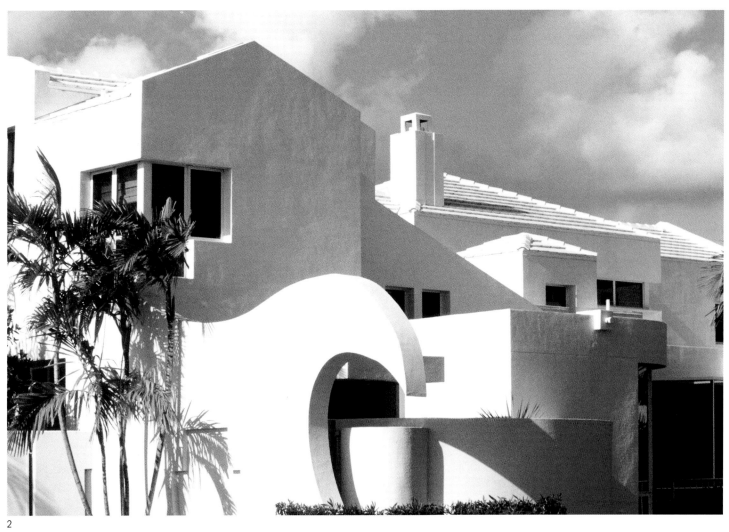

2

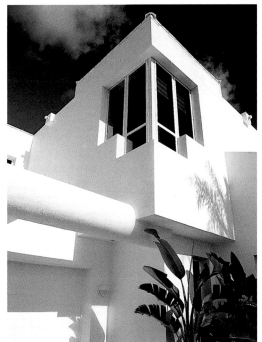

3

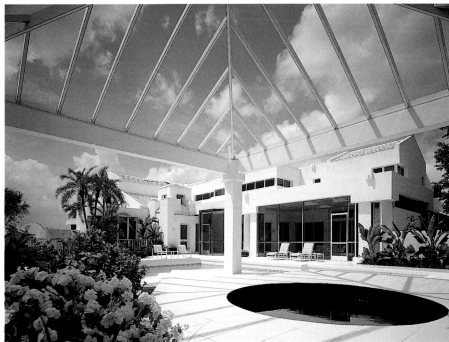

4

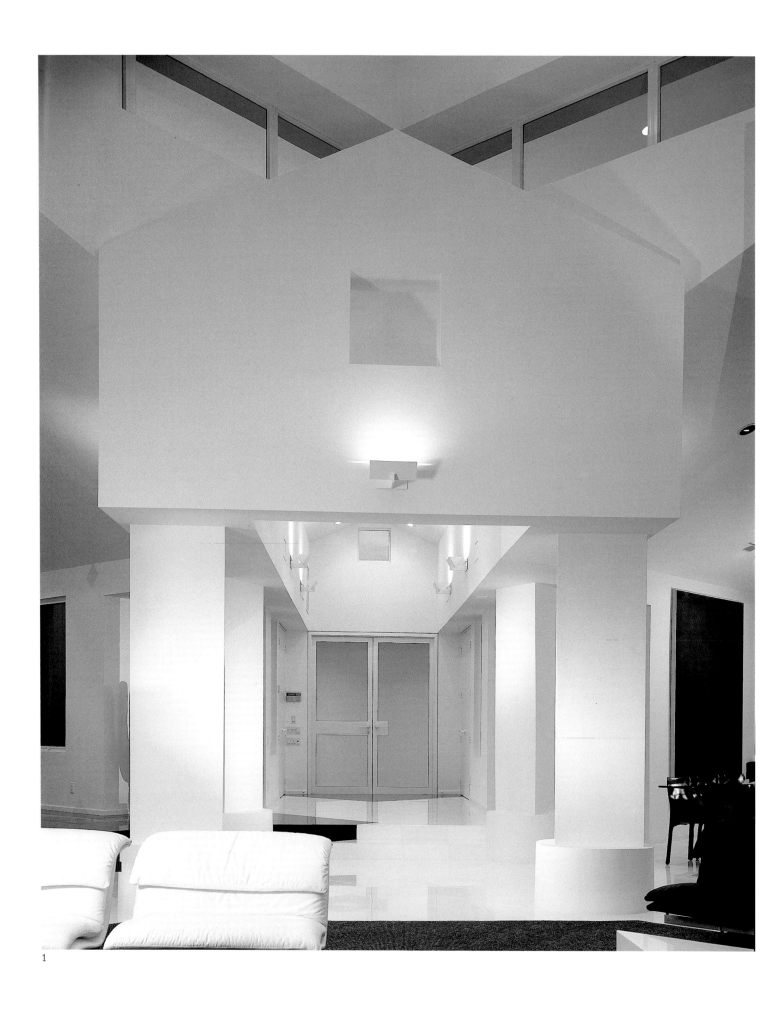

1

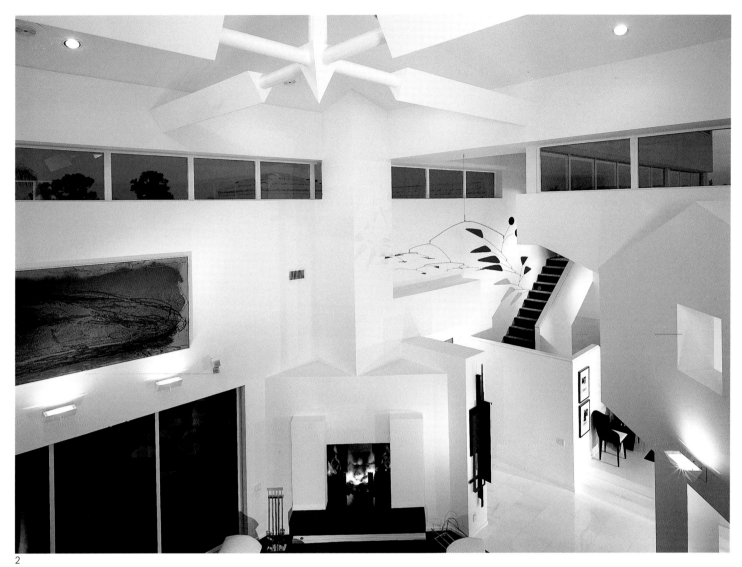

2

In the Siegel Residence, the suggestion of a building within a building becomes the entrance portal to the main living area and circulation routes (opposite).

Steel ties inside the 30-foot-high vaulted ceiling of the living area are sculpted to resemble an oversized ceiling fan, which the client said provided "propulsion" to the central space (above). Like the "wave wall" outside, this element stands as a subtle gesture of levity, easing the hard-edged unity of the building. These iconographic elements humanize the otherwise pristine statement of this building by introducing familiar forms with a sense of humor.

Interiors were designed with my daughter, Carey Berkus, to advance the clients' interest in bold, clean-lined contemporary artwork. Works in their collection by such artists as Kenneth Noland, Jules Olitski, and Alexander Calder benefit from a bright, spacious setting. Here, art becomes essential to the composition of space because the "container" is designed to recognize its importance. Connecting art and architecture through deliberate gesture enriches the existence of both.

3

1 Entrance portal, Siegel Residence, Boca Raton,
 Florida, 1989
2 Living area with decorative "ceiling fan" detail
3 Stair wall with custom furniture by Paul Tuttle

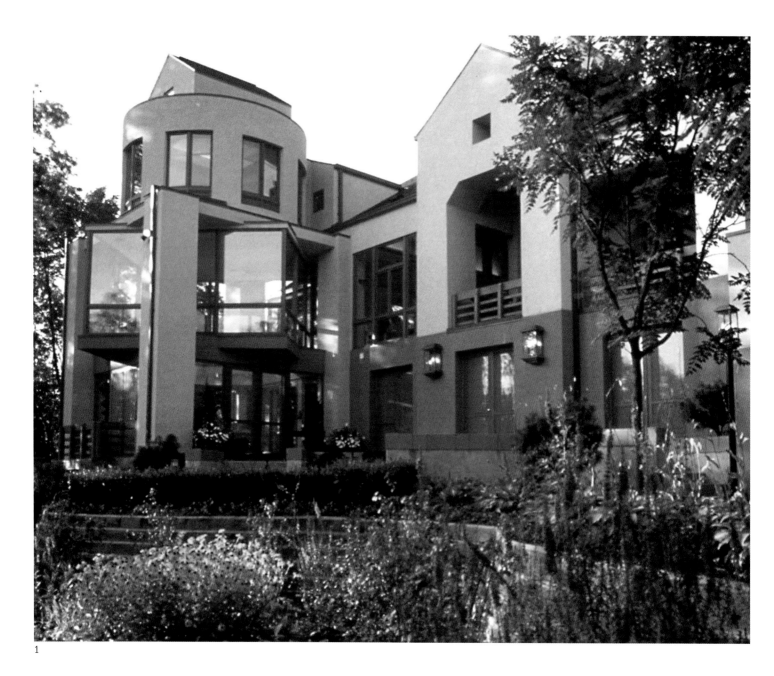

1

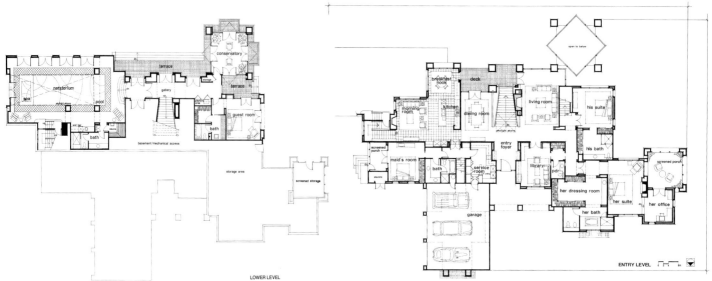

2 3

LOWER LEVEL

ENTRY LEVEL

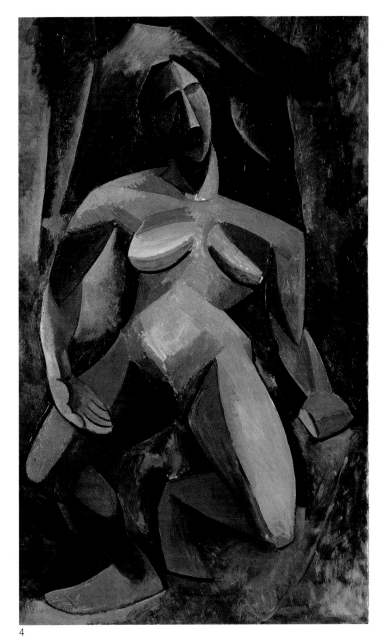

4

Houses tell different stories about the people for and with whom they are designed, and some buildings are more forthcoming than others. In the case of the Wade Residence (opposite), the activities conducted inside the home evidence themselves in the design as seen from the outside.

A futurist by profession, Gordon Wade assists major corporations in preparing for anticipated social changes. Thus, we designed a "tower of knowledge" (left, see also pages 10–11), which holds the client's office on its third-story level. It is an elevated platform for spotting trends on the horizon. The angular, geometric composition of this feature evokes the innovative thought required by the client's work. The rotation of the glass box form suggested to me the variety of angles found in Cubist paintings and sculptures.

In an early letter, the client proposed, "If I can go from bedroom to conservatory to swimming to morning coffee in an adventure of interior space, and work in an office flooded with sunlight, I will cast rose petals in your path." We conceived this home as a journey, a series of interior destinations stepping down a hillside on three living levels.

The house becomes a formal abstraction of the animated lives inside, as well as a portrait of the processes and of the personas involved in the design. External form is a vital concern, but it comes as a consequence of an effective arrangement of living and working spaces: the home is truly designed from within.

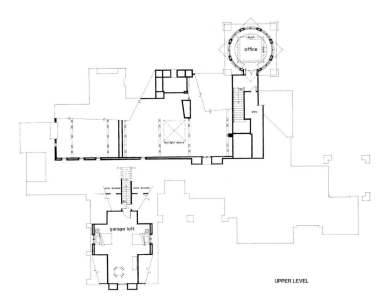

UPPER LEVEL

5

1 Rear facade featuring "tower of knowledge," Wade
 Residence, Villa Hills, Kentucky, 1992
2 First-floor plan, Wade Residence
3 Second-floor plan
4 Pablo Picasso, *The Dryad*, 1908
5 Third-floor plan

1

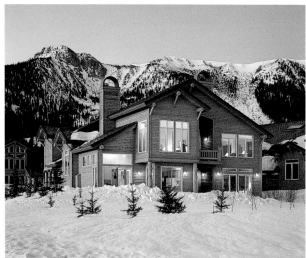

2

3

4

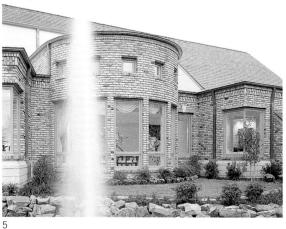

5

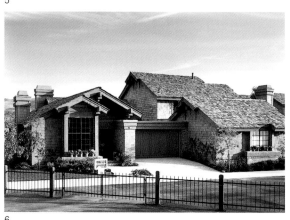

6

7

One of my deepest motivations is to extend what I have learned in the custom design of residences toward improving the quality of production-built housing (see opposite). My ultimate goal is to make good architecture attainable to many different kinds of people.

Designing housing for unknown clients in project architecture presents a complex set of challenges. Far from being anonymous design, the process requires anticipating the wants and needs of many people; it means answering to many voices rather than responding to an individual's request. Bringing architecture to a greater audience and introducing artful form within confined budgets have been stimulating challenges and opportunities during my career.

The connection of home to neighborhood and neighborhood to community is of great interest to me, as is extending the notion of designing from the inside out, from individual plan to broader community. I see a parallel interest in these relationships in Ed Rusha's *Yes/No* (above).

Examples of detached production homes:
1 Ocean Colony, Huntington Beach, California, 1998
2 Snowcreek V, Mammoth Lakes, California, 1991
3 The Oaks in Long Canyon, Simi Valley, California,
 1998, showing tiled staircase
4 View of entry, Ocean Hills Villas, Oceanside, California,
 1989
5 Garden facade, New American Home, Dallas, Texas,
 1987
6 Streetscape, Turtle Rock Highlands, Irvine, California,
 1979
7 Ed Ruscha, *Yes/No*, 1990

1

In designing Studio Colony, we wished to create an urban apartment complex whose modern design vocabulary was approachable to many. Its grid patterning is a colorful metaphor for the building blocks of a city. Color blocking energizes the prevalence of the grid throughout the complex: patterns of gray enliven the facade and awning details break the plane at staggered levels. The clock tower establishes a matrix of order, playfully indicating its role as an organizational reference point for this urban village (left).

Like Sol Lewitt's sculpture (above), urban design often employs the grid as a standard of order. In designing urban communities, reference points and variation in patterning can add life and humanity to the framework of the grid.

2

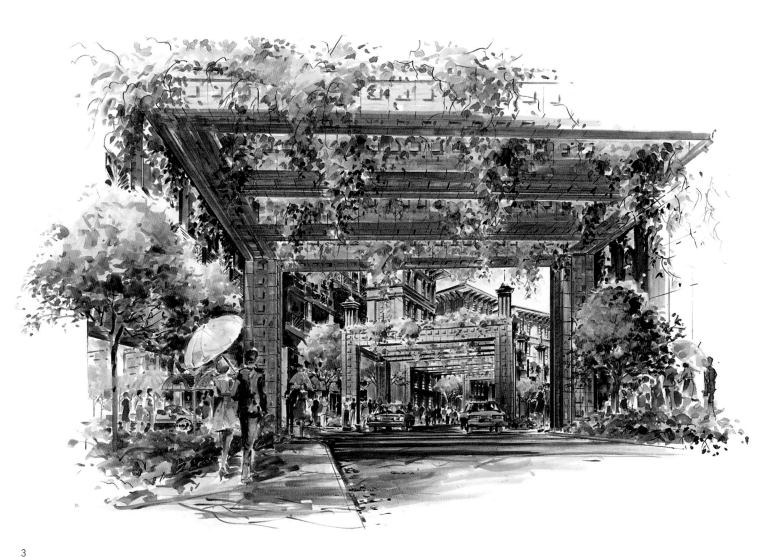

3

Portales is a high-density housing complex proposed for Scottsdale, Arizona. In developing the concept for this project, our team of architects and planners studied the history of land use patterns in the region. Recent decades of rapid growth have resulted in expansive development and homogenous suburban sprawl. This project promotes a positive trend in housing by encouraging high-density living in the downtown Scottsdale area

Flight from the cities is a widespread problem challenging us to reweave the abandoned urban core. Attracting people to pioneer in moving back to downtown demands that we redefine the rewards of a mixed-use urban setting. This requires a vision of the city as an organic entity that will grow and recede over decades. The creation of artists' studios and live-work environments can connect life within the urban core and address many of the physical ills present in communities worldwide.

The residences at Portales introduce a living platform for the creative; mature and young alike. A unique detached studio or home office stands across a pedestrian walkway from a group of living units, encouraging a zero-commute workspace. Anchoring the project is a central structure whose crescent shape creates an expressive urban form coordinating the outside corridors and thoroughfares.

Extensive gardens within the project provide balance, enlivening the built community with natural elements. Pedestrian walkways and open spaces provide relief within an urban landscape. The punctuation of open spaces, placement of points of reference, and patterning of the ground plane contribute to the creation of a vibrant community.

1 Sol Lewitt, *Three x Four x Three*, 1984
2 Pool plaza with clock tower, Studio Colony, Studio City,
 California, 1987
3 Preliminary illustration, Portales, Scottsdale, Arizona,
 1999 (in progress)

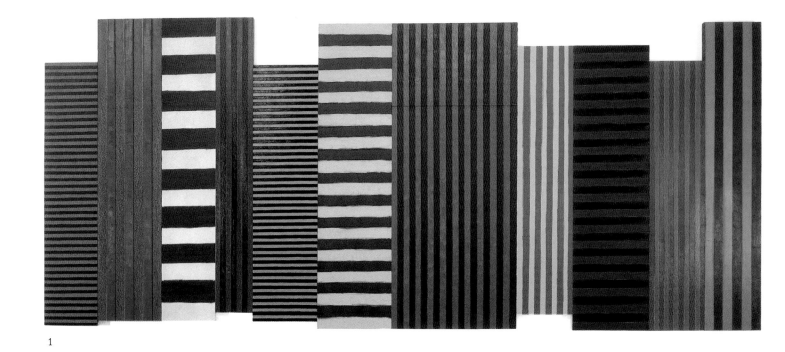

1

In the successful design of a dense urban living environment, the overall pattern of structure, materials, and color must protect individual identity, with an orchestration of form both harmonious and unique. Contextually, we must heed the directives of the past, as well as the voice of the present.

Sean Scully's canvas entitled *Backs and Fronts* (above) becomes a series of urban structures. It is a unified composition of individual structures, each distinct in its geometry and color. As I travel, I find myself visually transposing such abstract patterning over the downtown fabrics of various cities.

1 Sean Scully, *Backs and Fronts*, 1981
2 Proposed detached townhomes, Playa Vista, Marina
 del Rey, California, 1999 (in progress)
3 View of proposed Pacific Promenade townhomes,
 Playa Vista

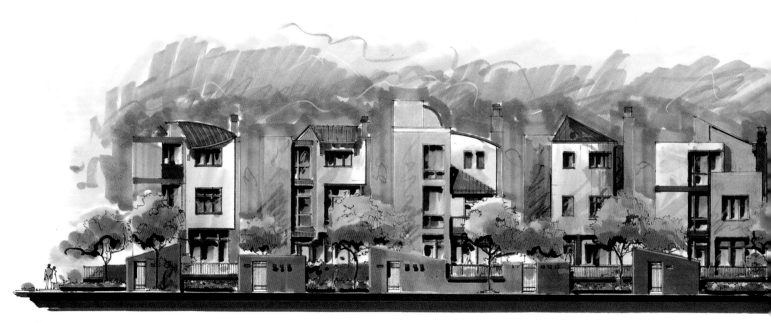

2

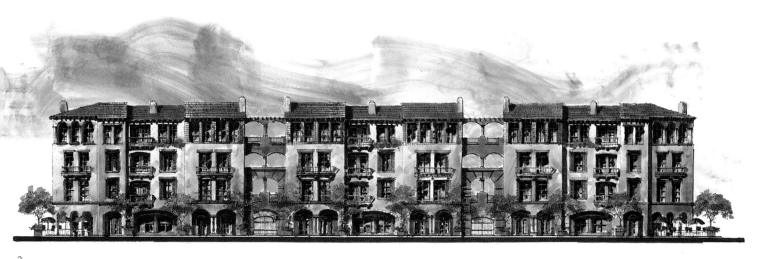

3

A collaborative venture engaging many architectural firms, Playa Vista promises exciting prospects in urban housing (see above and below). Located in Marina del Rey, California, the community as a whole is planned to tie together smaller neighborhoods, each with a distinct character. Our designs for this proposed project include a series of detached homes and a mixed-use project that has shops and places of business on the bottom floor and lofts on the stories above.

The ten residences we designed for Playa Vista (below) are conceived as individual structures. They depart from convention through the use of varied forms whose shapes, colors, and textures speak to one another as well as to the street. Thoroughly contemporary in design, they incorporate modern styling with materials that make them friendly to live with. A gathering of attached lofts (above) integrates the sensibility of traditional European towns into a modern setting. Window openings punctuate building envelopes and announce life within.

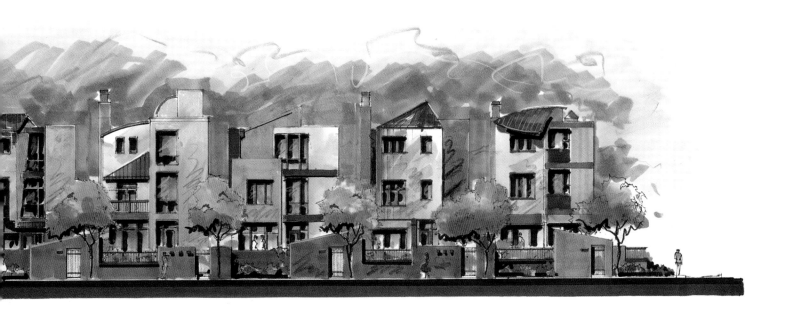

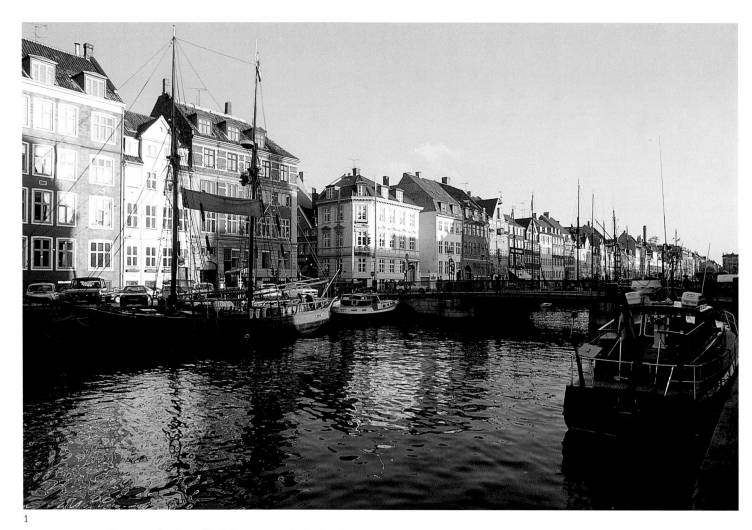

1

The organization of buildings around a body of water creates an attractive shared edge to connected living spaces. Like a pond or lake, the waterscape is inviting and soothing to traverse with the eye, yet it indicates the security provided by a protective boundary.

I feel tension release when I approach the water's edge. Time seems to pass a little more slowly as I watch the movement of a floating leaf.

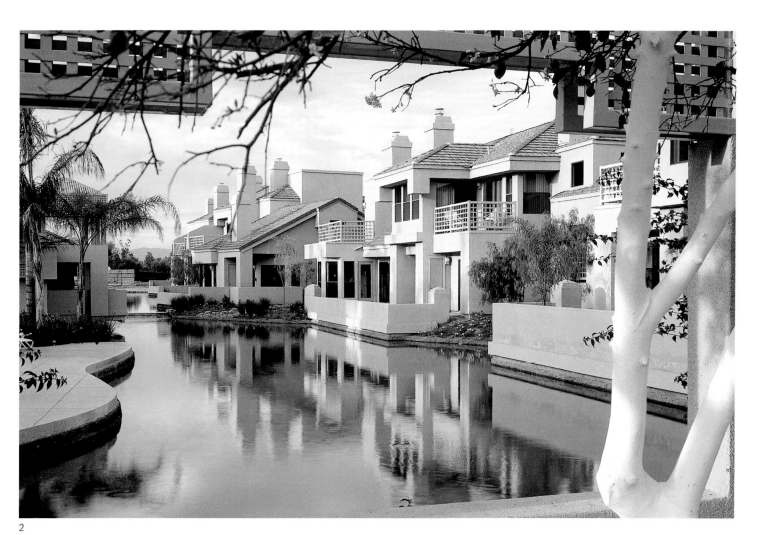

2

Buildings stand tall at the water's edge. In reflection, they become a fluid palette that dances with the movement of the air. Integrating structures with a body of water creates a continually changing foreground. Fluctuating patterns of color and form shift with the time of day, evoking the passage of seasons, the movement of the clock, and the gradual transitions of the landscape.

The integration of a reflective body of water extends the perception of space between structures in this neighborhood of attached homes at the Pavilions in Scottsdale, Arizona (above).

1 Traditional attached urban housing in Copenhagen
2 Attached residences along central waterscape, The
 Pavilions, Scottsdale, Arizona, 1985

In our plan for the proposed community of Chiricahua at Desert Mountain, Arizona, assemblages of rusticated materials and structures were to create an organic village (below). Melding the warm hues of the desert with strong vertical elements inspired by Sardinian design, the architecture looks as if it has evolved over time. At every step of the design, we have taken great care to preserve the natural topography, drainage corridors, and native saguaro forest.

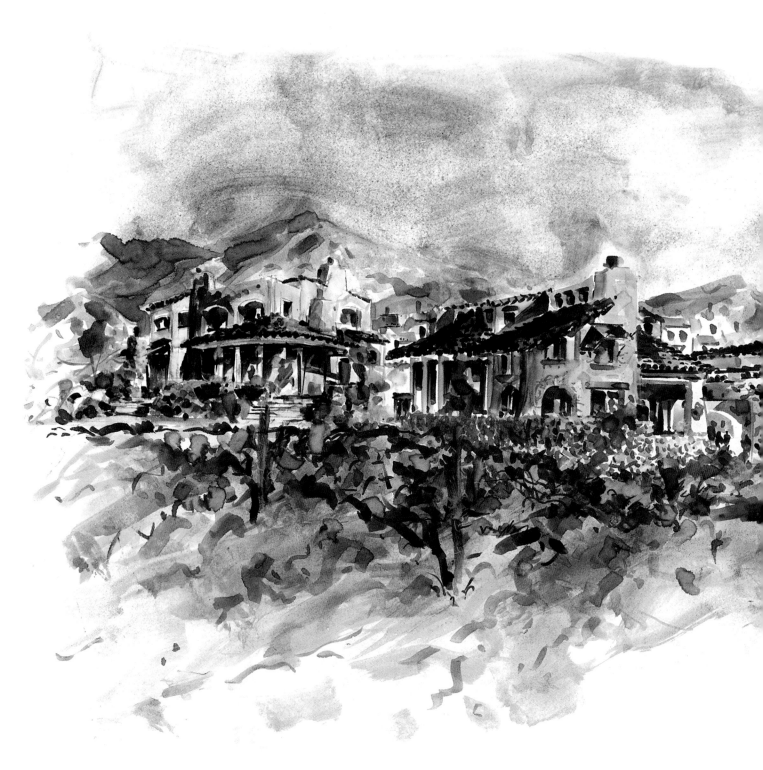

1

The residential community of Chiricahua occupies a mountainscape of breathtaking natural drama. Both in architecture and in planning, the project is designed to work harmoniously with its site. Residential, recreational, circulation, and open spaces maximize views of mountains and rocky outcrops. Parking structures follow the topographical gradient, merging gracefully with the hillside. Materials and color palette follow a consistent desert theme, rustic and rugged.

When complete, life will animate the structures of this hillside village connecting those we have not met with architecture that has occupied our minds for an extended period of time.

As an architect, I enjoy the conceptual stages of the creative process; structures materialize in thought much more quickly than they are realized from plan to fruition. The process, like life itself, is filled with peaks and valleys, ebbs and flows, elation and frustration.

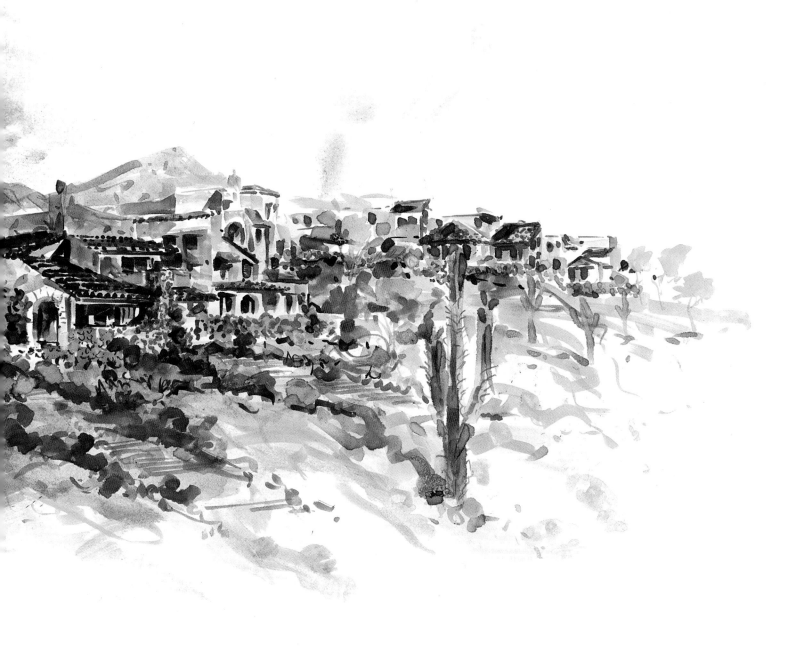

1 Hillside cottages, Chiricahua, Desert Mountain,
 Arizona, 1999 (in progress)

1

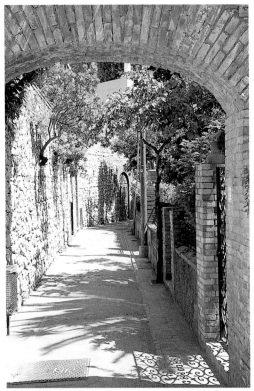

2

4

3

5

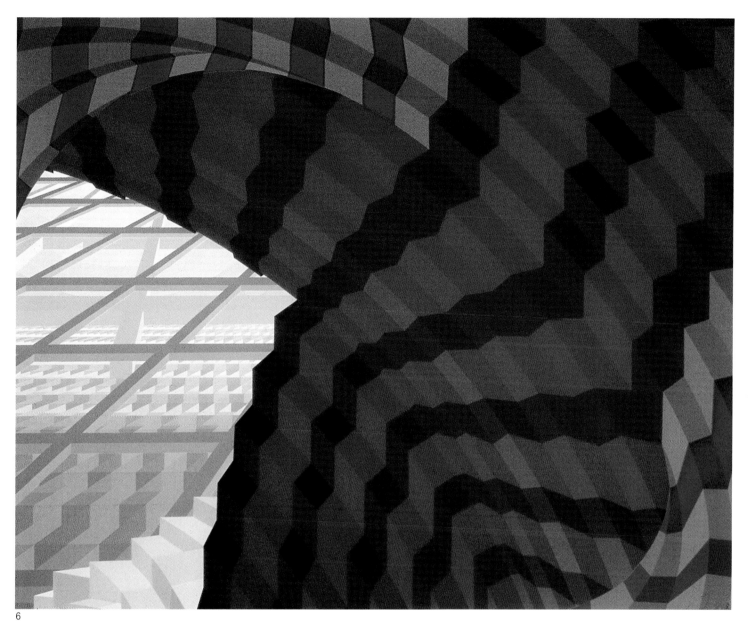

6

A visual invitation to enter is as important in high-density living as in individual home design. I often see parallels in artists' use of forms that draw the viewer into the composition. Al Held has constructed an archway in *Red Arch* (above) that functions like a passage from foreground to background. The courtyard entrances of Ocean Hills Villas (opposite bottom left) and Bella Vivente (opposite bottom right) make the transition from street to living room an exploration of fore- middle- and backgrounds.

1 Ruins of Roman fortification, Capri
2 Stone archway in Amalfi coastal region, Italy
3 Courtyard entry, Ocean Hills Villas, Oceanside,
 California, 1989
4 Untitled watercolor (Positano 1999) by the author
5 Casita and entrance gate, Bella Vivente at Lake Las
 Vegas, Henderson, Nevada, 1998
6 Al Held, *Red Arch*, 1999

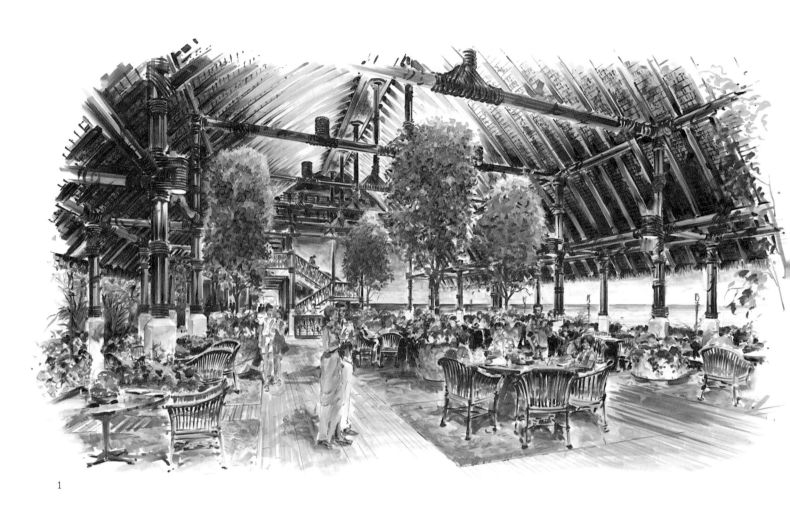

1

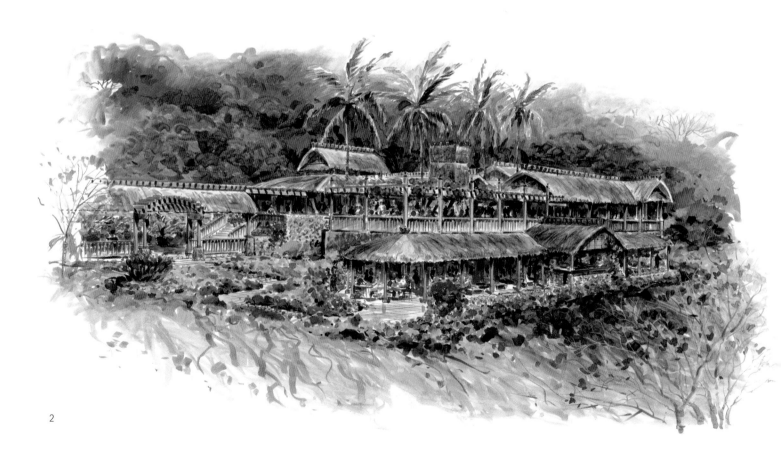

2

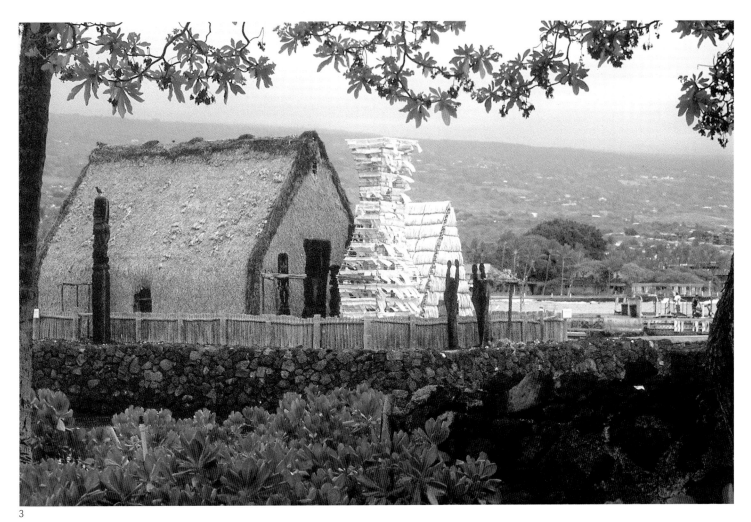

3

An architect who designs structures for different regions bears a responsibility to local traditions: indigenous architectural textures and styles come with reason.

In traditional Hawaiian buildings, unique and recognizable forms suggest the functions they have adapted to serve. The protected gathering areas offered by lanais (verandahs, seen opposite) feature open wall planes that encourage breezes to condition the structure, allowing heat to rise and dissipate. Natural materials offer structural benefits and maintain visual harmony with the surroundings.

Our designs for Hokuli'a are based on architecture indigenous to the Hawaiian Islands. Herb Kāne, a Hawaiian artist who works to preserve local history, consulted with us in incorporating indigenous traditional elements into the detailing of the resort. Intricate sennit lashings, both decorative and functional, draw from centuries-old building methods.

We envisioned the Hokuli'a resort as a sanctuary from the urban center—a destination that enhances the character of its setting, offering its visitors a shift in perspective.

1 Perspective of restaurant, Hokili'a, Kona, Hawaii,
 1999 (in progress)
2 Perspective of resort, Old Hawaii Club
3 Restored historic structures of Pu'uhonua o Honaunau
 National Park

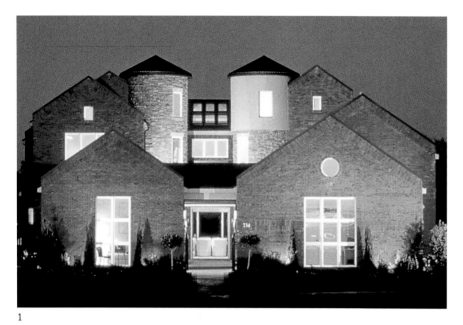

The Connections House was created as a project to investigate systems and conditions in the future. In approaching this task, we considered: How do people want to live, not just in the distant future, but in the next few months and years? How can changes in design make the home more adaptable to the changing needs of the people who occupy it, while providing a comfortable living environment? How can a home that is livable today adapt to changes that tomorrow's technology will bring? The resulting house is both innovative and rooted in familiar imagery.

1

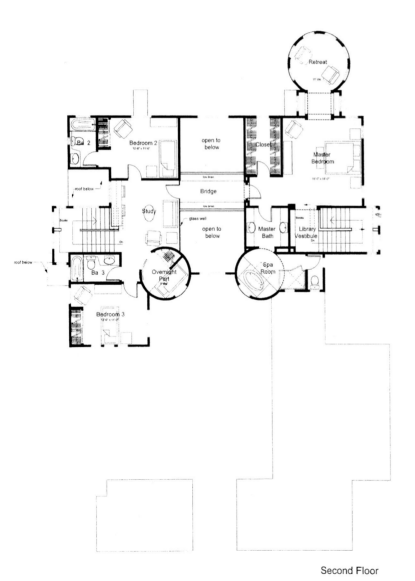

Second Floor

2

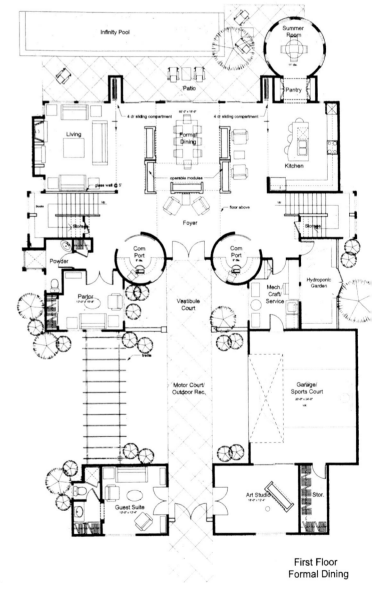

First Floor
Formal Dining

3

4

5

The central thought was to approach the home as platform. Sliding screens and moveable walls (composed of cabinets on casters) can be relocated in moments, allowing the living areas to be intimate or grand, to accommodate four for dinner or a family dinner party of fifty (above). The design attends to all family members, giving children parity with adults. Reached by its own stair, the children's suite offers a study area; in a separate wing, adults have their own retreat off the master bedroom. A bridge links the two wings fostering independence as well as connection within a family. Turrets house communication ports—offices wired for the future—as well as a spa room and children's overnight port. The garage converts to an athletic court. Nuances of structure connect the family members to one another and through technology the home is connected to the outside world.

First Floor
Celebration

6

1 Exterior, Connections House, Coppell, Texas, 1997
2 Second-floor plan
3 First-floor plan as configured for a formal dinner
4 Living area, configured to serve large party
5 Living area reconfigured for more intimate
 entertaining
6 Alternative first-floor plan, configured for large
 celebration

143

1

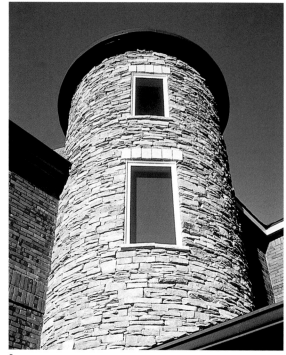

2

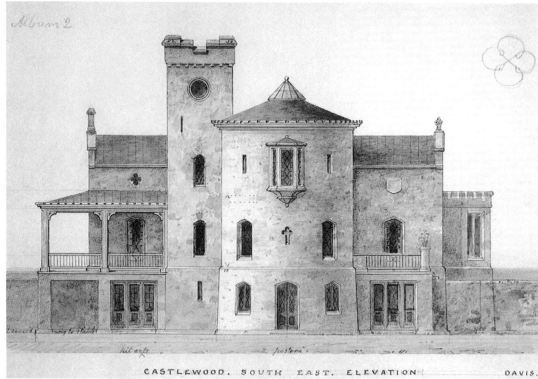

3

CASTLEWOOD. SOUTH EAST. ELEVATION DAVIS.

The Connections House is a village of thoughts about boundaries and connections: between our past and our future; between indoors and outdoors; between family members and generations; between community, workplace, and home. Balancing tradition with leading-edge technology, it addresses an unknown future by taking seriously the many needs and desires of today's families.

We designed and engineered this home to adapt to a family's evolving needs. Expanding and contracting within its walls, the home meets living and working requirements for multiple generations.

4

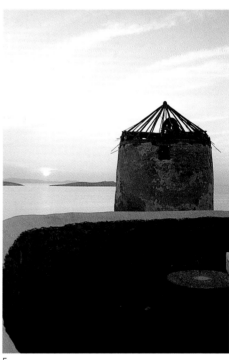

5

1 Children's room with "overnight port" furnished with
 authentic space paraphernalia, Connections House,
 Coppell, Texas, 1997
2 Cylindrical forms suggest connections to the village
 and the farm
3 Illustration of Castlewood for Joseph Howard, New
 Jersey, by architect Alexander Jackson Davis, 1859
4 View through skylight, Connections House
5 Traditional Greek windmill structure

For centuries, the term "folly" has been used to describe certain kinds of architecture, and like the term "art," has meant different things to different people. The whimsical structures found in the great gardens of 18th century France and England were follies created to highlight a beautiful view and to provoke the imagination. Follies are forms following fantasy—a moment to engage in the sheer joy of architecture.

Forms of creative expression can breathe energy into all aspects of life, and I relish opportunities to build for the sake of enjoyment.

When designing for myself, I have been able to play with forms closer to their original inspiration—to be a little more indulgent, giving free rein to abstraction and humor. The gallery I designed for my family's personal art collection, the Art Box (right), was an opportunity to discover new relationships among artworks and to share our collection with others.

I have long wished that more people could be in touch with art as an integral part of their lives. In response, this structure is a whimsical building with a purpose at once joyful and serious: the display and storage of art in an earthquake-prone landscape. A building lies toppled on the hill, a visual play intended to intrigue in a lighthearted manner; it stands in juxtaposition to the serious function of buildings.

With a comparable sense of the absurd, Donald Lipski's *The Yearling* captured its environment in New York's Central Park by presenting objects out of context and out of scale (below). By skewing reality, the artist has invited to us to partake in an adventure, to share in the whimsy of this public sculpture in an urban setting.

1

2

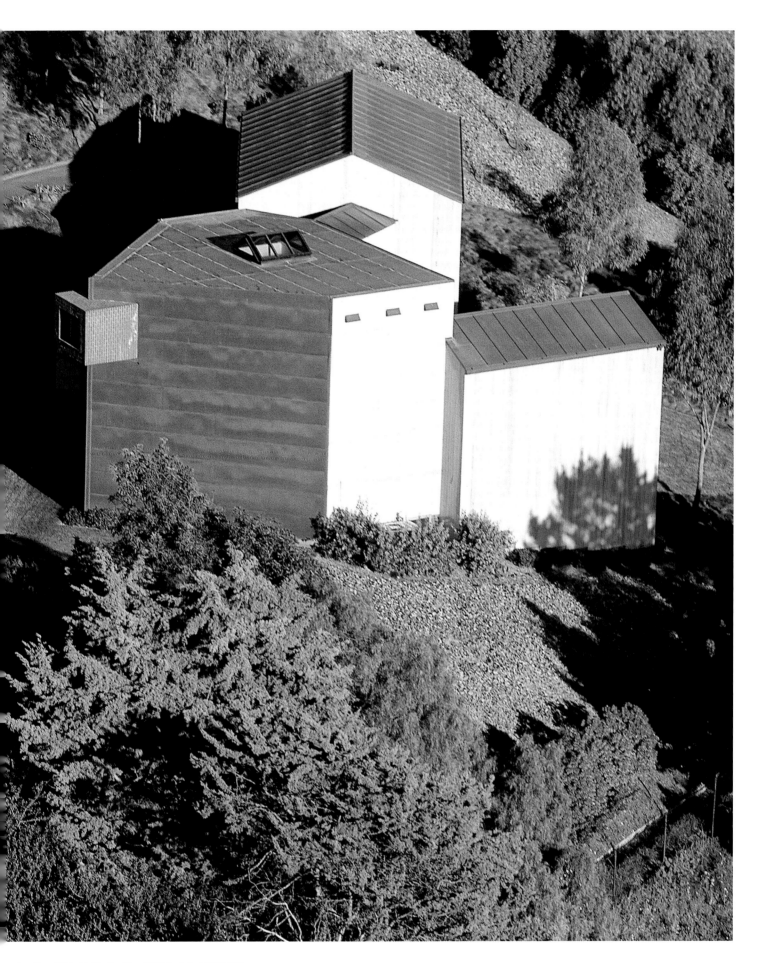

1 Donald Lipski, *The Yearling*, 1992 (installed 1997–98)
2 Aerial view of toppled house form, Art Box, Santa Barbara,
 California, 1983

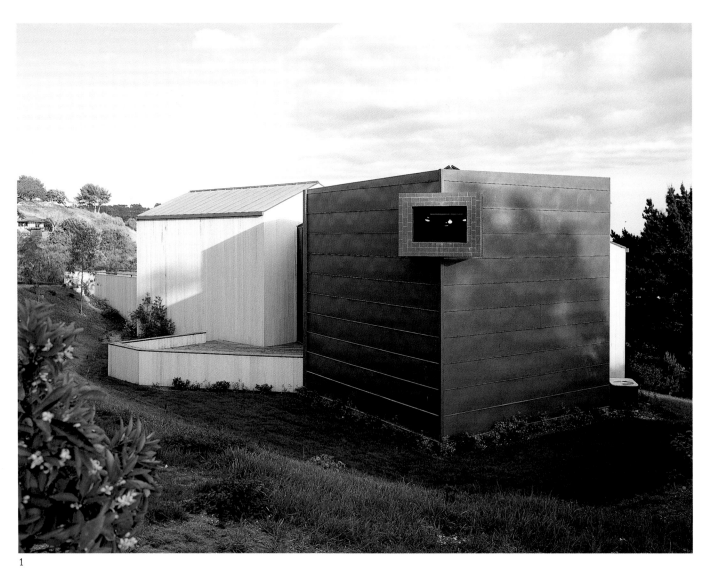

1

2

Conceived as an architectural folly, the Art Box (above) consists of two adjoining "monopoly houses," one upright, one tipped, so that roof becomes wall, chimney becomes window, and window becomes skylight. At rest on its side, the main gallery of the Art Box has been sacrificed to the earthquake gods, hopefully assuring safety for the art inside should nearby fault lines become active.

In our daily struggles with the forces of nature, we seek ways of balancing, defying or denying gravity, challenging physics. In our fantasies of art and structure, nature does not always win.

1 Exterior views, Art Box, Santa Barbara, California, 1983
2 Drawing by the author
3 "Temple" side of gallery exterior
4 Art Box "temple" entrance

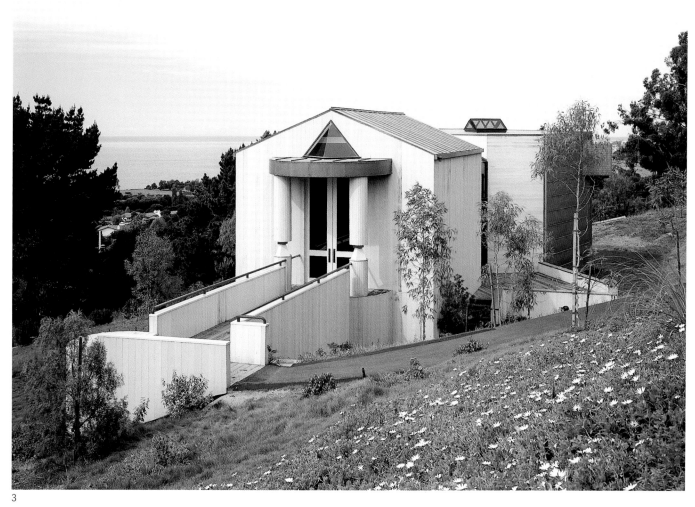

3

Viewers enter the gallery through the adjacent substructure, which is built in the spirit of a temple (above and right). Its entrance portico illustrates Palladian proportions and red block details in the front columns pay homage to the signature of Frank Lloyd Wright.

The doors open onto an art collection filled with contemporary abstraction. Crossing this entrance threshold suggests a symbolic act acknowledging the importance of history (see also following pages). Without historical grounding, we lack the foundation for understanding contemporary departures. When we have that foundation, the fun, and vitality that energize contemporary art and architecture can bring new life to our perspective on the past.

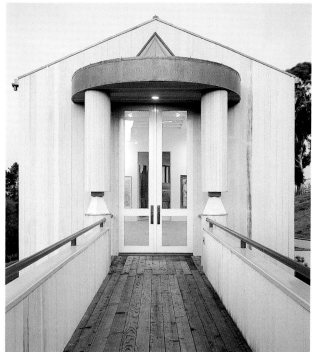

4

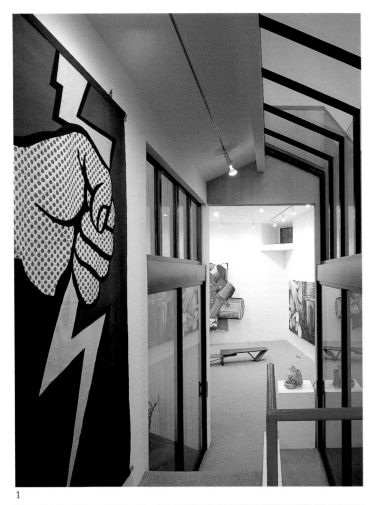

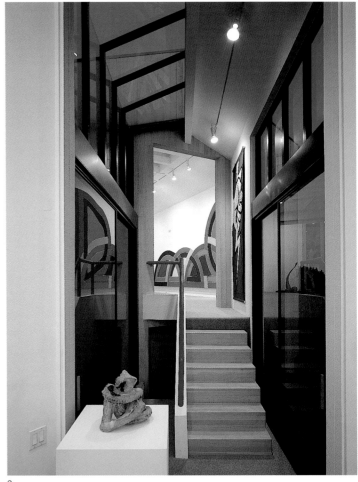

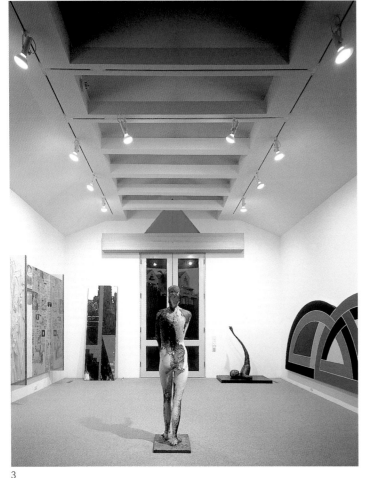

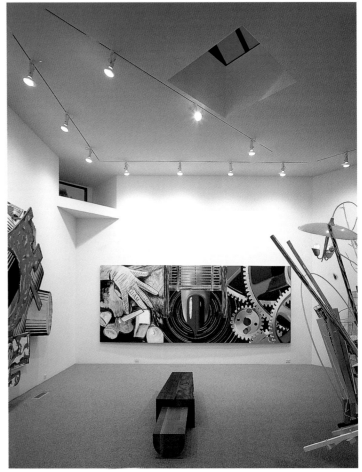

1

2

3

4

Designing a building for art is a privilege. My goal in designing the Art Box was to create a structure worthy of housing work that represented the experiences of generations of creative thinkers, recording their impressions of time and place.

Highlighting a shift between vertical and horizontal, familiar and unexpected, a glass-enclosed passageway links the two sections of the art gallery (below). This link indicates a symbolic connection between that which is defined and that which is imagined, a dialogue that stimulates our senses to investigate new possibilities.

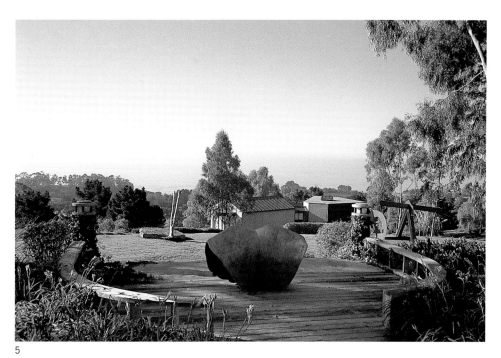

5

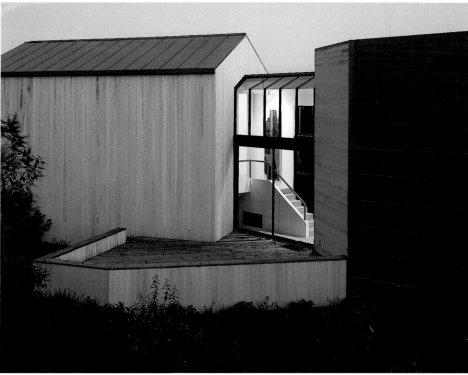

6

Interior views of the gallery in the Art Box, Santa Barbara, California, 1983:
1 Gallery interior with artworks
2 Sculptural stairway between gallery sections
3 "Temple" portion of the gallery
4 View of skylight exterior as upended window form and elevated window as part of the overturned chimney
5 The gallery provides an anchoring point for a collection of outdoor sculpture
6 Glass-enclosed passageway connects gallery spaces

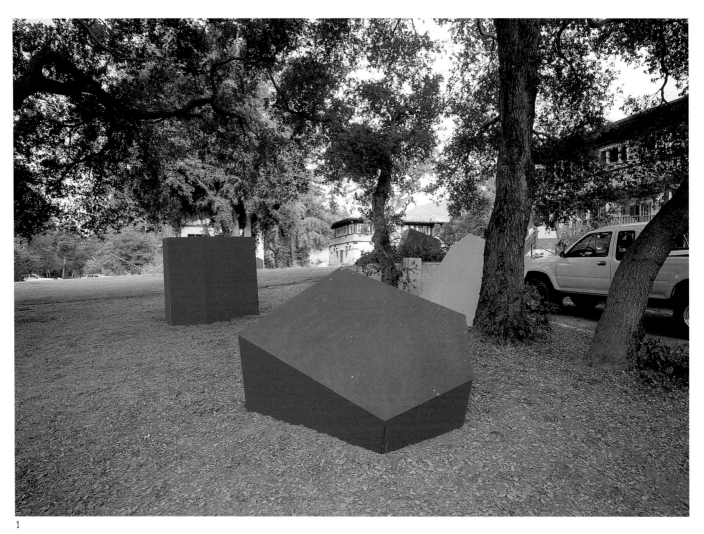

1

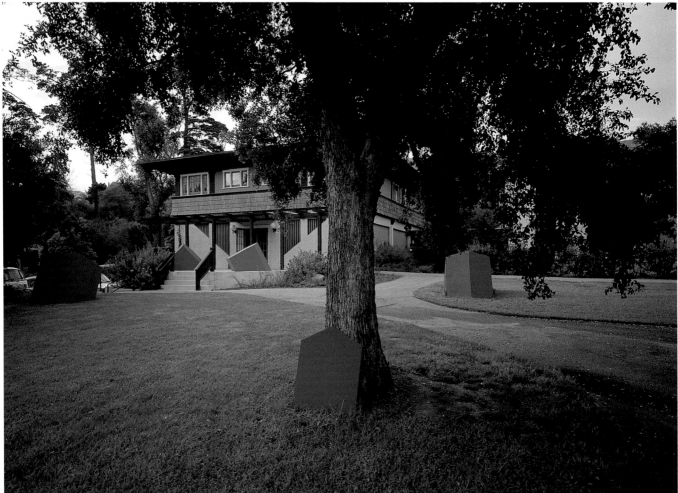

2

154

In 1989, gallery director R. Anthony Askew invited me to show my work through models and photographs at Westmont College's art gallery. This allowed me to pursue more variations of "toppled houses" in the form of temporary installations (opposite). Tumbled about the landscape, such houses questioned our orientation to structure, to gravity, and to one another. The primary-colored blocks reminded me of my early impressions of Calder's mobiles freely commanding the space they inhabited (see pages 38–9).

The San Francisco earthquake of 1989 inspired an addition to the installation (right) when director Robert McDonald brought the exhibit to the DeSaisset Museum. Sculptural houses settle into the ground in a room painted all in red, and diagrams of moving and crashing shapes skew notions of perspective and balance.

4

5

1& 2 Author's exhibit "Real and Ideal" at Westmont College, 1989
3-6 "Real and Ideal" installation at Santa Clara University, 1990

3

6

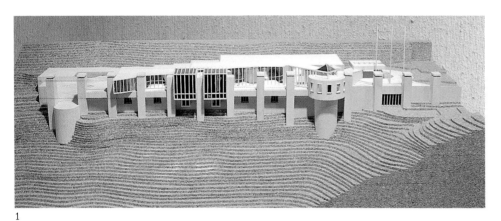

1

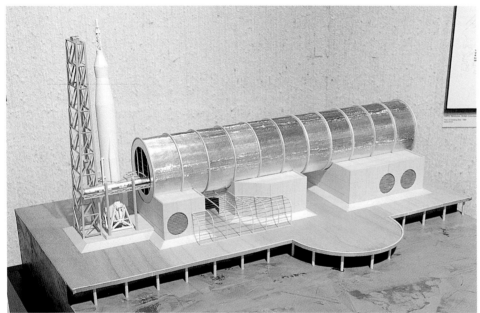

2

The exhibition entitled "Real and Ideal" presented documentation of built projects, along with architectural dreams that were not realized. Ideal projects are schemes that advance the design vocabulary. They are fantasies showing the purest creative intention prior to negotiating the constraints of site and situation. For example, the dramatic rock outcrop at Castle Pines, Colorado, inspired a clubhouse modeled after European fortresses to welcome returning golf "warriors" (top left).

Abstraction from recognizable forms became more literal in our proposal for an Air and Space Museum. At the request of the Vancouver Provincial Government, we studied the Expo '86 site for potential future uses. Our objective was to demonstrate alternative land and building uses to stimulate a rebirth of a decaying downtown edge, while maintaining the energy created by the Expo. We proposed an Air and Space Museum to transform the waterside into an international convergence of culture and technology. The proposed structure was an abstraction from the forms of a launching pad (bottom left).

1 Space Museum, Vancouver, British Columbia;
 proposal 1986, model 1989
2 Proposed Castle Pines Golf Course, proposal 1985,
 model 1989
3 Bus stop at Rancho Franciscan, Santa Barbara,
 California, 1989
4 Bus Stop at the Galleria, La Cumbre and State Streets,
 Santa Barbara, California, 1986
5 Metropolitan Transit District Consolidation Facility,
 Santa Barbara, California; proposal 1987, model
 1989

3

4

Sometimes the most enjoyable projects can be small things with everyday uses: a bus stop can offer an opportunity for playful departures.

A beach-themed bus stop (top left) was an especially lighthearted moment in our design of Rancho Franciscan, a senior citizens' apartment complex in Santa Barbara, California. Many of the residents of this complex used the bus as their primary means of transportation. I hoped that this suggestion of a day at the beach would brighten the waiting periods that were part of their routine.

Paying homage to Southern California's palm-lined streets, we designed the bus stop (top right) as a detail to the Santa Barbara Galleria, which stands on a busy street in a densely developed urban area. These structures have become street art.

These bus stop projects led to a working relationship with Santa Barbara's Metropolitan Transit District, who later requested a structure to house administrative functions. My first thoughts were to integrate the shapes of buses converging into the city's Spanish Colonial architectural vocabulary. Bus-like configurations became conference rooms, the central rotunda a public museum of transportation. This unrealized structure (right) addressed the need for public transportation to be people-friendly.

5

1

2

A museum proposed for Ruidoso, New Mexico, was imagined as a triad of Trojan horses on the desert—a tribute to the famed quarter horse races in the region. The power and freedom of spirit associated with the horse inspired a series of abstractions that easily translate into structure. Formal abstractions of palomino, bay and roan steeds frozen in structure were designed to house a collection of racing memorabilia and photographs. I often revisit the horse as building in my sketches.

1&2 Untitled drawings by the author, produced at Garner Tullis Workshop, New York, 1990
3&4 Untitled drawings by the author, 1989
5 Horse Museum, Ruidoso, New Mexico; proposal, model 1990
6&7 Untitled drawings by the author, 1989

3

4

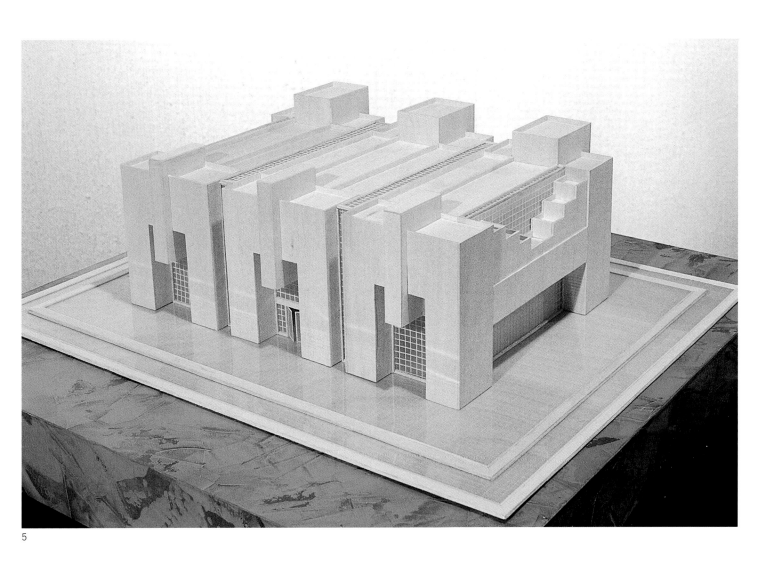

5

6

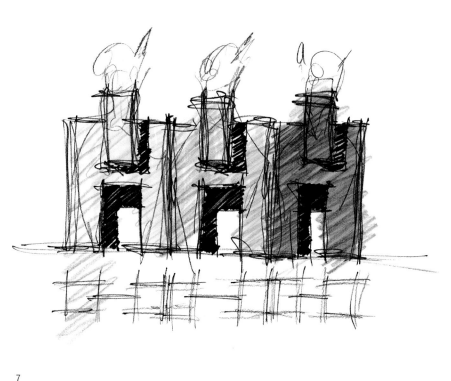

7

159

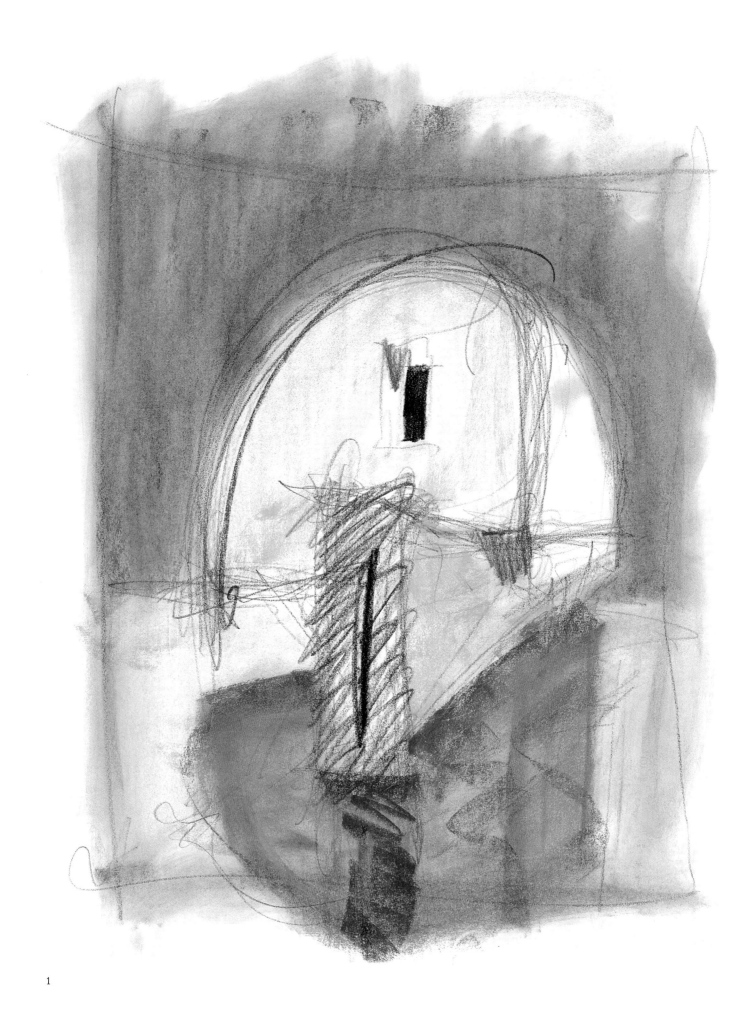

1

Commissioning a pool cabana, Howard and Fran Schoor, who live on a standard bred horse farm in New Jersey, desired a structure that would remind them of the Caribbean during the winter. The resulting pool house (right) stands atop a knoll above the stables. With its grounded stature and central barrel shape, the pool house takes on the presence of a horse overlooking the pastures below, commanding the landscape. The color scheme celebrates summer days and offers the eyes a tropical departure from the cold horizon throughout the gray winter months.

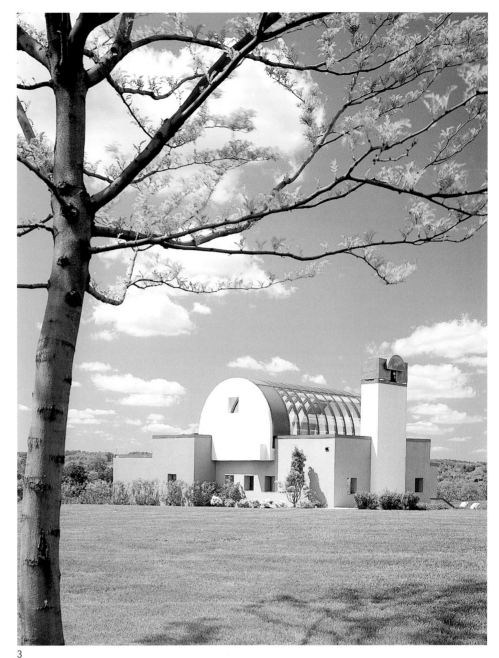

3

2

1 Untitled drawing (from *Mirage* series) by the author, 1998
2 Untitled sumi ink painting by the author, 1998
3 View from pasture showing chimney cap abstraction of horse form, Schoor Pool House, Colt's Neck, New Jersey, 1988
4 View from poolside, Schoor Pool House

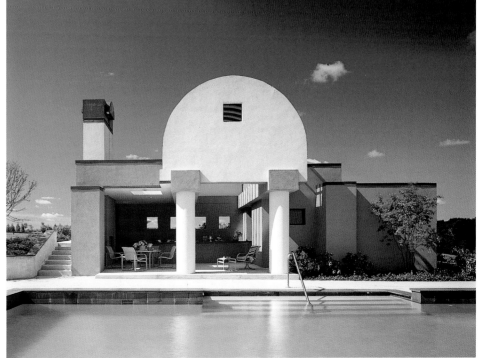

4

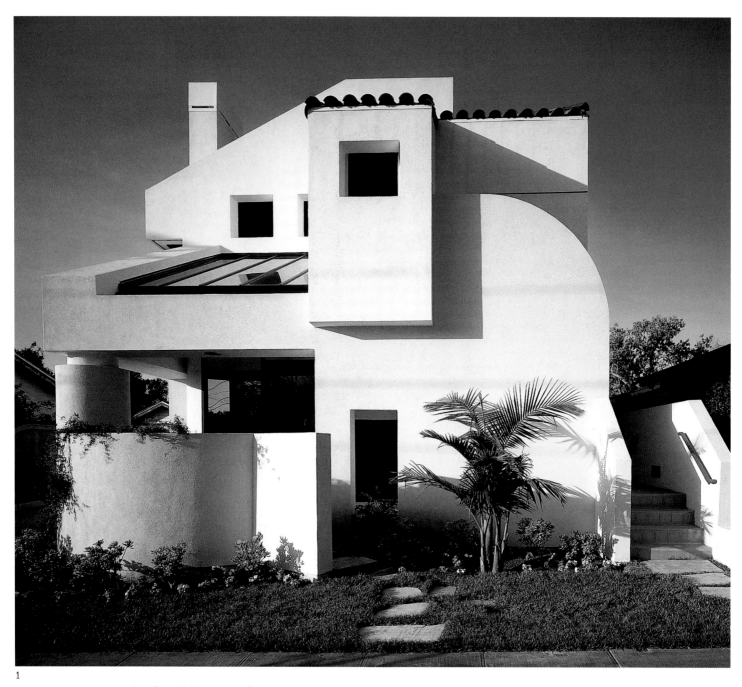

1

An obstetrician–gynecologist in my community wanted a building for his practice. As we discussed programmatic issues, I kept coming back to the female form. I was motivated by the challenge of integrating elements that suggested nuances of femininity.

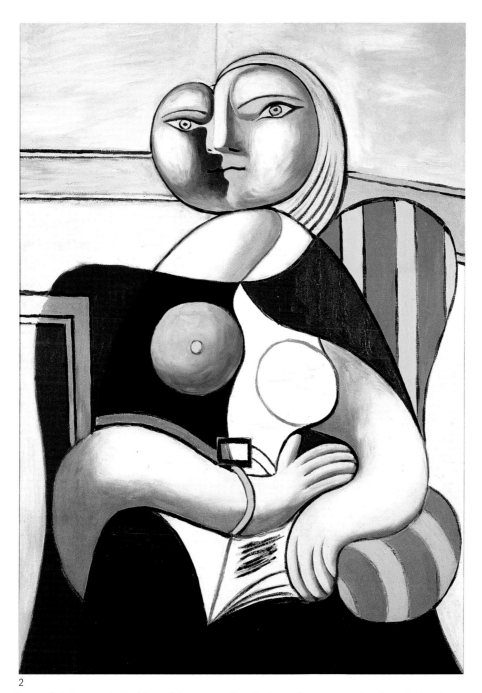

2

The completed building (opposite) bears similarities with some of Picasso's paintings (see above). The facade is a composition of abstracted forms—suggesting a face, a shoulder, and a breast—and defining the practice of the doctor of obstetrics and gynecology.

Both works are portraits: the painting is a portrait of a woman, and the building is a portrait of the function it houses.

1 Facade suggests Cubist space, Secord Medical
 Building, Santa Barbara, California, 1988
2 Pablo Picasso, *Reading*, 1932

1

1&2 Untitled drawings (from *Mirage* series) by the author, 1998
3 Photograph by Macduff Everton, *Umpqua Aquaculture, Oyster Farm, Winchester Bay, Oregon, 1998*

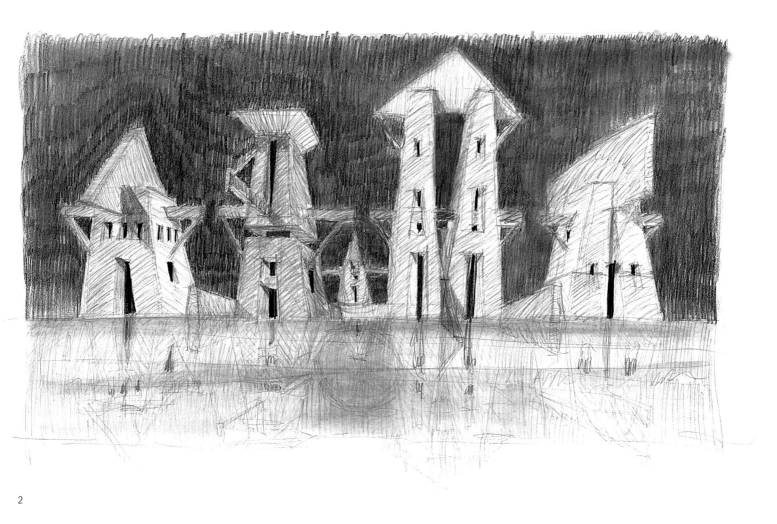

2

Architectural "mirages" are my visions of buildings unrestricted by structural laws and the confines of materiality. Like the containers that drift in the photograph by Macduff Everton (below), these imagined structures (above and opposite) float on reflective pools, groundless and weightless.

Ideal forms that cannot be brought to life can nonetheless serve as motivating forces surfacing in subtle ways in built forms.

3

In designing the Siegel residence (see pages 122–125), located in a Florida coastal city, we had to address the possibility that the dwelling could one day find itself in the path of a hurricane. This matter seemed to call for more than structural consideration. As an additional preventative measure, we gave the house a wall detail in the shape of a tall wave (opposite) paying a form of tribute to the "hurricane gods." Inscribed in the side of the wave is the silhouette of an ark—a declaration of hope that the home would carry its family safely through the storm.

When faced with something beyond our control and larger than we can comprehend, we are lost if we cannot find a way to smile.

1

1 Michael Heizer's earthwork *Double Negative*, Mormon Mesa, Nevada, 1969–70; offering and photograph by the author
2 "Wave wall" detail, Siegel Residence, Boca Raton, Florida, 1989

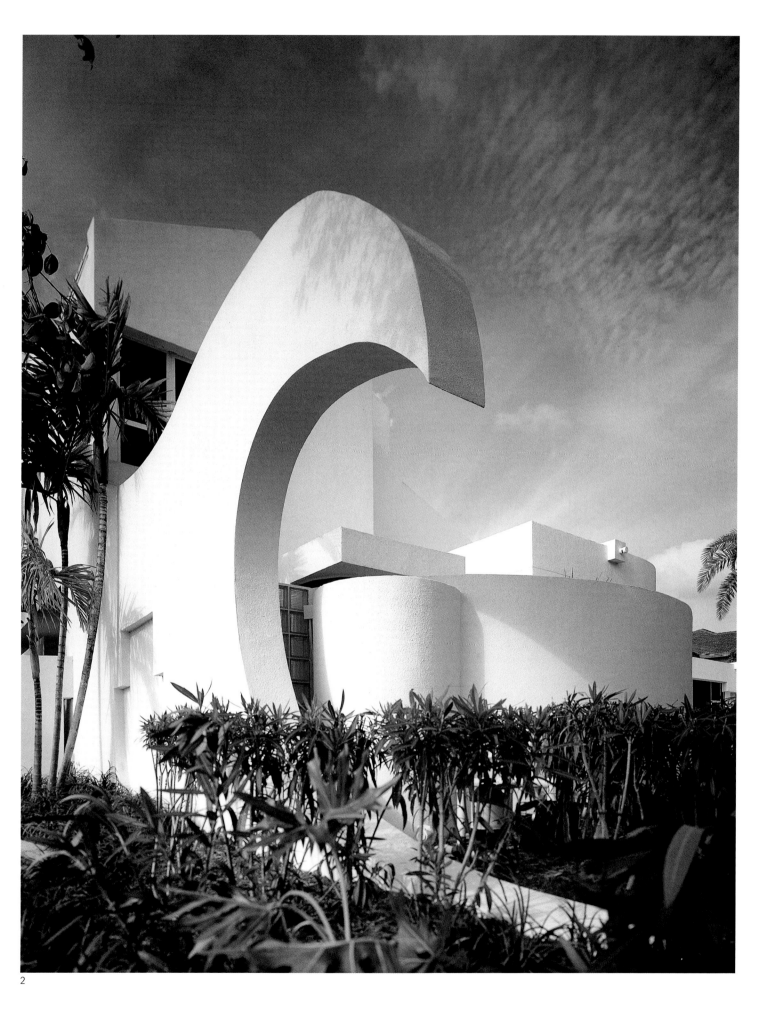

The role of the futurist is well documented throughout history. Leonardo da Vinci anticipated human flight, LeCorbusier dreamed of a machine world, while Frank Lloyd Wright would have given every citizen an acre of land to live on. Buckminster Fuller's geodesic dome was also an eloquent, purposeful innovation. What all of these visions share is an optimistic outlook toward the future and a belief in technology and change.

In the past 20 years, I have watched the rise in popularity of an approach to community development that esteems only proven, familiar designs that came of age prior to 1940. Some advocates of this neotraditional style capitalize on a desire to step back into history, to recreate an imagined time of safety, security, and connection with our neighbors.

The images created by these townscapes, while attractive in their evocations of an uncomplicated past, have little to do with the present age of technology all around us. What has happened to the future? While I am a firm believer in learning from the past, we need to be wary of the power of nostalgia. Solutions that have worked in decades past may not always contain the answers we seek.

What would happen if all artists were driven to repaint imagery of the past; if investigation of new relationships was abandoned for tried and true form? Handcuff creativity and there would be no need for imagination.

My visions of the future question the value of permanence in architecture, particularly in housing. We have subdivided and built communities with the thought that permanence was ideal. Gradually we have filled the squares with concrete. However, as an increasingly mobile society, we have continued to move on, sprawling beyond the next hill and leaving outdated infrastructure in our wake. If we built certain components with change and transition in mind, the village could become a more organic entity, able to adapt to the needs of the next generation.

Perhaps we should create ephemeral communities. Ensuing generations might not then have to deal with our egocentric need to dictate permanence, and static blocks would not be our legacy.

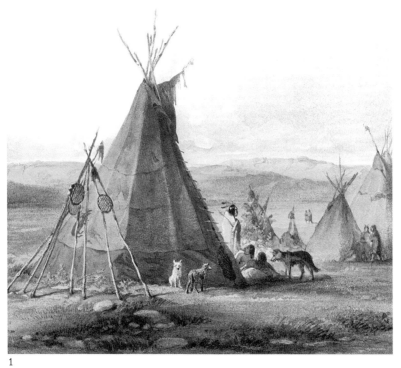

1

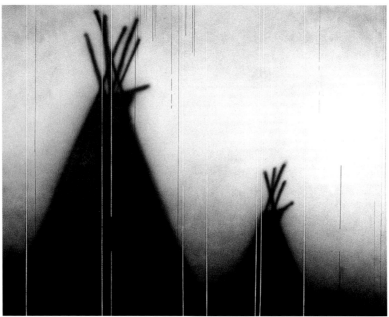

2

3

4

5

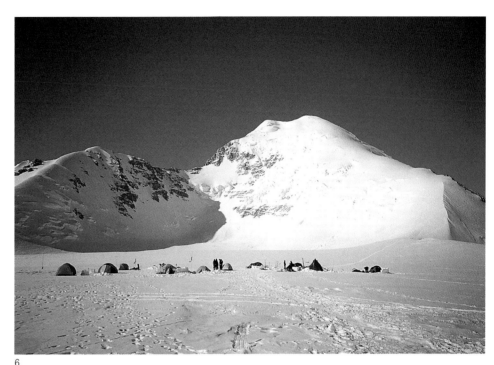
6

The 1984 Olympics took place on sites throughout southern California utilizing existing facilities to create festive international villages through the use of temporary structures. Tents accommodated thousands of people: competitors, visitors, volunteers, media, officials, and support staff (see above left). As Commissioner of Rowing, I had the task of structuring the Lake Casitas competition site and seeing to its removal. Efficiently erected, the encampment on the lake reminded me of Camelot, filled with drama and romance. And following the games, it all went away. The environment was completely restored, unspoiled.

I was reminded of that ephemeral village during an expedition to the Antarctic in 1994. In this vast, frozen wilderness, even the minimal contact that humans have had with this environment has made a measurable impact. When we came to make an encampment there (above right), foremost in our minds was the need to leave the environment as close as possible to the state in which we found it. We kept our camps small and carried our waste with us as we went.

In seeking solutions to today's housing challenges, we may be wise to consider structures that can be moved and rebuilt with minimal impact on the landscape. All over the world, nomadic tribes have kept their cultures mobile to adapt to changing resources. How would it affect our ways of living to imagine our homes as movable structures?

1 Karl Bodmer, *An Assinboine Encampment at Fort Union*, 1833
2 Ed Ruscha, *Western*, 1991
3 Wigwam Motel, Holbrook, Arizona, photograph by the author
4 Rowing Pavilion, 1984 Summer Olympics, Lake Casitas, California
5 Rowing Pavilion
6 Antarctic campsite, photograph by the author

1

I began exploring movable architectural forms early in my career with a study of mobile homes and building systems. Never taken seriously as architecture, the familiar, restrictive "boxes on wheels" (opposite top left) were my launching pad for a series of prototypes for modular homes.

I believed that more could be done with modular housing, and a continuing exploration of the possibilities of "architecture on wheels" has extended throughout my career.

We started developing possibilities for movable housing in 1968, in conjunction with the University of California, Los Angeles (UCLA) School of Urban Planning. Centered around building systems, our research team explored historical use patterns and current technologies, creating the foundation for the design of what we came to call "mobile modules"—a system for factory-built homes that went far beyond the mobile homes of the day (see above).

Rather than being proportionally restricted to what could be carried on a single truck, these mobile modules allowed various styles of houses to be constructed from several separate modules. Tens of thousands of these units were built in the 1970s and beyond.

Buildings on Wheels

2

3

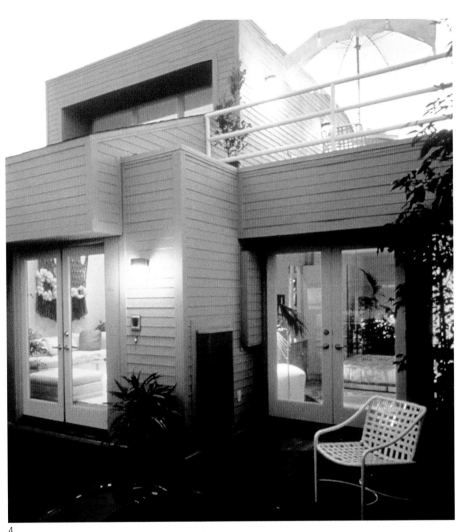

4

In 1980, *Housing* magazine asked our firm to design a prototype modular home to be shown at the National Association of Home Builders Show. Far-reaching social and material concerns were addressed in HMX-1 (top right), including tandem ownership, home-to-office communications, rooftop living, and small-lot design. This was the first of many prototypes we designed to be manufactured in a factory, transported to the site, and erected in a variety of configurations, from single-family detached to multi-family attached.

Our modular units were entirely mobile and capable of being reconfigured to meet different demands. Moreover, they offered new solutions to a fundamental need: to make the best use possible of a limited amount of floor space.

1 Mobile Modular Housing (prototype), 1969; photograph by Julius Shulman
2 The image often called to mind by the idea of movable homes
3 HMX-1, Las Vegas, Nevada, 1981, as built on a showroom floor
4 HMX-1 on a more traditional lot

1

The success of HMX-1 led to the creation of the Housing Information Center in 1984. Directed by Elise Platt, this non-profit organization was responsible for the series of modular home constructions known as New Expanding Shelter Technology (NEST).

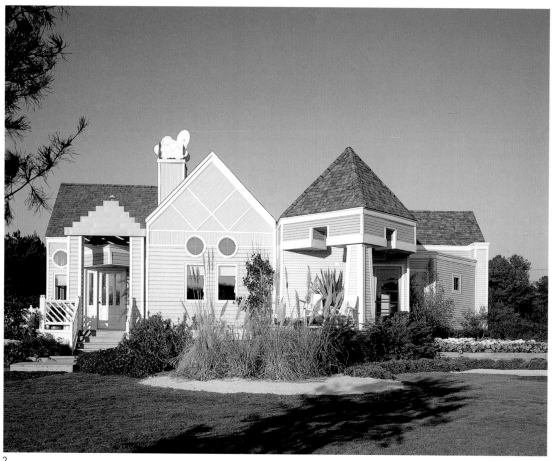

2

NEST Houses explored new possibilities for architecture on wheels. In collaboration with builders and manufacturers, a new NEST house was designed and constructed each year from 1985 to 1990. The project demonstrated the ways that modular housing units could be designed and configured, creating homes that served a variety of needs. Constructed on site from sets of standardized sections that were assembled elsewhere, each of the houses showcased the most advanced materials and technology then available.

We designed the NEST houses to change people's expectations of what architecture on wheels could accomplish. The Housing Information Center was committed to show the world that modules could provide exciting living environments, meet a wide range of market and site specific requirements, and be more flexible.

The connection to the land is important to our sense of well-being, however, the permanent commitment of a residential structure to a place may become an outdated notion in an era of rapid technological advancement.

3

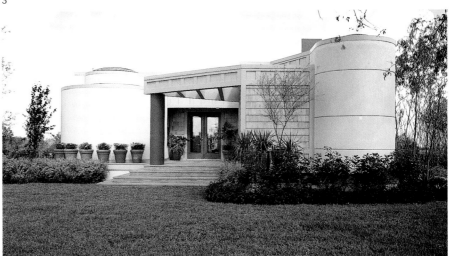

4

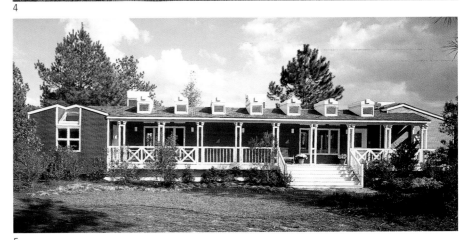

5

1 Photograph by Richard Ross, *Miniature Trailer, Museum of Jurassic Technology, Los Angeles, 1999*
2 NEST '90, Atlanta, Georgia, 1990
3 NEST '85, Houston, Texas, 1985
4 NEST '86, Dallas, Texas, 1986
5 NEST '88, Dallas, Texas, 1988
6 NEST '89, Atlanta, Georgia, 1989

6

In the early 1990s, our pursuit of the possibilities of modular structures took the form of the Mod Pod. This project was conceived as temporary shelter—a dignified living space in less than 100 square feet.

Alone or in combination, Mod Pod units can serve as emergency housing after a disaster, as a single-occupant residence (bottom), as a dormitory, a medical compound, or a vacation shelter. Various styles of these units can be added to existing buildings to create off-the-shelf living quarters, home offices, or guest bedrooms.

1

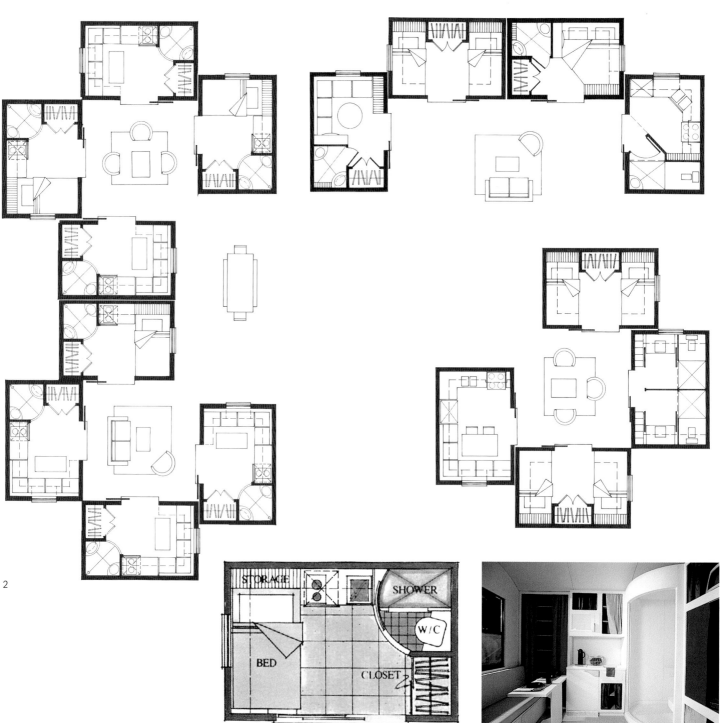

2

STORAGE

SHOWER

W/C

BED

CLOSET

3

4

5

Rapidly deployable, each 8x12' box can be fabricated on location or built on a rigid frame to be trucked or flown by helicopter to the site. While temporary, the Mod Pod is not disposable. These lightweight structures are designed to withstand heavy use. They can then be cleaned up and sent on to their next destination.

These modules create a grid of movable forms, a village connected by conduit to sources of energy, or a community designed to disperse, as need dictates. Peter Halley's paintings (above) allude to the high-tech circuitry and information systems that will transform our infrastructure. These colorful geometric compositions suggest to me the architectural massing of villages tied by conduits.

1 Units arranged as a pair connected by a porch, Mod
 Pod (prototype), 1992
2 Potential arrangements of the modules
3 Floor plan of "Self-Contained Unit" module
4 Interior of single "Self-Contained Unit"
5 Peter Halley, *Forced Exposure*, 1999
6&7 Models demonstrate potential configurations of
 modules

6

7

1

2

The Millennium House (above) is a concept intended to raise questions, to spark discussion, to encourage a rethinking of the challenges of building homes and communities, and to pose solutions that anticipate future needs.

Currently in development, the Millennium House is a kit of parts based on a power and utility platform. Much as a computer platform accommodates different plug-in peripheral devices with various functions, the core of the house contains all power and utility fixtures, including kitchen and bath functions. Living and working "cells" plug into and onto the utility platform. This offers plan flexibility and adaptability for site, lifestyle, and demographic changes. Plenums carry all electrical and mechanical systems sending energy from the core through cabling and conduits to connected modules. The utility platform utilizes alternative power sources and materials, and thus incorporates the means of achieving sustainability.

Less reliant upon elaborate infrastructure, the Millennium House requires only water and a means of transportation to be brought to the site. These houses are also designed to be dismantled and moved to a different site when necessary. Plug-in/plug-out construction enables such houses to be built practically overnight. This construction is designed to encourage new land use policies not based on static zoning and subdivision principles.

The mobility of these structures could allow new neighborhoods to grow and contract with greater ease. And as a result, the land where they are used need not be permanently planned for housing, commercial, or agricultural use.

New possibilities for ownership are also present in this flexible planning: home ownership could mean a percentage of a neighborhood, rather than a particular land parcel. As demographics and economies change, the owner group of the entire neighborhood could sell the land as a unit, which could then be converted to another use. Such a system could facilitate changes in land use with reduced environmental impact.

I am inspired by many artists who articulate environmental and social concerns through their media. Kathryn Miller created sculptural sod houses (below) that burst into foliage and were ultimately planted in the landscape to draw attention to environmental concerns. Richard Ross's photograph of defunct launch site structures (opposite) captures the futility of establishing infrastructure that can never go away.

1 Richard Ross, *Complex 34, Man to Moon Launch Site,*
 Cape Canaveral, 1995
2 Perspective of Millennium neighborhood, Millennium
 House, 1999 (prototype, in progress)
3 *The Subdivision,* an installation by Kathryn Miller,
 1992

3

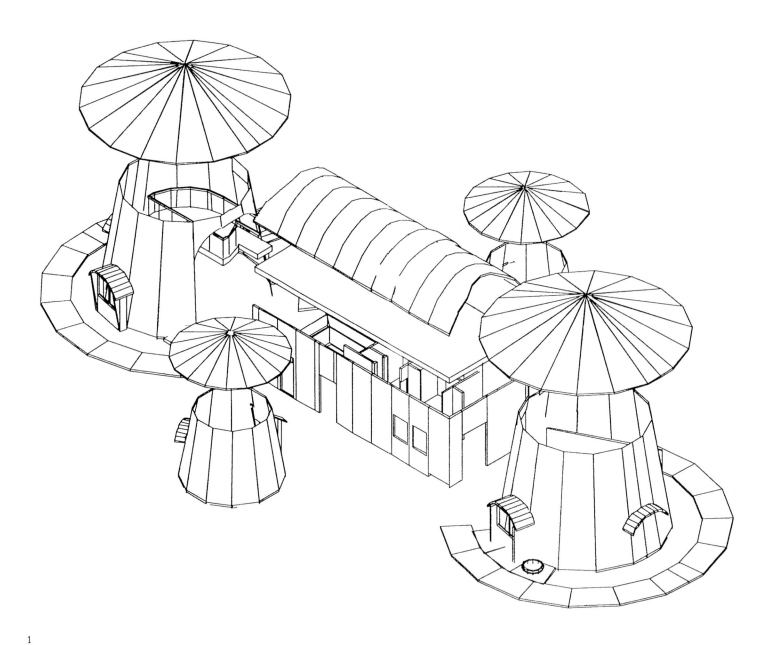

1

The proposed Millennium House is based on organic growth patterns and forms found in nature (see below). Modules are softly curved habitats meant to envelop rather than contain. Architectural textiles establish walls that deny mass and substance without sacrificing insulation, privacy, or comfort.

Through the development of new energy sources, new land use patterns, new building forms, and the utilization of new materials, the home of the 21st century may contain the means of change built into its platform. Homes, neighborhoods, and communities could be able to move and evolve without devastating the environment or leaving behind a blighted landscape.

We may do well to follow the example set by artists exploring the ephemeral as we seek new avenues for the form of future communities.

1 Axonometric, Millennium House, 1999 (prototype, in progress)
2 Organic inspiration for the Millennium House
3 Christo and Jeanne-Claude's temporary environmental work of art *The Umbrellas, Japan-USA, 1984–1991* (Ibaraki, Japan site)
4 Fan vault, photograph by the author
5 Claes Oldenburg, *Crusoe Umbrella*, 1979
6 Christo and Jeanne-Claude's temporary environmental work of art *The Umbrellas, Japan-USA, 1984–1991* (California site)

2

3

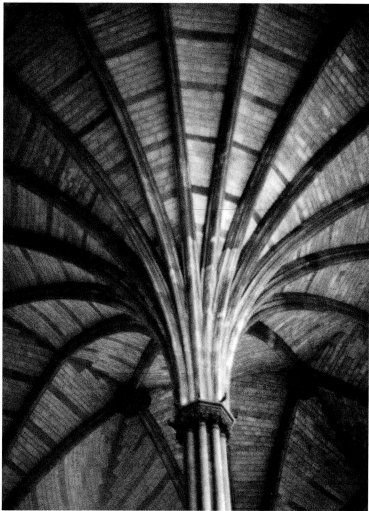

4

5

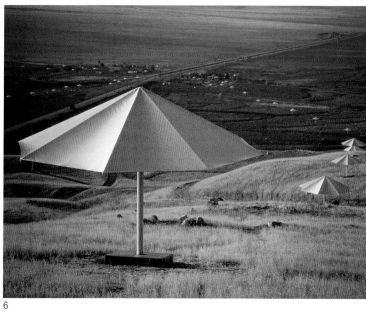

6

181

Of the lifetime I have spent thinking about the connections and parallels in art and architecture, the past ten years have been devoted to collecting the fragments that have become this project. My desire to put this book into the public realm was less about my architectural experiences and more about the way I have focused my career on creating a visual language that articulates my creative processes. When I come upon a dynamic artwork or well thought out building, old or new, my viewpoint is altered. I am inspired to embark upon the next adventure.

Standing in front of paintings and sculptures or watching a dance, I realize how fortunate we are to have a world filled with creative souls who punctuate the predictable. I enjoy the process as well as the result and am continually challenging myself to further understand and investigate.

Art and architecture have enriched my life. I believe the connections that we make throughout life create a greater understanding of the past, present, and future. My interest in the human condition makes me an eternal optimist and my search for great composition will continue to drive me to investigate new form and substance. I hope this book serves as a road map for some, but in the end everyone must formulate their own approaches to exploring what will endure. I intend to follow this work with my views of future urban manifestations and explore in a similar manner the connections that I believe will become logical paths in the making of rational human settlements.

Well-conceived architecture can be the foundation for solving many of the problems evident in our built environment. It is an exciting challenge to develop a unique form that brings to life the interests of those within. Sometimes this means designing a building in direct collaboration with the people who will utilize it; at other times it means designing for the unknown. In all cases the practice demands agility in recognizing and negotiating the needs, wills, and desires of all who will be affected. This is the common thread through my career: the will to collaborate, the desire to create new spatial relationships, to develop connections among people, structure, art, and history. Any pitfalls along the way have only made the high points more rewarding. It has been a wonderful trip so far.

Harry Reese, *The End,* 1991

Appendix 1: Featured Artworks

Herbert Bayer
In Search of Times Past, (n.d.)
Gelatin silver print of photomontage, edition 26 of
 40
11" x 13.874"
Collection Santa Barbara Museum of Art
Museum purchase with funds provided by the
 Chalifoux Fund, Auction! Auction!
Courtesy of Margaret Mallory
Photography by Scott McClaine
© 2000 Artists Rights Society (ARS), New York/VG
 Bild-Kunst, Bonn
(page XII)

Seasonal Reflections, 1980
80" x 80"
Acrylic on canvas
Courtesy of Javan Bayer
© 2000 Artists Rights Society (ARS), New York/VG
 Bild-Kunst, Bonn
(page 26)

Thomas Hart Benton
Wagon Ride, (n.d.)
Lithograph on paper
18" x 19"
Collection Santa Barbara Museum of Art
Anonymous Donor
Photography by Scott McClaine
© T. H. Benton and R. P. Benton Testamentary Trusts,
 licensed by Visual Artists and Galleries Associa-
 tion (VAGA), New York
(page 58)

Karl Bodmer
An Assinboine Encampment at Fort Union, 1833
© Wood River Gallery/Eyewire Inc.
(page 170)

Alexander Calder
Fafnir-Dragon II, 1969
Painted steel
128" x 152"
©2000 Estate of Alexander Calder/ARS, New York
(page 38, 112)

Untitled, 1973–74
Gouache on paper
© 2000 Estate of Alexander Calder/ARS, New York
(page 22)

Suzanne Caporael
Whatever He Says, 1986
Oil on canvas
84" x 72"
Courtesy the artist
(page 60)

Paul Cezanne
Houses at L'Estaque, 1880–85
© Wood River Gallery/Eyewire Inc.
(page 79)

View of Gardanne, 1885–86
©Wood River Gallery/Eyewire, Inc.
(page 34)

Christo
The Pont Neuf, Wrapped (Project for Paris), two
 preparatory drawings, 1980
Pencil, pastel, charcoal on paper
15.5" x 65.625"/42.5" x 65.625"
Collection Santa Barbara Museum of Art, gift of
 Women's Board in memory of Virginia Williams
Photography by Scott McClaine
© Christo 1980
(page 42)

Christo and Jeanne-Claude
The Umbrellas, Japan-USA, 1984-1991
Temporary environmental work of art
Photographs by Wolfgang Volz
© Christo 1991
(page 181)

Alexander Jackson Davis
Eglise du Saint Esprit, New York City, 1834
Architectural illustration
© Wood River Gallery/Eyewire, Inc.
(page 17)

Castlewood for Joseph Howard, New Jersey, 1859
Architectural illustration
© Wood River Gallery/Eyewire, Inc.
(page 144)

Aristides Demetrios
Steel Drawing IV, 1996
Steel sculpture
28" x 27" x 18"
Courtesy the artist
(page 25)

Richard Diebenkorn
Ocean Park No. 48, 1971
Oil on canvas
108" x 82"
Collection of Zola and John Rex
Photograph ©1995, Douglas M. Parker
(page 33)

William Dole
Hypotheses, 1971
Collage
26" x 18.5"
Collection Barry and Gail Berkus
(page 29)

Macduff Everton
Bamboo, Moss Temple, Kyoto, Japan, 1999
Color photograph
© 1999 Macduff Everton
(page 82)

Callamish Stone Circle, Isle of Lewis, Outer Hebrides,
 Scotland, 1997
Color photograph
© 1997 Macduff Everton
(page 108)

Moss Garden, Saiho-ji, Kyoto, Japan, 1999
Color photograph
©1999 Macduff Everton
(page 121)

*Umpqua Aquaculture, Oyster Farm, Winchester Bay,
 Oregon, 1998*
Photograph
©1998 Macduff Everton
(page 165)

Andy Goldsworthy
Untitled project in Santa Barbara, California, 1992
Courtesy the artist
(page 41)

Adolph Gottlieb
Red Sea, 1971
Alkyd resin on prepared linen
48" x 60"
© Adolph and Esther Gottlieb Foundation, licensed
 by VAGA, New York
(page 92)

Peter Halley
Forced Exposure, 1999
Acrylic, Day-Glo, metallic acrylic, and Roll-a-Tex on
 canvas
74" x 140"
Private collection
Courtesy the artist
(page 177)

Ann Hamilton
still life, 1988
table piled with 800 white dress shirts, singed and
 gilded on the edge
Courtesy Sean Kelly, New York
(page 40)

The choice a salamander gave to Hobson, 1987
Type C print
20" x 24"
Courtesy Sean Kelly, New York
(page 18)

volumen, 1995
Installation at Art Institute of Chicago
60' x 7' x 22'
Photography by Michael Tropea
Courtesy Sean Kelly, New York
(page 43)

Frederick Hammersley
Upside Down #5, 1974
Oil on linen
36" x 36"
Courtesy the artist
(page 19)

Tim Hawkinson
Lingum, 1999
Ink on Chromacoat Paper
48" x 81.5"
Collection Suzanne and David Booth
Courtesy the artist and Ace Gallery
(page 12)

Al Held
Brughes II, 1981
Acrylic on canvas
84" x 84"
Collection Santa Barbara Museum of Art, Gift of
 Carol L. Valentine
Photography by Scott McClaine
© Al Held, licensed by VAGA, New York
(page 14)

Red Arch, 1999
Acrylic on canvas
48" x 60"
Courtesy the artist
© Al Held, licensed by VAGA, New York
(page 139)

David Hockney
Mulholland Drive: The Road to the Studio, 1980
Acrylic on canvas
86" x 243"
Collection Los Angeles County Museum of Art
© David Hockney
(page 20–21)

*Sitting in the Zen Garden at the Ryoanji Temple,
 Kyoto, Feb. 19, 1983*
Photographic collage, edition of 20
57" x 46"
© David Hockney
(page 95)

Hendrik Hondius
Illustration from *Instruction en la Science de
 Perspective*, 1617
© Wood River Gallery/Eyewire Inc.
(page 81)

Utagawa Kunisada II
Tokaido, Totsuka, 1862, 4th month
Color woodblock print
14.75" x 10"
Collection Santa Barbara Museum of Art
Gift of the Frederick B. Kellam collection
Photography by Scott McClaine
(page 84)

Sol Lewitt
Three x Four x Three, 1984
Aluminum and enamel
169" x 169.5" x 169.25"
Collection Walker Art Center, Minneapolis; Walker
 Special Purchase Fund, 1987
© 2000 Sol Lewitt/ARS, New York
(page 130)

Donald Lipski
The Yearling, 1992, installed 1997–98
Painted steel and fiberglass
Installation view at the Doris C. Freedman Plaza, New
 York, NY, for the Public Art Fund
Courtesy the artist and Galerie Lelong, NY
© Galerie Lelong, NY
(page 148)

Rene Magritte
The Castle in the Pyrenees, 1959
Oil on canvas
79" x 55"
Herscovici/Art Resource, New York
© 2000 C. Herscovici, Brussels/ARS, New York
(page 114)

The Human Condition II, 1935
39.5" x 28.75"
Oil on canvas
Private collection/Superstock
© 2000 C. Herscovici, Brussels/ARS, New York
(page 17)

Kathryn Miller
The Subdivision, 1992
Soil, seeds, wood, text, photos, and map
Gallery installation
Courtesy the artist
(page 179)

Piet Mondrian
Composition No. 1, Black, Yellow and Blue, 1927
Oil on canvas
Christie's Images/Superstock
© 2000 ARS, New York/Beeldrecht, Amsterdam
(page 104)

John Okulick
Sawtooth, 1985
Painted wood
50" x 63" x6"
Courtesy the artist
(page 90)

Claes Oldenburg
Crusoe Umbrella, 1979
Painted steel and fiberglass
Approx. 32' x 36' x 56'
Collection City of Des Moines
(page 181)

Pablo Picasso
Reading, 1932
Oil on canvas
51.25" x 38.08"
Collection Musée Picasso, Paris
Giraudon/Art Resource, New York
© 2000 Estate of Pablo Picasso/ARS, New York
(page 5, 163)

The Dryad, 1908
Oil on canvas
72.56" x 42.5"
Collection The Hermitage, St. Petersburg, Russian
 Federation
Scala/Art Resource, New York
© 2000 Estate of Pablo Picasso/ARS, New York
(page 127)

Three Women, 1908-9
Oil on canvas
78.75" x 70.08"
Collection The Hermitage, St. Petersburg, Russian
 Federation
Scala/Art Resource, New York
© 2000 Estate of Pablo Picasso/ARS, New York
(page 65)

Violin and Guitar, 1913
Oil on canvas
65" x 54"
Collection The Hermitage, St. Petersburg, Russian
 Federation
Hermitage Museum/Superstock
© 2000 Estate of Pablo Picasso/ARS, New York
(page 102)

Harry Reese
Gateless Gate, 1992
Acrylic on canvas
48" x 60"
Courtesy the artist
(page 93)

The End, 1991
Photograph of type
Courtesy the artist
(page 184)

Carol Robertson
Untitled, 1997
Unique work on paper
27" x 33"
Courtesy the artist and Richard Tullis II
(page 25)

Richard Ross
Ancient Agora, Athens, Greece, 1984
Color photograph
© Richard Ross
(page 9)

*Landing Strips for the Space Shuttle, Edwards Air
 Force Base, 1995*
Color photograph
© Richard Ross
(page 28)

Launchpad #39, Cape Canaveral, 1995
Color photograph
© Richard Ross
(page 178)

*Trailer Diorama, Museum of Jurassic Technology, Los
 Angeles, 1999*
Color photograph
© Richard Ross
(page 174)

Ed Ruscha
Brave Man's Porch, 1996
Acrylic on canvas
82" x 50"
Courtesy the artist
(page 23)

Pacific Coast Highway, 1998
Acrylic on canvas
64" x 72"
Courtesy the artist
(page 18)

See, 1992
Acrylic on linen
19" x 24"
Courtesy the artist
(page 1)

The Act of Letting a Person into Your Home, 1983
Oil on canvas
84" x 137.75"
Courtesy the artist
(page 56)

Western, 1991
Acrylic on canvas
72" x 96"
Courtesy the artist
(page 170)

Yes/No, 1987
Acrylic on canvas
54" x 120"
Courtesy the artist
(page 129)

Sean Scully
Backs and Fronts, 1981
Oil on canvas
96" x 240"
Courtesy the artist
© Sean Scully
(page 132)

Dark Face, 1986
Oil on linen
114" x 96"
Collection High Museum of Art, Atlanta, Georgia
© Sean Scully
(page 7)

Change #8, 1975
Acrylic and masking tape
22.5" x 30.25"
Courtesy the artist
© Sean Scully
(page 83)

Charles Simonds
Towers, 1985
Ceramic
24" x 24" x 18"
Collection Barry and Gail Berkus
(page 47)

Robert Stackhouse
Approaching Blue Diviner, 1990
9' x 5' Watercolor and charcoal on paper
Courtesy the artist and Dolan/Maxwell Gallery
(page 117)

Inside a Passage Structure, 1986
Watercolor, charcoal, graphite on paper
89.5" x 120"
Courtesy the artist and Dolan/Maxwell Gallery
(page 87)

Frank Stella
Raqqa 1, 1967
10' x 25'
Acrylic on canvas
© 2000 Frank Stella/ARS, New York
(page 12)

Joseph Stella
The By Product Storage Tanks, (n.d.)
Charcoal on paper
21.875" x 28"
Collection Santa Barbara Museum of Art
Gift of Wright S. Luddington
Photography by Scott McClaine
(page 60)

Richard Tullis II
John Walker, 1988
Gelatin silver print
Courtesy Richard Tullis II
(page 30)

James Turrell
Meeting, 1980–86
Installation at P.S.1 Contemporary Art Center, New
 York
Courtesy James Turrell, P.S.1 and Barbara Gladstone
 Gallery
(page 88)

Walter Ufer
Oferta para San Esquipula, 1918
© Wood River Gallery/Eyewire, Inc.
(page 51)

Marion K. Wachtel
Pueblo of Walpi, 1929
© Wood River Gallery/Eyewire, Inc.
(page 49)

Nickolas Wilder
Early Morning Avignon, 1986
Oil, rag ground on linen on board
48" x 56"
(page 8)

Ken Yokota
Call 'em Bananas, 1984
Ceramic, wood, and steel
7' x 18" x 4'6" (apr.)
Courtesy the artist
(page 22)

In progress, 1999

Chiricahua
Desert Mountain, Arizona
B3 Architects + Planners
Desert Mountain Properties, developer
(page 136–137)

Hokuli'a
Kona, Hawaii
B3 Architects + Planners
Oceanside 1250, developer
(page 140)

Legacy (land plan proposal)
Newtown, Connecticut
Berkus Design Studio
(page 68)

Millennium House (prototype, in progress)
Berkus Design Studio
(page 179, 180)

Playa Vista
Marina del Rey, California
B3 Architects + Planners
Playa Vista Inc., developer
(page 132, 133)

Portales
Scottsdale, Arizona
B3 Architects + Planners
The Empire Group, developer
(page 131)

Private Residence (in progress)
Bighorn, California
Berkus Design Studio
(page 21)

Santa Barbara Botanic Gardens (proposal)
Santa Barbara, CA
(page 118–121)

Yagoda Residence
Scottsdale, Arizona
B3 Architects + Planners
(page 117)

1998

Bella Vivente at Lake Las Vegas
Henderson, Nevada
B3 Nevada, design architect
Amstar Homes, builder
(page 138)

Doumani–Hunter Residence (proposal)
Berkus Design Studio
Napa, California
(page 116)

Las Campanas Spa & Fitness Center
Santa Fe, New Mexico
B3 Architects + Planners
Las Campanas Limited Partnership, developer
(page 53)

The Oaks in Long Canyon
Simi Valley, California
B3 Architects + Planners
New Urban West, builder
(page 128)

1997

Connections House
Coppell, Texas
B3 Architects + Planners
Coordinated by *Builder* and *Home* magazines
Centex Homes, builder
(page 142, 143, 144, 145)

Glen Annie Golf Club
Goleta, California
B3 Architects + Planners
Environmental Golf, Inc., developer
(page 63)

Ocean Colony
Huntington Beach, California
B3 Architects + Planners
New Urban West, builder
(page 128)

Snowcreek Sales and Marketing Office
Mammoth Lakes, California
Berkus Design Studio
Dempsey Construction Corp., developer
(page 87)

Spindrift Cove (private residence)
Carmel, California
Berkus Design Studio
(page 115)

1995

Burnap Residence
Sun Valley, Idaho
Barry A. Berkus, AIA (a California Corporation)
(page 86)

Las Campanas Golf Clubhouse
Santa Fe, New Mexico
B3 Architects + Planners
Las Campanas Limited Partnership, developer
(page 24, 50, 52)

Terner Residence and Renovation of Case Study
 House #9
Pacific Palisades, California
Barry A. Berkus, AIA, and B3 Architects + Planners
(page 6, 96, 98, 99, 100, 101, 103, 104, 105)

1994

Felker Residence
Paradise Valley, Arizona
Barry A. Berkus, AIA
(page 25, 27, 54, 55)

Henry Residence
Pasadena, California
Barry A. Berkus, AIA
(page 89)

Maas Residence
Palm Desert, California
Barry A. Berkus, AIA
Andrew Pierce Corp., builder
(page 49)

1993

Horiguchi Residence
Palm Desert, California
Barry A. Berkus, AIA
Andrew Pierce Corp., builder
(page 57)

Reide Residence
Palm Desert, California
Barry A. Berkus, AIA
Andrew Pierce Corp., builder
(page 25)

1983

Via Abrigada
Santa Barbara, California
Barry A. Berkus, AIA
(page 13, 38, 112, 113)

1982

Descanso Gardens
La Canada, California
Barry A. Berkus, AIA
Bernards Brothers Inc., builder
(page 87)

1981

HMX-1
NAHB 1981, Las Vegas, Nevada
Berkus Group Architects
Roger Halloway, builder
(page 173)

1979

Turtle Rock Highlands
Irvine, California
Barry A. Berkus, AIA
The Bren Company, developer
(page 128)

1969

Mobile Modular Housing
Barry A. Berkus and Environmental Systems
(page 172)

1965

Woodleigh
La Canada, California
Barry A. Berkus
(page 85)

N.B. All architectural photographs not otherwise cited are by the author or by employees of the author's affiliated firms (Barry A. Berkus, AIA; Berkus Group Architects; B3 Architects + Planners; Berkus Design Studio). Numbers in parentheses refer to illustration numbers. Numbers not in parentheses refer to page numbers where the photos cited appear.

Russell Abraham: 50 (1); 52 (1)

Farshid Assassi: 39 (1); 148–149 (2); 150 (1); 152–153 (1–6)

Otto Baitz: 161 (3, 4)

Jim Bartsch: 89 (4, 5); 93 (3)

Tom Bonner: 6 (1); 98 (2); 100 (2, 4); 103 (2); 104 (2); 105 (3)

Tom Burt: 93 (7)

James Chen: 4 (1); 84 (2, 3); 157 (3); 162 (1)

Joe Cotitta, Syde Images: 25 (5); 54 (1, 2); 55 (4)

Dugan/Powers/Yocum: 17 (4); 111 (2, 3)

Macduff Everton: 56 (2)

Bill Hedrich/Hedrich-Blessing: 174 (2); 175 (3–6)

Ron Kolb: 10 (1); 126 (1)

Fred Lindholm: 86 (1)

Peter Malinowski/InSite: 24 (4); 32 (2); 49 (3); 57 (3); 63 (4, 5); 73 (2); 85 (4, 5); 109 (3); 154–155 (1–6); with Glenn Cormier: 38 (1); 122–123 (1–4); 124–125 (1–3); 167 (2)

Robb Miller: 16 (1); 23 (5); 27 (4); 36 (3); 38 (3); 49 (2); 57 (4); 61 (3); 62 (1, 2); 64 (1); 70 (1); 74 (3); 77 (2); 78 (1); 79 (4–6); 80 (1); 81 (3); 87 (5); 112 (1, 2); 113 (3, 4); 128 (1–6); 130 (2); 135 (2); 138 (3); 151 (3, 4); 157 (4); 173 (4)

Rob Muir: 115 (2, 3)

Erin O'Boyle: 138 (4)

Julius Shulman: 99 (3); 100 (1, 3); 172 (1)

Grant Taylor: 53 (3)

David VanHoy: 97 (2, 3); 101 (5)

Alexander Vertikoff: 92 (1)

Keith S. Walklet (for Yosemite Concession Services Corp.): 120 (2)

James F. Wilson (for Builder magazine): 142 (1), 143 (4, 5), 144 (1, 2); 145 (4)

McDaniel Woolf: 86 (2)

Architect and art collector Barry A. Berkus has been on the forefront of residential design in the United States and abroad for nearly 40 years. With his wife Gail, Berkus has been named among the world's top 200 art collectors, and they continue to support emerging artists and art institutions. Major museums around the world have shown works from their collections.

Barry A. Berkus is the founder and president of B3 Architects and Berkus Design Studio. Since his first architectural work in 1958, Berkus has redefined living patterns in housing. Residential architecture, master planned communities, and a broad range of commercial, land planning and institutional projects throughout the world have originated in his firms. Based in Santa Barbara, California, his design and planning practice has had offices in New York, Los Angeles, Irvine, San Francisco, Chicago, Atlanta, Washington, D.C., Miami, Tokyo, and Kuala Lumpur. Berkus design teams have received more than 300 design and planning awards from regional, national and international competitions.

Berkus is frequently published in international and domestic periodicals. *Architectural Digest* named him among the world's top 100 architects in 1991. In 1999, the readers of *Residential Architect* selected Berkus as one of the ten most significant figures of 20th century residential architecture, and *Builder* magazine counted Berkus as one of the 100 most influential individuals in the past century of American housing.

Berkus's interest in building systems has spearheaded extensive research and development of modular housing and the study of building methods abroad. In Japan, his work has extended from the planning and design of new towns to developing the current building codes for framed construction. Other international projects have included the planning of communities in Malaysia, master planning of residential villages for EuroDisney, and a provincial government commissioned plan for the redevelopment of the waterfront Expo site in Vancouver, British Columbia.

Berkus has lectured in Asia, Europe, and the United States at university and industry symposia on the future of the built environment. He has served on a sub-panel of the National Institute of Building Sciences. He was named by the University of California, Santa Barbara, as an Alumnus of the Year in 1989. He has served on the Policy Advisory Board for the Harvard University Joint Center of Housing Studies, and served as Commissioner of Rowing for the 1984 Summer Olympic Games in Los Angeles. Berkus is currently a member of the American Institute of Architects and the Urban Land Institute.